Sri Aurobindo on Indian Art

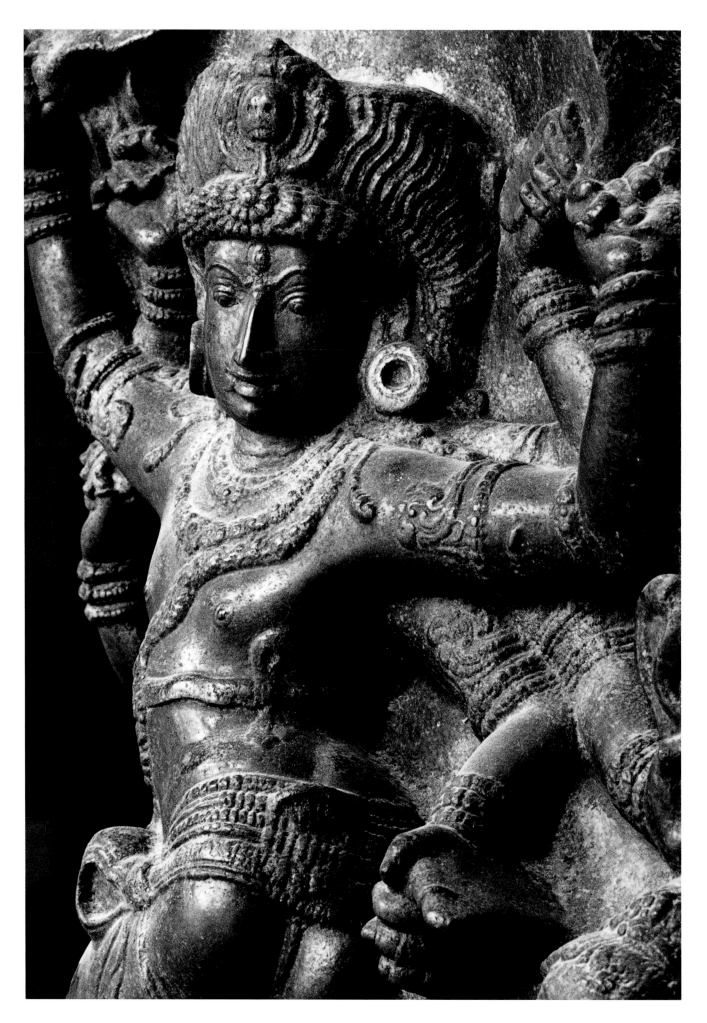

Sri Aurobindo on Indian Art
Selections from His Writings

with
Photographs by Elisabeth Beck

Mapin Publishing Pvt.Ltd.

First published in India
in 1999 by
Mapin Publishing Pvt. Ltd.
Chidambaram, Ahmedabad 380013 India
web-site: www.mapinpub.com

Simultaneously published in the United States of America
in 1999 by
Grantha Corporation
80 Cliffedgeway, Middletown, NJ 07701

Distributed in North America by
Antique Collectors' Club
Market Street Industrial Park
Wappingers' Falls, NY 12590
Tel: 800-252-5321 ◆ Fax: 914-297-0068
web-site: www.antiquecc.com

Distributed in the United Kingdom & Europe by
Antique Collectors' Club
5 Church Street, Woodbridge
Suffolk IP12 1DS
Tel: 1394-385-501 ◆ Fax: 1394-384-434
email: accvs@aol.com

ISBN: 1-890206-14-8 (Grantha)
ISBN: 81-85822-61-1 (Mapin)
LC: 98-68335

Compiled by Elisabeth Beck
Layout concept by Dolly Sahiar
Design by Paulomi Shah / Mapin Design Studio
Processed and printed by Tien Wah Press, Singapore

Captions:
Frontispiece
Eight-armed Shiva Gaja-Samhara dancing a
triumphant dance, wrapped in the skin of
the elephant demon. From Darasuram, now
in the Tanjore museum. Chola, twelfth century.

Contents Page
The sun-god Pushan. Detail. Sun-temple
of Konarak, Ganga-dynasty, thirteenth century.

Acknowledgement

While doing this book many friends helped me by expressing the importance and necessity to have Sri Aurobindo's words made visible by pictures. Their encouragement carried me through this work. To all of them my gratitude.

I want to particularly thank Ernst Beck for his contribution of some very fine photographs which are included in this volume.

My thanks are also due to Sri Aurobindo Ashram Trust for giving me permission to use Sri Aurobindo's writings for this volume.

Elisabeth Beck

The greatness of the ideals of the past

is a promise of greater ideals

for the future.

A continual expansion of what stood

behind past endeavour and

capacity is the one abiding

justification of a living culture.

– Sri Aurobindo

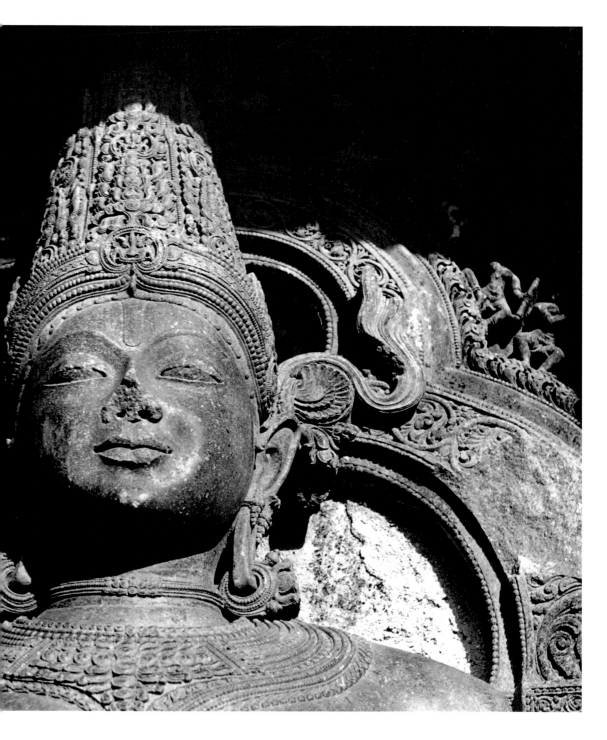

Contents

Introductory Note

The three chapters on Indian Art selected for this book were originally published by Sri Aurobindo in his monthly review *Arya*, where they appeared in 1920 as part of a series entitled *A Defence of Indian Culture*. Together with a fourth chapter on Painting which is not included here, they were reprinted in 1947 in the booklet *The Significance of Indian Art*. After Sri Aurobindo's passing, the whole of *A Defence of Indian Culture* and some related essays from the *Arya* were published under the title *The Foundations of Indian Culture*. The present book contains the full text of Sri Aurobindo's three chapters on *Indian Art*, published in *The Foundations of Indian Culture* (volume 14 of the Birth Centenary Edition 1972, Pondicherry). They are followed by excerpts from this text, printed on a grey background and illustrated with photographs. Relevant quotations from other writings of Sri Aurobindo, mainly from volume 17, are added here and there.

Sri Aurobindo wrote these essays at a time when his country was struggling to recover its identity and assert its right to exist as a free nation. In those days Indian culture was appreciated abroad only by rare individuals and hardly recognised by the imposed system of education in India itself. The disappearance of virtually all that makes India's culture distinctly Indian was considered by some to be a possible and desirable outcome of British rule. Under these circumstances Sri Aurobindo found it necessary to comment on a book that had recently been published in England, *India and the Future*, (1917) by the dramatic critic William Archer. Archer was not only prejudiced against India, but poorly qualified to write on the subject. His book would long have been forgotten if it had not prompted Sri Aurobindo's spirited reply. Since then European colonialism and the attitudes that went with it have long faded into the past, yet Sri Aurobindo's enlightened interpretation of Indian sculpture and temple architecture has remained as a beacon for all who seek a true understanding of Indian culture.

Sri Aurobindo's appreciation of art flowed from a wide background of knowledge and experience. His education in England gave him a broad outlook on European art in all its phases and his natural intimacy with the Hindu conception of life widened his comprehension even more. Moreover he had the intuitive insight and spiritual vision of a Yogi. The keynote that runs through this book is that Indian art is created from within and not from without, that it does not copy physical Nature and therefore does not convey a feeling of naturalness but of a deeper reality. Most art shows the world of creative imagination, a world reconstructed by the mind's formative faculty. The faculty through which the Indian artist seeks to create is the inner vision, not the imagination, it is a spiritual seeing and not an outer sensibility, the subtle body taking shape in a form, the body as a vessel of the breath and movement of Life. For the Indian artist is a seer; what he envisages is

the truth and beauty of another world behind this material world that we can feel and touch: it is the world of fundamental truths behind this universe of fleeting appearances.

The photographs were taken over many years in various parts of India. The temples and sculptures shown in this book are the work of different schools at different times and in various phases of development. Indian sculpture is always part of a larger unit, a monument or a temple and as such integral part of the total form. Sculptures in museums are detached from their original context and partly lose their inherent power of expression. Great care was therefore taken to reproduce – with few exceptions – sculptures which are still *in situ* and part of the whole and thus fulfil their original purpose. They were thought of as most suitable to express visually the meaning of Sri Aurobindo's words.

Indian Art 1

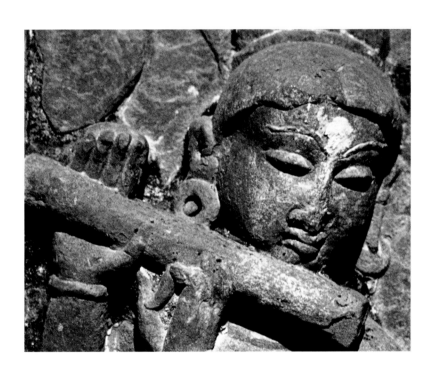

A good deal of hostile or unsympathetic western criticism of Indian civilisation has been directed in the past against its aesthetic side and taken the form of a disdainful or violent depreciation of its fine arts, architecture, sculpture and painting. Mr. Archer would not find much support in his wholesale and undiscriminating depreciation of a great literature, but here too there has been, if not positive attack, much failure of understanding; but in the attack of Indian art, his is the lastest and shrillest of many hostile voices. This aesthetic side of a people's culture is of the highest importance and demands almost as much scrutiny and carefulness of appreciation as the philosophy, religion and central formative ideas which have been the foundation of Indian life and of which much of the art and literature are a conscious expression in significant aesthetic forms. Fortunately, a considerable amount of work has been already done in the clearing away of misconceptions about Indian sculpture and painting and, if that were all, I might be content to refer to the works of Mr. Havell and Dr. Coomaraswamy or to the sufficient understanding though less deeply informed and penetrating criticism of others who cannot be charged with a prepossession in favour of oriental work. But a more general and searching consideration of first principles is called for in any complete view of the essential motives of Indian culture. I am appealing mainly to that new mind of India which long misled by an alien education, view and influence is returning to a sound and true idea of its past and future; but in this field the return is far from being as pervading, complete and luminous as it should be. I shall confine myself therefore first to a consideration of the sources of misunderstanding and pass from that to the true cultural significance of Indian aesthetic creation.

Mr. Archer pursuing his policy of Thorough devotes a whole chapter to the subject. This chapter is one long torrent of sweeping denunciation. But it would be a waste of time to take his attack as serious criticism and answer all in detail. His reply to defenders and eulogists is amazing in its shallowness and triviality, made up mostly of small, feeble and sometimes irrelevant points, big glaring epithets and forcibly senseless phrases, based for the rest of misunderstanding or a sheer inability to conceive the meaning of spiritual experiences and metaphysical ideas, which betrays an entire absence of the religious sense and the philosophic mind. Mr. Archer is of course a rationalist and contemner of philosophy and entitled to his deficiencies; but why then try to judge things into the sense of which one is unable to enter and exhibit the spectacle of a blind man discoursing on colours? I will cite one or two instances which will show the quality of his criticism and amply justify a refusal to attach any positive value to the actual points he labours to make, except for the light they throw on the psychology of the objectors.

I will first give an instance amazing in its inaptitude. The Indian ideal figure of the masculine body insists on two features among many, a characteristic width at the shoulders and slenderness in the middle. Well, an objection to broadness of girth and largeness of belly – allowed only where they are appropriate as in sculptures of Ganesha or the Yakshas – is not peculiar to the Indian aesthetic sense; an emphasis, even a pronounced emphasis on their opposites is surely intelligible enough an aesthetic tradition, however some may prefer a more realistic and prosperous presentation of the human figure. But Indian poets and authorities on art have given in this connection the simile of the lion, and lo and behold Mr. Archer

solemnly discoursing on this image as a plain proof that the Indian people were just only out of the semi-savage state! It is only too clear that they drew the ideal of heroic manhood from their native jungle, from theriolatry, that is to say, from a worship of wild beasts! I presume on the same principle and with the same stupefying ingenuity he would find in Kamban's image of the sea for the colour and depth of Sita's eyes clear evidence of a still more primitive savagery and barbaric worship of inanimate nature, or in Valmiki's description of his heroine's "eyes like wine", *madireksana*, evidence of a chronic inebriety and semi-drunken inspiration of the Indian poetic mind. This is one example of Mr. Archer's most telling points. It is by no means an isolated though it is an extreme specimen, and the absurdity of that particular argument only brings out the triviality of this manner of criticism. It is on a par with the common objection to the slim hands and feet loved of the Bengal painters which one hears sometimes advanced as a solid condemnation of their work. And that can be pardoned in the average man who under the high dispensation of modern culture is not expected to have any intelligent conception about art, – the instinctive appreciation has been already safely killed and buried. But what are we to say of a professed critic who ignores the deeper motives and fastens on details in order to give them this kind of significance?

But there are more grave and important objections in this criticism; for Mr. Archer turns also to deal with philosophy in art. The whole basis of Indian artistic creation, perfectly conscious and recognised in the canons, is directly spiritual and intuitive. Mr. Havell rightly lays stress on this essential distinction and speaks in passing of the infinite superiority of the method of direct perception over intellect, an assertion naturally offensive to the rationalistic mind, though it is now increasingly affirmed by leading western thinkers. Mr. Archer at once starts out to hack at it with a very blunt tomahawk. How does he deal with this crucial matter? In a way which misses the whole real point and has nothing whatever to do with the philosophy of art. He fastens on Mr. Havell's coupling of the master intuition of Buddha with the great intuition of Newton and objects to the parallel because the two discoveries deal with two different orders of knowledge, one scientific and physical, the other mental or psychic, spiritual or philosophic in nature. He trots out from its stable the old objection that Newton's intuition was only the last step in a long intellectual process, while according to this positive psychologist and philosophic critic the intuitions of Buddha and other Indian sages had no basis in any intellectual process of any kind or any verifiable experience. It is on the contrary the simple fact, well-known to all who know anything of the subject, that the conclusions of Buddha and other Indian philosophers (I am not now speaking of the inspired thought of the Upanishads which was pure spiritual experience enlightened by intuition and gnosis,) were preceded by a very acute scrutiny of relevant psychological phenomena and a process of reasoning which, though certainly not rationalistic, was as rational as any other method of thinking. He clinches his refutation by the sage remark that these intuitions which he chooses to call fantasies contradict one another and therefore, it seems, have no sort of value except their vain metaphysical subtlety. Are we to conclude that the patient study of phenomena, the scrupulous and rigidly verifiable intellectual reasonings and conclusions of western scientists have led to no conflicting or contradictory results? One could never imagine at this rate that the science of heredity is torn by conflicting "fantasies" in the same field. It is a minor matter that Mr. Archer

happens to be wrong in his idea of Buddha's intuition when he says that he would have rejected a certain Vedantic intuition, since Buddha neither accepted nor rejected, but simply refused at all to speculate on the supreme cause. His intuition was confined to the cause of sorrow and the impermanence of things and the release by extinction of ego, desire and *samskara,* and so far as he chose to go, his intuition of this extinction, Nirvana, and the Vedantic intuition of the supreme unity were the seeing of one truth of spiritual experience, seen no doubt from different angles of vision and couched in different intellectual forms, but with a common intuitive substance. The rest was foreign to Buddha's rigidly practical purpose. All this leads us far afield from our subject, but our critic has a remarkably confused mind and to follow him is to be condemned to divagate.

Thus far Mr. Archer on intuition. This is the character of his excursions on first principles in art. Is it really necessary to point out that a power of mind or spirit may be the same and yet act differently in different fields? Or that a certain kind of intuition may be prepared by a long intellectual training, but that does not make it a last step in an intellectual process, any more than the precedence of sense activity makes intellectual reasoning a last step of sense-perception? The reason overtops sense and admits us to other and subtler ranges of truth; the intuition similarly overtops reason and admits us to a more direct and luminous power of truth. But very obviously, in the use of the intuition the poet and artist cannot proceed precisely in the same way as the scientist or philosopher. Leonardo da Vinci's remarkable intuitions in science and his creative intuitions in art started from the same power, but the surrounding or subordinate mental operations were of a different character and colour. And in art itself there are different kinds of intuition. Shakespeare's seeing of life differs in its character and aids from Balzac's or Ibsen's, but the essential part of the process, that which makes it intuitive, is the same. The Buddhistic, the Vedantic seeing of things may be equally powerful starting-points for artistic creation, may lead one to the calm of a Buddha or the other to the rapture dance or majestic stillness of a Shiva, and it is quite indifferent to the purpose of art to which of them the metaphysician may be inclined to give a logical preference. These are elementary notions and it is not surprising that one who ignores them should misunderstand the strong and subtle artistic creations of India.

The weakness of Mr. Archer's attack, its empty noise and violence and exiguity of substance must not blind us to the very real importance of the mental outlook from which his dislike of Indian art proceeds. For the outlook and the dislike it generates are rooted in something deeper than themselves, a whole cultural training, natural or acquired temperament and fundamental attitude towards existence, and it measures, if the immeasurable can be measured, the width of the gulf which till recently separated the oriental and the western mind and most of all the European and the Indian way of seeing things. An inability to understand the motives and methods of Indian art and a contempt of or repulsion from it were almost universal till yesterday in the mind of Europe. There was little difference in this regard between the average man bound by his customary first notions and the competent critic trained to appreciate different forms of culture. The gulf was too wide for any bridge of culture then built to span. To the European mind Indian art was a thing barbarous, immature, monstrous, an arrested growth from humanity's primitive

savagery and incompetent childhood. If there has been now some change, it is due to the remarkably sudden widening of the horizon and view of European culture, a partial shifting even of the standpoint from which it was accustomed to see and judge all that it saw. In matters of art the western mind was long bound up as in a prison in the Greek and Renaissance transition modified by a later mentality with only two side rooms to escape, the romantic and the realistic motives, but these were only wings of the same building; for the base was the same and a common essential canon united their variations. The conventional superstition of the imitation of Nature as the first law or the limiting rule of art governed even the freest work and gave its tone to the artistic and critical intelligence. The canons of western artistic creation were held to be the sole valid criteria and everything else was regarded as primitive and half developed or else strange and fantastic and interesting only by its curiosity. But a remarkable change has begun to set in, even though the old ideas still largely rule. The prison, if not broken, has at least had a wide breach made in it; a more flexible vision and a more profound imagination have begun to superimpose themselves on the old ingrained attitude. As a result, and as a contributing influence towards this change, oriental or at any rate Chinese and Japanese art have begun to command something like adequate recognition.

But the change has not gone far enough for a thorough appreciation of the deepest and most characteristic spirit and inspiration of Indian work. An eye or an effort like Mr. Havell's is still rare. For the most part even the most sympathetic criticism stops short at a technical appreciation and imaginative sympathy which tries to understand from outside and penetrates into so much only of the artistic suggestion as can be at once seized by the new wider view of a more accomplished and flexible critical mentality. But there is little sign of the understanding of the very well-spring and spiritual fountain of Indian artistic creation. There is therefore still a utility in fathoming the depths and causes of the divergence. That is especially necessary for the Indian mind itself, for by the appreciation excited by an opposing view it will be better able to understand itself and especially to seize what is essential in Indian art and must be clung to in the future and what is an incident or a phase of growth and can be shed in the advance to a new creation. This is properly a task for those who have themselves at once the creative insight, the technical competence and the seeing critical eye. But everyone, who has at all the Indian spirit and feeling, can at least give some account of the main, the central things which constitute for him the appeal of Indian painting, sculpture and architecture. This is all I shall attempt, for it will be in itself the best defence and justification of Indian culture on its side of aesthetic significance.

The criticism of art is a vain and dead thing when it ignores the spirit, aim, essential motive from which a type of artistic creation starts and judges by the external details only in the light of a quite different spirit, aim and motive. Once we understand the essential things, enter into the characteristic way and spirit, are able to interpret the form and execution from that inner centre, we can then see how it looks in the light of other standpoints, in the light of the comparative mind. A comparative criticism has its use, but the essential understanding must precede it if it is to have any real value. But while this is comparatively easy in the wider and more flexible turn of literature, it is, I think, more difficult in the other arts, when the difference of spirit is deep, because there the absence of the mediating word,

the necessity of proceeding direct from spirit to line and form brings about a special intensity and exclusive concentration of aim and stress of execution. The intensity of the thing that moves the work is brought out with a more distinct power, but by its very stress and directness allows of few accommodations and combined variations of appeal. The thing meant and the thing done strike deep home into the soul or the imaginative mind, but touch it over a smaller surface and with a lesser multitude of points of contact. But whatever the reason, it is less easy for a different kind of mind to appreciate.

The Indian mind in its natural poise finds it almost or quite as difficult really, that is to say, spiritually to understand the arts of Europe, as the ordinary European mind to enter into the spirit of Indian painting and sculpture. I have seen a comparison made between a feminine Indian figure and a Greek Aphrodite which illustrates the difficulty in an extreme form. The critic tells me that the Indian figure is full of a strong spiritual sense, – here of the very breath and being of devotion, an ineffable devotion, and that is true, it is a suggestion or even a revolution which breaks through or overflows the form rather than depends on the external work, – but the Greek creation can only awaken a sublimated carnal or sensuous delight. Now having entered somewhat into the heart of meaning of Greek sculpture, I can see that this is a wrong account of the matter. The critic has got into the real spirit of the Indian, but not into the real spirit of the Greek work; his criticism from that moment, as a comparative appreciation, loses all value. The Greek figure stresses no doubt the body, but appeals through it to an imaginative seeing inspiration which aims at expressing a certain divine power of beauty and gives us therefore something which is much more than a merely sensuous aesthetic pleasure. If the artist has done this with perfection, the work has accomplished its aim and ranks as a masterpiece. The Indian sculptor stresses something behind, something more remote to the surface imagination, but nearer to the soul, and subordinates to it the physical form. If he has only partially succeeded or done it with power but with some fault in the execution, his work is less great, even though it may have a greater spirit in the intention; but when he wholly succeeds, then his work too, is a masterpiece, and we may prefer it with a good conscience, if the spiritual, the higher intuitive vision is what we most demand from art. This however need not interfere with an appreciation of both kinds in their own order.

But in viewing much of other European work of the very greatest repute, I am myself aware of a failure of spiritual sympathy. I look for instance on some of the most famed pieces of Tintoretto, – not the portraits, for those give the soul, if only the active or character soul in the man, but say, the Adam and Eve, the St. George slaying the dragon, the Christ appearing to Venetian Senators, and I am aware of standing baffled and stopped by an irresponsive blankness somewhere in my being. I can see the magnificence and power of colouring and design, I can see the force of externalised imagination or the spirited dramatic rendering of action, but I strive in vain to get out any significance below the surface or equivalent to the greatness of the form, except an incidental minor suggestion here and there and this is not sufficient for me. When I try to analyse my failure, I find at first certain conceptions which conflict with my expectation or my own way of seeing. This muscular Adam, the sensuous beauty of this Eve do not bring home to me the mother or the father of the race, this dragon seems to me only a surly portentous

beast in great danger of being killed, not a creative embodiment of monstrous evil, this Christ with his massive body and benevolent philosophic visage almost offends me, is not at any rate the Christ whom I know. But these are after all incidental things; what is really the matter is that I come to this art with a previous demand for a kind of vision, imagination, emotion, significance which it cannot give me. And not being so self-confident as to think that what commands the admiration of the greatest critics and artists is not admirable, I can see this and pause on the verge of applying Mr. Archer's criticism of certain Indian work and saying that the mere execution is beautiful or marvellous but there is no imagination, nothing beyond what is on the surface. I can understand that what is wanting is really the kind of imagination I personally demand; but though my acquired cultured mind explains this to me and may intellectually catch at the something more, my natural being will not be satisfied, I am oppressed, not uplifted by this triumph of life and the flesh and of the power and stir of life, – not that I object to these things in themselves or to the greatest emphasis on the sensuous or even the sensual, elements not at all absent from Indian creation, if I can get something at least of the deeper thing I want behind it, – and I find myself turning away from the work of one of the greatest Italian masters to satisfy myself with some "barbaric" Indian painting or statue, some calm unfathomable Buddha, bronze Shiva or eighteen-armed Durga slaying the Asuras. But the cause of my failure is there, that I am seeking for something which was not meant in the spirit of this art and which I ought not to expect from its characteristic creation. And if I had steeped myself in this Renascence mind as in the original Hellenic spirit, I could have added something to my inner experience and acquired a more catholic and universal aesthesis.

I lay stress on this psychological misunderstanding or want of understanding, because it explains the attitude of the natural European mind to the great works of Indian art and puts on it its right value. This mind catches only what is kin to European effort and regards that too as inferior, naturally and quite rightly since the same thing is more sincerely and perfectly done from a more native fountain of power in western work. That explains the amazing preference of better informed critics than Mr. Archer for the bastard Gandharan sculpture to great and sincere work original and true in its unity, – Gandharan sculpture which is an unsatisfying, almost an impotent junction of two incompatible motives, incompatible at least if one is not fused into the other as here certainly it is not fused, – or its praise otherwise incomprehensible of certain second-rate or third-rate creations and its turning away from others noble and profound but strange to its conceptions. Or else it seizes with appreciation – but is it really a total and a deeply understanding appreciation? – on work like the Indo-Saracenic which in no way akin to western types has yet the power at certain points to get within the outskirts of its circle of aesthetic conceptions. It is even so much struck by the Taj as to try to believe that it is the work of an Italian sculptor, some astonishing genius, no doubt, who Indianised himself miraculously in this one hour of solitary achievement, – for India is a land of miracles, – and probably died of the effort, for he has left us no other work to admire. Again it admires, at least in Mr. Archer, Javanese work because of its humanity and even concludes from that that it is not Indian. Its essential unity with Indian work behind the variation of manner is invisible to this

mind because the spirit and inner meaning of Indian work is a blank to its vision and it sees only a form, a notation of the meaning, which, therefore, it does not understand and dislikes. One might just as well say that the Gita written in the Devanagiri is a barbaric, monstrous or meaningless thing, but put into some cursive character at once becomes not Indian, because human and intelligible!

But, ordinarily, place this mind before anything ancient, Hindu, Buddhistic or Vedantic in art and it looks at it with a blank or an angry incomprehension. It looks for the sense and does not find any, because either it has not in itself the experience and finds it difficult to have the imagination, much more the realisation of what this art does really mean and express, or because it insists on looking for what it is accustomed to see at home and, not finding that, is convinced that there is nothing to see or nothing of any value. Or else if there is something which it could have understood, it does not understand because it is expressed in the Indian form and the Indian way. It looks at the method and form and finds it unfamiliar, contrary to its own canons, is revolted, contemptuous, repelled, speaks of the thing as monstrous, barbarous, ugly or null, passes on in a high dislike or disdain. Or if it is overborne by some sense of unanalysable beauty of greatness or power it still speaks of a splendid barbarism. Do you want an illuminating instance of this blankness of comprehension? Mr. Archer sees the Dhyani Buddha with its supreme, its unfathomable, its infinite spiritual calm which every cultured oriental mind can at once feel and respond to in the depths of his being, and he denies that there is anything, –- only drooped eyelids, an immobile pose and an insipid, by which I suppose he means a calm passionless face[1]. He turns for comfort to the Hellenic nobility of expression of the Gandharan Buddha, or to the living Rabindranath Tagore more spiritual than any Buddha from Peshawar to Kamkura, an inept misuse of comparison against which I imagine the great poet himself would be the first to protest. There we have the total incomprehension, the blind window, the blocked door in the mind, and there too the reason why the natural western mentality comes to Indian art with a demand for something other than what its characteristic spirit and motive intend to give, and, demanding that, is not prepared to enter into another kind of spiritual experience and another range of creative sight, imaginative power and mode of self-expression.

This once understood, we can turn to the difference in the spirit and method of artistic creation which has given rise to the mutual incomprehension; for that will bring us to the positive side of the matter. All great artistic work proceeds from an act of intuition, not really an intellectual idea or a splendid imagination, – these are only mental translations, – but a direct intuition of some truth of life or being, some significant form of that truth, some development of it in the mind of man. And so far there is no difference between great European and great Indian work. Where then begins the immense divergence? It is there in everything else, in the

1. In a note Mr. Archer mentions and very rightly discounts an absurd apology for these Buddhas, viz., that the greatness and spirituality are not at all in the work, but in the devotion of the artist! If the artist cannot put into his work what was in him, – and here it is not devotion that is expressed, – his work is a futile abortion. But if he has expressed what he has felt, the capacity to feel it must also be there in the mind that looks at his work.

object and field of intuitive vision, in the method of working out the sight or suggestion, in the part taken in the rendering by the external form and technique, in the whole way of the rendering to the human mind, even in the centre of our being to which the work appeals. The European artist gets his intuition by a suggestion from an appearance in life and Nature or, if it starts from something in his own soul, relates it at once to an external support. He brings down that intuition into his normal mind and sets the intellectual idea and the imagination in the intelligence to clothe it with a mental stuff which will render its form to the moved reason, emotion, aesthesis. Then he missions his eye and hand to execute it in terms which start from a colourable "imitation" of life and Nature – and in ordinary hands too often end there – to get at an interpretation that really changes it into the image of something not outward in our own being or in universal being which was the real thing seen. And to that in looking at the work we have to get through colour and line and disposition or whatever else may be the part of the external means, to their mental suggestions and through them to the soul of the whole matter. The appeal is not direct to the eye of the deepest self and spirit within, but to the outward soul by a strong awakening of the sensuous, the vital, the emotional, the intellectual and imaginative being, and of the spiritual we get as much or as little as can suit itself to and express itself through the outward man. Life, action, passion, emotion, idea, Nature seen for their own sake and for an aesthetic delight in them, these are the object and field of this creative intuition. The something more which the Indian mind knows to be behind these things looks out, if at all, from behind many veils. The direct and unveiled presence of the Infinite and its godheads is not evoked or thought necessary to the greater greatness and the highest perfection.

The theory of ancient Indian art at its greatest – and the greatest gives its character to the rest and throws on it something of its stamp and influence – is of another kind. Its highest business is to disclose something of the Self, the Infinite, the Divine to the regard of the soul, the Self through its expressions, the Infinite through its living finite symbols, the Divine through his powers. Or the Godheads are to be revealed, luminously interpreted or in some way suggested to the soul's understanding or to its devotion or at the very least to a spiritually or religiously aesthetic emotion. When this hieratic art comes down from these altitudes to the intermediate worlds behind ours, to the lesser godheads and genii, it still carries into them some power or some hint from above. And when it comes quite down to the material world and the life of man and the things of external Nature, it does not altogether get rid of the greater vision, the hieratic stamp, the spiritual seeing, and in most good work – except in moments of relaxation and a humorous or vivid play with the obvious – there is always something more in which the seeing presentation of life floats as in an immaterial atmosphere. Life is seen in the self or in some suggestion of the infinite or of something beyond or there is at least a touch and influence or these which helps to shape the presentation. It is not that all Indian work realises this ideal; there is plenty no doubt that falls short, is lowered, ineffective or even debased, but it is the best and the most characteristic influence and execution which gives its tone to an art and by which we must judge. Indian art in fact is identical in its spiritual aim and principle with the rest of Indian culture.

A seeing in the self accordingly becomes the characteristic method of the Indian

artist and it is directly enjoined on him by the canon. He has to see first in his spiritual being the truth of the thing he must express and to create its form in his intuitive mind; he is not bound to look out first on outward life and Nature for his model, his authority, his rule, his teacher or his fountain of suggestions. Why should he when it is something quite inward he has to bring out into expression? It is not an idea in the intellect, a mental imagination, an outward emotion on which he has to depend for his stimulants, but an idea, image, emotion of the spirit, and the mental equivalents are subordinate things for help in the transmission and give only a part of the colouring and the shape. A material form, colour, line and design are his physical means of the expression, but in using them he is not bound to an imitation of Nature, but has to make the form and all else significant of his vision, and if that can only be done or can best be done by some modification, some pose, some touch or symbolic variation which is not found in physical Nature, he is at perfect liberty to use it, since truth to his vision, the unity of the thing he is seeing and expressing is his only business. The line, colour and the rest are not his first, but his last preoccupation, because they have to carry on them a world of things which have already taken spiritual form in his mind. He has not for instance to recreate for us the human face and body of the Buddha or some one passion or incident of his life, but to reveal the calm of Nirvana through a figure of the Buddha, and every detail and accessory must be turned into a means or an aid of his purpose. And even when it is some human passion or incident he has to portray, it is not usually that alone, but also or more something else in the soul to which it points or from which it starts or some power behind the action that has to enter into the spirit of his design and is often really the main thing. And through the eye that looks on his work he has to appeal not merely to an excitement of the outward soul, but to the inner self, *antaratman*. One may well say that beyond the ordinary cultivation of the aesthetic instinct necessary to all artistic appreciation there is a spiritual insight or culture needed if we are to enter into the whole meaning of Indian artistic creation, otherwise we get only at the surface external things or at the most at things only just below the surface. It is an intuitive and spiritual art and must be seen with the intuitive and spiritual eye.

This is the distinctive character of Indian art and to ignore it is to fall into total incomprehension or into much misunderstanding. Indian architecture, painting, sculpture are not only intimately one in inspiration with the central things in Indian philosophy, religion, Yoga, culture, but a specially intense expression of their significance. There is much in the literature which can be well enough appreciated without any very deep entry into these things, but it is comparatively a very small part of what is left of the other arts, Hindu or Buddhistic, of which this can be said. They have been largely a hieratic aesthetic script of India's spiritual, contemplative and religious experience.

Indian Art 2

Architecture

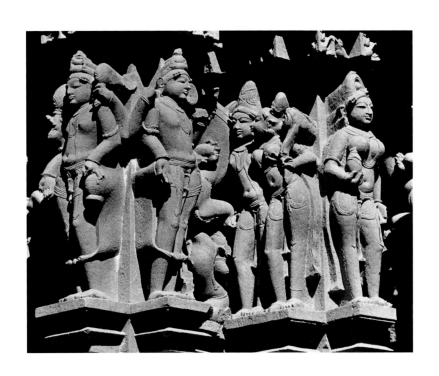

Architecture, sculpture and painting, because they are the three great arts which appeal to the spirit through the eye, are those too in which the sensible and the invisible meet with the strongest emphasis on themselves and yet the greatest necessity of each other. The form with its insistent masses, proportions, lines, colours, can here only justify them by their service for the something intangible it has to express; the spirit needs all the possible help of the material body to interpret itself to itself through the eye, yet asks of it that it shall be as transparent a veil as possible of its own greater significance. The art of the East and the art of the West, – each in its characteristic or mean, for there are always exceptions, – deal with the problem of these two interlocking powers in a quite a different way. The western mind is arrested and attracted by the form, lingers on it and cannot get away from its charm, loves it for its own beauty, rests on the emotional, intellectual, aesthetic suggestions that arise directly from its most visible language, confines the soul in the body; it might almost be said that for this mind form creates the spirit, the spirit depends for its existence and for everything it has to say on the form. The Indian attitude to the matter is at the opposite pole to this view. For the Indian mind, form does not exist except as a creation of the spirit and draws all its meaning and value from the spirit. Every line, arrangement of mass, colour, shape, posture, every physical suggestion, however many, crowded, opulent they may be, is first and last a suggestion, a hint, very often a symbol which is in its main function a support for a spiritual emotion, idea, image that again goes beyond itself to the less definable, but more powerfully sensible reality of the spirit which has excited these movements in the aesthetic mind and passed through them into significant shapes.

This characteristic attitude of the Indian reflective and creative mind necessitates in our view of its creations an effort to get beyond at once to the inner spirit of the reality it expresses and sees from it and not from outside. And in fact to start from the physical details and their synthesis appears to me quite the wrong way to look at an Indian work of art. The orthodox style of western criticism seems to be to dwell scrutinisingly on the technique, on form, on the obvious story of the form, and then pass to some appreciation of beautiful or impressive emotion and idea. It is only in some deeper and more sensitive minds that we get beyond that depth into profounder things. A criticism of that kind applied to Indian art leaves it barren or poor of significance. Here the only right way is to get at once through a total intuitive or revelatory impression or by some meditative dwelling on the whole, *dhyana* in the technical Indian term, to the spiritual meaning and atmosphere, make ourselves one with that as completely as possible, and then only the helpful meaning and value of all the rest comes out with a complete and revealing force. For here it is the spirit that carries the form, while in most western art it is the form that carries whatever there may be of spirit. The striking phrase of Epictetus recurs to the mind in which he describes man as a little soul carrying a corpse, *psucharion ei bastazon nekron*. The more ordinary western outlook is upon animate matter carrying in its life a modicum of soul. But the seeing of the Indian mind and of Indian art is that of a great, a limitless self and spirit, *mahan atma*, which carries to us in the sea of its presence a living shape of itself, small in comparison to its own infinity, but yet sufficient by the power that informs this symbol to support some aspect of that infinite's self-expression. It is therefore essential

that we should look here not solely with the physical eye informed by the reason and the aesthetic imagination, but make the physical seeing a passage to the opening of the inner spiritual eye and a moved communion in the soul. A great oriental work of art does not easily reveal its secret to one who comes to it solely in a mood of aesthetic curiosity or with a considering critical objective mind, still less as the cultivated and interested tourist passing among strange and foreign things; but it has to be seen in loneliness, in the solitude of one's self, in moments when one is capable of long and deep meditation and as little weighted as possible with the conventions of material life. That is why the Japanese with their fine sense in these things, – a sense which modern Europe with her assault of crowded art galleries and over-pictured walls seems to have quite lost, though perhaps I am wrong, and those are the right conditions for display of European art, – have put their temples and their Buddhas as often as possible away on mountains and in distant or secluded scenes of Nature and avoid living with great paintings in the crude hours of daily life, but keep them by preference in such a way that their undisputed suggestions can sink into the mind in its finer moments or apart where they can go and look at them in a treasured secrecy when the soul is at leisure from life. That is an indication of the utmost value pointing to the nature of the appeal made by eastern art and the right way and mood for looking at its creations.

Indian architecture especially demands this kind of inner study and this spiritual self-identification with its deepest meaning and will not otherwise reveal itself to us. The secular buildings of ancient India, her palaces and places of assembly and civic edifices have not outlived the ravages of time; what remains to us is mostly something of the great mountain and cave temples, something too of the temples of her ancient cities of the plains, and for the rest we have the fanes and shrines of her later times, whether situated in temple cities and places of pilgrimage like Srirangam and Rameshwaram or in her great once regal towns like Madura, when the temple was the centre of life. It is then the most hieratic side of a hieratic art that remains to us. These sacred buildings are the signs, the architectural self-expression of an ancient spiritual and religious culture. Ignore the spiritual suggestion, the religious significance, the meaning of the symbols and indications, look only with the rational and secular aesthetic mind, and it is vain to expect that we shall get to any true and discerning appreciation of this art. And it has to be remembered too that the religious spirit here is something quite different from the sense of European religions; and even mediaeval Christianity, especially as now looked at by the modern European mind which has gone through the two great crises of the Renascence and recent secularism, will not in spite of its oriental origin and affinities be of much real help. To bring in into the artistic look on an Indian temple occidental memories or a comparison with the Greek Parthenon or Italian church or Duomo or Campanile or even the great Gothic cathedrals of mediaeval France, though these have in them something much nearer to the Indian mentality, is to intrude a fatally foreign and disturbing element or standard in the mind. But this consciously or else subconsciously is what almost every European mind does to a greater or less degree, – and it is here a pernicious immixture, for it subjects the work of a vision that saw the immeasurable to the tests of an eye that dwells only on measure.

Indian sacred architecture of whatever date, style or dedication goes back to some-

thing timelessly ancient and now outside India almost wholly lost, something which belongs to the past, and yet it goes forward too, though this the rationalistic mind will not easily admit, to something which will return upon us and is already beginning to return, something which belongs to the future. An Indian temple, to whatever godhead it may be built, is in its inmost reality an altar raised to the divine Self, a house of the Cosmic Spirit, an appeal and aspiration to the Infinite. As that and in the light of that seeing and conception it must in the first place be understood, and everything else must be seen in that setting and that light, and then only can there be any real understanding. No artistic eye however alert and sensible and no aesthetic mind however full and sensitive can arrive at that understanding, if it is attached to a Hellenised conception of rational beauty or shuts itself up in a materialised or intellectual interpretation and fails to open itself to the great things here meant by a kindred close response to some touch of the cosmic consciousness, some revelation of the greater spiritual Self, some suggestion of the Infinite. These things, the spiritual Self, the Cosmic Spirit, the Infinite, are not rational, but suprarational, eternal presences, but to the intellect only words, and visible, sensible, near only to an intuition and revelation in our inmost selves. An art which starts from them as a first conception can only give us what it has to give, their touch, their nearness, their self-disclosure, through some responding intuition and revelation in us, in our own soul, our self. It is this which one must come to it to find and not demand from it the satisfaction of some quite other seeking or some very different turn of imagination and more limited superficial significance.

This is the first truth of Indian architecture and its significance which demands emphasis and it leads at once to the answer to certain very common misapprehensions and objections. All art reposes on some unity and all its details, whether few and sparing or lavish and crowded and full, must go back to that unity and help its significance; otherwise it is not art. Now we find our western critic telling us with an assurance which would be stupefying if one did not see how naturally it arose, that in Indian architecture there is no unity, which is as much as to say that there is here no great art at all, but only a skill in the execution of crowded and unrelated details. We are told by otherwise sympathetic judges that there is an overloading of ornament and detail which, however beautiful or splendid in itself, stands in the way of unity, an attempt to load every rift with ore, an absence of calm, no unfilled spaces, no relief to the eye. Mr. Archer as usual carries up the adverse criticism to the extreme clamorous top notes; his heavily shotted phrases are all a continuous insistence on this one theme. The great temples of the South of India are, he allows, marvels of massive construction. He seems by the way to have a rooted objection to massiveness in architecture or great massed effects in sculpture, regardless of their appropriateness or need, although he admits them in literature. Still this much there is and with it a sort of titanic impressiveness, but of unity, clarity, nobility there is no trace. This observation seems to my judgement sufficiently contradictory, since I do not understand how there can be a marvel of construction, whether light or massive, without any unity, – but here is not even, it seems, a trace of it, – or a mighty impressiveness without any greatness or nobility whatever, even allowing this to be a titanic and not an Olympian nobleness. He tells us that everything is ponderous, everything here overwrought and the most prominent features swarming, writhing with contorted semi-human figures are as

senseless as anything in architecture. How, one might ask, does he know that they are senseless, when he practically admits that he has made no attempt to find what is their sense, but has simply assumed from the self-satisfied sufficiency of his own admitted ignorance and failure to understand that there cannot be any meaning? And the whole thing he characterises as a monstrosity built by Rakshasas, ogres, demons, a gigantesque barbarism. The northern buildings find a little less disfavour in his eyes, but the difference in the end is small or none. There is the same ponderousness, absence of lightness and grace, an even greater profusion of incised ornament; these too are barbaric creations. Alone the Mahomedan architecture, called Indo-Saracenic, is exempted from this otherwise universal condemnation.

It is a little surprising after all, however natural the first blindness here, that even assailants of this extreme kind, since they must certainly know that there can be no art, no effective construction without unity, should not have paused even once to ask themselves whether after all there must not be here some principle of oneness which they had missed because they came with alien conceptions and looked at things from the wrong end, and before pronouncing this magisterial judgement should not have had patience to wait in a more detached and receptive way upon the thing under their eye and seen whether then some secret of unity did not emerge. But it is the more sympathetic and less violent critic who deserves a direct answer. Now it may readily be admitted that the failure to see at once the unity of this architecture is perfectly natural to a European eye, because unity in the sense demanded by the western conception, the Greek unity gained by much suppression and a sparing use of detail and circumstance or even the Gothic unity got by casting everything into the mould of a single spiritual aspiration, is not there. And the greater unity that really is there can never be arrived at at all, if the eye begins and ends by dwelling on form and detail and ornament, because it will then be obsessed by these things and find it difficult to go beyond to the unity which all this in its totality serves not so much to express in itself, but to fill it with that which comes out of it and relieve its oneness by multitude. An original oneness, not a combined or synthetic or an effected unity, is that from which this art begins and to which its work when finished returns or rather lives in it as in its self and natural atmosphere. Indian sacred architecture constantly represents the greatest oneness of the Self, the cosmic, the infinite in the immensity of its world-design, the multitude of its features of self-expression, *laksana*, (yet the oneness is greater than and independent of their totality and in itself indefinable), and all its starting-point of unity in conception, its mass of design and immensity of material, its crowding abundance of significant ornament and detail and its return towards oneness are only intelligible as necessary circumstances of this poem, this epic or this lyric – for there are smaller structures which are such lyrics – of the Infinite. The western mentality, except in those who are coming or returning, since Europe had once something of this cult in her own way, to this vision, may find it difficult to appreciate the truth and meaning of such an art, which tries to figure existence as a whole and not in its pieces; but I would invite those Indian minds who are troubled by these criticisms or partly or temporarily overpowered by the western way of seeing things, to look at our architecture in the light of this conception and see whether all but minor objections do not vanish as soon as the real meaning makes itself felt and gives body to the first indefinable impression and emotion which we experience before the greater constructions of the Indian builders..

To appreciate this spiritual-aesthetic truth of Indian architecture, it will be best to look first at some work where there is not the complication of surroundings now often out of harmony with the building, outside even those temple towns which still retain their dependence on the sacred motive, and rather in some place where there is room for a free background of Nature. I have before me two prints which can well serve the purpose, a temple at Kalahasti, a temple at Sinhachalam, two buildings entirely different in treatment and yet one in the ground and universal motive. The straight way here is not to detach the temple from its surroundings, but to see it in unity with the sky and low-lying landscape or with the sky and hills around and feel the thing common to both, the construction and its environment, the reality in Nature, the reality expressed in the work of art. The oneness to which this Nature aspires in her inconscient self-creation and in which she lives, the oneness to which the soul of man uplifts itself in his conscious spiritual upbuilding, his labour of aspiration here expressed in stone, and in which so upbuilt he and his work live, are the same and the soul-motive is one. Thus seen, this work of man seems to be something which has started out and detached itself against the power of the natural world, something of the one common aspiration in both to the same infinite spirit of itself, – the inconscient uplook and against it the strong single relief of the self-conscient effort and success of finding. One of these buildings climbs up bold, massive in projection, up-piled in the greatness of a forceful but sure ascent, preserving its range and line to the last, the other soars from the strength of its base, in the grace and emotion of a curving mass to a rounded summit and crowning symbol. There is in both a constant, subtle yet pronounced lessening from the base towards the top, but at each stage a repetition of the same form, the same multiplicity of insistence, the same crowded fullness and indented relief, but one maintains its multiple endeavour and indication to the last, the other ends in a single sign. To find the significance we have first to feel the oneness of the infinity in which this nature and this art live, then see this thronged expression as the sign of the infinite multiplicity which fills this oneness, see in the regular lessening ascent of the edifice the subtler and subtler return from the base on earth to the original unity and seize on the symbolic indication of its close at the top. Not absence of unity, but a tremendous unity is revealed. Reinterpret intimately what this representation means in the terms of our own spiritual self-existence and cosmic being, and we have what these great builders saw in themselves and reared in stone. All objections, once we have got at this identity in spiritual experience, fall away and show themselves to be what they really are, the utterance and cavil of an impotent misunderstanding, an insufficient apprehension or a complete failure to see. To appreciate the detail of Indian architecture is easy when the whole is thus seen and known; otherwise it is impossible.

This method of interpretation applies, however different the construction and the nature of the rendering, to all Dravidian architecture, not only to the mighty temples of far-spread fame, but to unknown roadside shrines in small towns, which are only a slighter execution of the same theme, a satisfied suggestion here, but the greater buildings a grandiose fulfilled aspiration. The architectural language of the north is of a different kind, there is another basic style; but here too the same spiritual, meditative, intuitive method has to be used and we get at the same result, an aesthetic interpretation or suggestion of the one spiritual experience, one in all its complexity and diversity, which founds the unity of the infinite variation of Indian

spirituality and religious feeling and the realised union of the human self with the Divine. This is the unity too of all the creations of this hieratic art. The different styles and motives arrive at or express that unity in different ways. The objection that an excess of thronging detail and ornament hides, impairs or breaks up the unity is advanced only because the eye has made the mistake of dwelling on the detail first without relation to this original spiritual oneness, which has first to be fixed in an intimate spiritual seeing and union and then all else seen in that vision and experience. When we look on the multiplicity of the world, it is only a crowd-ed plurality that we can find and to arrive at unity we have to reduce, to suppress what we have seen or sparingly select a few indications or to be satisfied with the unity of this or that separate idea, experience or imagination; but when we have realised the Self, the infinite unity and look back on the multiplicity of the world, then we find that oneness able to bear all the infinity of variation and circumstance we can crowd into it and its unity remains unabridged by even the most endless self-multiplication of its informing creation. We find the same thing in looking at this architecture. The wealth of ornament, detail, circumstance in Indian temples represents the infinite variety and repetition of the worlds, – not our world only, but all the planes, – suggests the infinite multiplicity in the infinite oneness. It is a mat-ter of our own experience and fullness of vision how much we leave out or bring in, whether we express so much or so little or attempt as in the Dravidian style to give the impression of a teeming inexhaustible plenitude. The largeness of this unity is base and continent enough for any super-structure or content of multitude.

To condemn this abundance as barbarous is to apply a foreign standard. Where after all are we bound to draw the line? To the pure classical taste, Shakespeare's art once appeared great but barbarous for a similar reason, – one remembers the Gallic description of him as a drunken barbarian of genius, – his artistic unity non-existent or spoilt by crowding tropical vegetation of incident and character, his teeming imagination violent, exaggerated, sometimes bizarre, monstrous, without symmetry, proportion and all the other lucid unities, lightnesses, graces loved by the classic mind. That mind may say of his work in a language like Mr. Archer's that here there is indeed a titanic genius, a mass of power, but of unity, clarity, classic nobility no trace, but rather an entire absence of lucid grace and lightness and restraint, a profusion of wild ornament and an imaginative riot without law or measure, strained figures, distorted positions and gestures, no dignity, no fine, just, rationally natural and beautiful classic movement and pose. But even the strictest Latin mind has now got over its objections to the "splendid barbarism" of Shakespeare and can understand that here is a fuller, less sparing and exiguous vision of life, a greater intuitive unity than the formal unities of the classic aesthe-sis. But the Indian vision of the world and existence was vaster and fuller than Shakespeare's because it embraced not merely life, but all being, not merely hum-anity, but all the worlds and all Nature and cosmos. The European mind not having arrived except in individuals at any close, direct, insistent realisation of the unity of the infinite Self or the cosmic consciousness peopled with its infinite multi-plicity, is not driven to express these things, cannot understand or put up with them when they are expressed in this oriental art, speech and style and object to it as the Latin mind once objected to Shakespeare. Perhaps the day is not distant when it will see and understand and perhaps even itself try to express the same thing in another language.

The objection that the crowding details allow no calm, gives no relief or space to the eye, falls under the same heading, springs from the same root, is urged from a different experience and has no validity for the Indian experience. For this unity on which all is upborne, carries in itself the infinite space and calm of the spiritual realisation, and there is no need for other unfilled spaces or tracts of calm of a lesser more superficial kind. The eye is here only a way of access to the soul, it is to that that there is the appeal, and if the soul living in this realisation or dwelling under the influence of this aesthetic impression needs any relief, it is not from the incidence of life and form, but from the immense incidence of that vastness of infinity and tranquil silence, and that can only be given by its opposite, by an abundance of form and detail and life. As for the objection in regard to Dravidian architecture to its massiveness and its titanic construction, the precise spiritual effect intended could not be given otherwise; for the infinite, the cosmic seen as a whole in its vast manifestation is titanic, is mighty in material and power. It is other and quite different things also, but none of these are absent from Indian construction. The great temples of the north have often in spite of Mr. Archer's dictum, a singular grace in their power, a luminous lightness relieving their mass and strength, a rich delicacy of beauty in their ornate fullness. It is not indeed the Greek lightness, clarity or naked nobleness, nor is it exclusive, but comes in a fine blending of opposites which is in the very spirit of the Indian religious, philosophical and aesthetic mind. Nor are these things absent from many Dravidian buildings, though in certain styles they are boldly sacrificed or only put into minor incidents, – one instance of the kind Mr. Archer rejoices in as an oasis in the desert of this to him unintelligible mass of might and greatness, – but in either case suppressed so that the fullness of solemn and grandiose effect may have a complete, an undiminished expression.

I need not deal with adverse strictures of a more insignificant kind, such as the dislike of the Indian form of the arch and dome, because they are not the radiating arch and dome of other styles. That is only an intolerant refusal to admit the beauty of unaccustomed forms. It is legitimate to prefer one's own things, those to which our mind and nature have been trained, but to condemn other art and effort because it also prefers its own way of arriving at beauty, greatness, self-expression, is a narrowness which with the growth of a more catholic culture ought to disappear. But there is one comment on Dravidian temple architecture which is worth noting because it is made by others than Mr. Archer and his kind. Even a sympathetic mind like Professor Geddes is impressed by some sense of a monstrous effect of terror and gloom in these mighty buildings. Such expressions are astonishing to an Indian mind because terror and gloom are conspicuously absent from the feelings aroused in it by its religion, art or literature. In the religion they are rarely awakened and only in order to be immediately healed and, even when they come, are always sustained by the sense of a supporting and helping presence, an eternal greatness and calm or love or Delight behind; the very goddess of destruction is at the same time the compassionate and loving Mother; the austere Maheshwara, Rudra, is also Shiva, the auspicious, Ashutosha, the refuge of men. The Indian thinking and religious mind looks with calm, without shrinking or repulsion, with an understanding born of its agelong effort at identity and oneness, at all that meets it in the stupendous spectacle of the cosmos. And even its asceticism, its turning from the world, which begins not in terror and gloom, but in a

sense of vanity and fatigue, or of something higher, truer, happier than life, soon passes beyond any element of pessimistic sadness into the rapture of the eternal peace and bliss. Indian secular poetry and drama is throughout rich, vital and joyous and there is more tragedy, terror, sorrow and gloom packed into a few pages of European work than we find in the whole mass of Indian literature. It does not seem to me that Indian art is at all different in this respect from the religion and literature. The western mind is here thrusting in its own habitual reactions upon things in the indigenous conception in which they have no proper place. Mark the curious misreading of the dance of Shiva as a dance of Death and Destruction, whereas, as anybody ought to be able to see who looks upon the Nataraja, it expresses on the contrary the rapture of the cosmic dance with the profundities behind of the unmoved eternal and infinite bliss. So too the figure of Kali which is so terrible to European eyes is, as we know, the Mother of the universe accepting this fierce aspect of destruction in order to slay the Asuras, the powers of evil in man and the world. There are other strands in this feeling in the western mind which seem to spring from a dislike of anything uplifted far beyond the human measure and others again in which we see a subtle survival of the Greek limitation, the fear, gloom and aversion with which the sunny terrestrial Hellenic mind commonly met the idea of the beyond, the limitless, the unknown; but that reaction has no place in Indian mentality. And as for the strangeness and formidable aspect of certain unhuman figures or the conception of demons or Rakshasas, it must be remembered that the Indian aesthetic mind deals not only with the earth but with psychic planes in which these things exist and ranges freely among them without being overpowered because it carries everywhere the stamp of a large confidence in the strength and the omnipresence of the Self or the Divine.

I have dwelt on Hindu and especially on Dravidian architecture because the latter is the most fiercely attacked as the most uncompromisingly foreign to European taste. But a word too may be said about Indo-Moslem architecture. I am not concerned to defend any claim for the purely indigenous origin of its features. It seems to me that here the Indian mind has taken in much from the Arab and Persian imagination and in certain mosques and tombs I seem to find an impress of the robust and bold Afghan and Moghul temperament; but it remains clear enough that it is still on the whole a typically Indian creation with the peculiar Indian gift. The richness of decorative skill and imagination has been turned to the uses of another style, but it is the same skill which we find in the northern Hindu temples, and in the ground we see, however toned down, something sometimes of the old epic mass and power, but more often that lyric grace which we see developing before the Mohammedan advent in the indigenous sculpture, – as in the schools of the North-East and of Java, – and sometimes a blending of the two motives. The modification, the toning down sets the average European mind at ease and secures its suffrage. But what is it that it so much admires? Mr. Archer tells us at first that it is its rational beauty, refinement and grace, normal, fair, refreshing after the monstrous riot of Hindu yogic hallucination and nightmare. That description which might have been written of Greek art, seems to me grotesquely inapplicable. Immediately afterwards he harps on quite another and an incompatible phrase, and calls it a fairyland of exquisite architecture. A rational fairyland is a wonder which may perhaps be hereafter discovered by some strange intertwining of the nineteenth and twentieth century minds, but I do not think it has yet existed on

earth or in the heavens. Not rational but magical beauty satisfying and enchanting to some deeper quite suprarational aesthetic soul in us is the inexpressible charm of these creations. But still where does the magic touch our critic? He tells us in a rapt journalistic style. It is the exquisite marble traceries, the marvellous loggias and arcades, the magnificent plinths and platforms, the majestic gateways, *et cetera*. And is this then all? Only the charm of an outward material luxury and magnificence? Yes; Mr. Archer again tells us that we must be content here with a visual sensuous beauty without any moral suggestion. And that helps him to bring in the sentence of destructive condemnation without which he could not feel happy in dealing with Indian things: this Moslem architecture suggests not only unbridled luxury, but effeminacy and decadence! But in that case, whatever its beauty, it belongs entirely to a secondary plane of artistic creation and cannot rank with the great spiritual aspirations in stone of the Hindu builders.

I do not demand "moral suggestions" from architecture, but is it true that there is nothing but a sensuous outward grace and beauty and luxury in these Indo-Moslem buildings? It is not at all true of the characteristic greater work. The Taj is not merely a sensuous reminiscence of an imperial amour or a fairy enchantment hewn from the moon's lucent quarries, but the eternal dream of a love that survives death. The great mosques embody often a religious aspiration lifted to a noble austerity which supports and is not lessened by the subordinated ornament and grace. The tombs reach beyond death to the beauty and joy of Paradise. The buildings of Fatehpur-Sikri are not monuments of an effeminate luxurious decadence, – an absurd description for the mind of the time of Akbar, – but give form to a nobility, power and beauty which lay hold upon but do not wallow on the earth. There is not here indeed the vast spiritual content of the earlier Indian mind, but it is still an Indian mind which in these delicate creations absorbs the West Asian influence, and lays stress on the sensuous as before in the poetry of Kalidasa, but uplifts it to a certain immaterial charm, rises often from the earth without quite leaving it into the magical beauty of the middle world and in the religious mood touches with a devout hand the skirts of the Divine. The all-pervading spiritual obsession is not there, but other elements of life not ignored by Indian culture and gaining on it since the classical times are here brought under a new influence and are still penetrated with some radiant glow of a superior lustre.

Indian Art 3

Sculpture

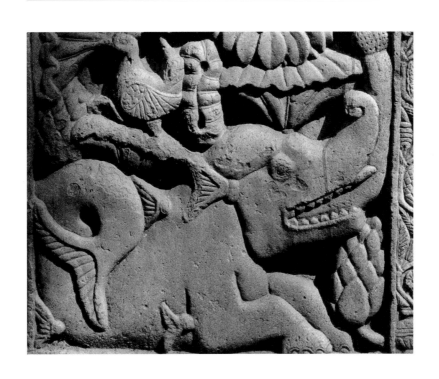

The sculpture and painting of ancient India have recently been rehabilitated with a surprising suddenness in the eyes of a more cultivated European criticism in the course of that rapid opening of the western mind to the value of oriental thought and creation which is one of the most significant signs of a change that is yet only in its beginning. There have even been here and there minds of a fine perception and profound originality who have seen in a return to the ancient and persistent freedom of oriental art, its refusal to be shackled or debased by an imitative realism, its fidelity to the true theory of art as an inspired interpretation of the deeper soul-values of existence lifted beyond servitude to the outsides of Nature, the right way to the regeneration and liberation of the aesthetic and creative mind of Europe. And actually, although much western art runs still along the old grooves, much too of its most original recent creation has elements or a guiding direction which brings it nearer to the eastern mentality and understanding. It might then be possible for us to leave it at that and wait for time to deepen this new vision and vindicate more fully the truth and greatness of the art of India.

But we are concerned not only with the critical estimation of our art by Europe, but much more nearly with the evil effect of the earlier depreciation on the Indian mind which has been for a long time side-tracked off its true road by a foreign, an anglicised education and, as a result, vulgarised and falsified by the loss of its own true centre, because this hampers and retards a sound and living revival of artistic taste and culture and stands in the way of a new age of creation. It was only a few years ago that the mind of educated India – "educated" without an atom of real culture – accepted contentedly the vulgar English estimate of our sculpture and painting as undeveloped inferior art or even a mass of monstrous and abortive miscreation, and though that has passed and there is a great change, there is still very common a heavy weight of second-hand occidental notions, a bluntness or absolute lacking of aesthetic taste[1], a failure to appreciate, and one still comes sometimes across a strain of blatantly anglicised criticism which depreciates all that is in the Indian manner and praises only what is consistent with western canons. And the old style of European criticism continues to have some weight with us, because the lack of aesthetic or indeed of any real cultural training in our present system of education makes us ignorant and undiscriminating receptacles, so that we are ready to take the considered opinions of competent critics like Okakura or Mr. Laurence Binyon and the rash scribblings of journalists of the type of Mr. Archer, who write without authority because in these things they have neither taste nor knowledge, as of equal importance and the latter even attract a greater attention. It is still necessary therefore to reiterate things which, however obvious to a trained or sensitive aesthetic intelligence, are not yet familiar to the average mind still untutored or habituated to a system of false weights and values. The work of recovering a true and inward understanding of ourselves – our past and our present self and from that our future – is only in its commencement for the majority of our people.

1. For example, one still reads with a sense of despairing stupefaction "criticism" that speaks of Ravi Varma and Abanindranath Tagore as artistic creators of different styles, but an equal power and genius!

To appreciate our own artistic past at its right value we have to free ourselves from all subjection to a foreign outlook and see our sculpture and painting, as I have already suggested about our architecture, in the light of its own profound intention and greatness of spirit. When we so look at it, we shall be able to see that the sculpture of ancient and mediaeval India claims its place on the very highest levels of artistic achievement. I do not know where we shall find a sculptural art of a more profound intention, a greater spirit, a more consistent skill of achievement. Inferior work there is, work that fails or succeeds only partially, but take it in its whole, in the long persistence of its excellence, in the number of masterpieces, in the power with which it renders the soul and the mind of a people, and we shall be tempted to go further and claim for it a first place. The art of sculpture has indeed flourished supremely only in ancient countries where it was conceived against its natural background and support, a great architecture. Egypt, Greece, India take the premier rank in this kind of creation. Mediaeval and modern Europe produced nothing of the same mastery, abundance and amplitude, while on the contrary in painting later Europe has done much and richly and with a prolonged and constantly renewed inspiration. The difference arises from the different kind of mentality required by the two arts. The material in which we work makes its own peculiar demand on the creative spirit, lays down its own natural conditions, as Ruskin has pointed out in a different connection, and the art of making in stone or bronze calls for a cast of mind which the ancients had and the moderns have not or have had only in rare individuals, an artistic mind not too rapidly mobile and self-indulgent, not too much mastered by its own personality and emotion and the touches that excite and pass, but founded rather on some great basis of assured thought and vision, stable in temperament, fixed in its imagination on things that are firm and enduring. One cannot trifle with ease in this sterner material, one cannot even for long or with safety indulge in them in mere grace and external beauty or the more superficial, mobile and lightly attractive motives. The aesthetic self-indulgence which the soul of colour permits and even invites, the attraction of the mobile play of life to which line of brush, pen or pencil gives latitude, are here forbidden or, if to some extent achieved, only within a line of restraint to cross which is perilous and soon fatal. Here grand or profound motives are called for, a more or less penetrating spiritual vision or some sense of things eternal to base the creation. The sculptural art is static, self-contained, necessarily firm, noble or severe and demands an aesthetic spirit capable of these qualities. A certain mobility of life and mastering grace of line can come in upon this basis, but if it entirely replaces the original Dharma of the material, that means that the spirit of the statuette has come into the statue and we may be sure of an approaching decadence. Hellenic sculpture following this line passed from the greatness of Phidias through the soft self-indulgence of Praxiteles to its decline. A later Europe has failed for the most part in sculpture, in spite of some great work by individuals, an Angelo or a Rodin, because it played externally with stone and bronze, took them as a medium for the representation of life and could not find sufficient basis of profound vision or spiritual motive. In Egypt and in India, on the contrary, sculpture preserved its power of successful creation through several great ages. The earliest recently discovered work in India dates back to the fifth century B.C. and is already fully evolved with an evident history of consummate previous creation behind it, and the latest work of some high value comes down to within a few centuries from our own time. An

assured history of two millenniums of accomplished sculptural creation is a rare and significant fact in the life of a people.

This greatness and continuity of Indian sculpture is due to the close connection between the religious and philosophical and the aesthetic mind of the people. Its survival into times not far from us was possible because of the survival of the cast of the antique mind in that philosophy and religion, a mind familiar with eternal things, capable of cosmic vision, having its roots of thought and seeing in the profundities of the soul, in the most intimate, pregnant and abiding experiences of the human spirit. The spirit of this greatness is indeed at the opposite pole to the perfection within limits, the lucid nobility or the vital fineness and physical grace of Hellenic creation in stone. And since the favourite trick of Mr. Archer and his kind is to throw the Hellenic ideal constantly in our face, as if sculpture must be either governed by the Greek standard or worthless, it is as well to take note of the meaning of the difference. The earlier and more archaic Greek style had indeed something in it which looks like a reminiscent touch of a first creative origin from Egypt and the Orient, but there is already there the governing conception which determined the Greek aesthesis and has dominated the later mind of Europe, the will to combine some kind of expression of an inner truth with an idealising imitation of external Nature. The brilliance, beauty and nobility of the work which was accomplished, was a very great and perfect thing, but it is idle to maintain that that is the sole possible method or the one permanent and natural law of artistic creation. Its highest greatness subsisted only so long – and it was not for very long – as a certain satisfying balance was struck and constantly maintained between a fine, but not very subtle, opulent or profound spiritual suggestion and an outward physical harmony of nobility and grace. A later work achieved a brief miracle of vital suggestion and sensuous physical grace with a certain power of expressing the spirit of beauty in the mould of the senses; but this once done, there was no more to see or create. For the curious turn which impels at the present day the modern mind to return to spiritual vision through a fiction of exaggerated realism which is really a pressure upon the form of things to yield the secret of the spirit in life and matter, was not open to the classic temperament and intelligence. And it is surely time for us to see, as is now by many admitted, that an acknowledgement of the greatness of Greek art in its own province ought not to prevent the plain perception of the rather strait and narrow bounds of that province. What Greek sculpture expressed was fine, gracious and noble, but what it did not express and could not by the limitations of its canon hope to attempt, was considerable, was immense in possibility, was that spiritual depth and extension which the human mind needs for its larger and deeper self-experience. And just this is the greatness of Indian sculpture that it expresses in stone and bronze what the Greek aesthetic mind could not conceive or express and embodies it with a profound understanding of its right conditions and a native perfection.

The more ancient sculptural art of India embodies in visible form what the Upanishads threw out into inspired thought and the Mahabharata and Ramayana portrayed by the word in life. This sculpture like the architecture springs from spiritual realisation, and what it creates and expresses at its greatest is the spirit in form, the soul in body, this or that living soul-power in the divine or the human, the universal and cosmic individualised in suggestion but not lost in individuality,

the impersonal supporting a not too insistent play of personality, the abiding moments of the eternal, the presence, the idea, the power, the calm or potent delight of the spirit in its actions and creations. And over all the art something of this intention broods and persists and is suggested even where it does not dominate the mind of the sculptor. And therefore as in the architecture so in the sculpture, we have to bring a different mind to this work, a different capacity of vision and response, we have to go deeper into ourselves to see than in the more outwardly imaginative art of Europe. The Olympian gods of Phidias are magnified and uplifted human beings saved from a too human limitation by a certain divine calm of impersonality or universalised quality, divine type, *guna*; in other work we see heroes, athletes, feminine incarnations of beauty, calm and restrained embodiments of idea, action or emotion in the idealised beauty of the human figure. The gods of Indian sculpture are cosmic beings, embodiments of some great spiritual power, spiritual idea and action, inmost psychic significance, the human form a vehicle of this soul meaning, its outward means of self-expression; everything in the figure, every opportunity it gives, the face, the hands, the posture of the limbs, the poise and turn of the body, every accessory, has to be made instinct with the inner meaning, help it to emerge, carry out the rhythm of the total suggestion, and on the other hand everything is suppressed which would defeat this end, especially all that would mean an insistence on the merely vital or physical, outward or obvious suggestions of the human figure. Not the ideal physical or emotional beauty, but the utmost spiritual beauty or significance of which the human form is capable, is the aim of this kind of creation. The divine self in us is its theme, the body made a form of the soul is its idea and its secret. And therefore in front of this art it is not enough to look at it and respond with the aesthetic eye and the imagination, but we must look also into the form for what it carries and even through and behind it to pursue the profound suggestion it gives into its own infinite. The religious or hieratic side of Indian sculpture is intimately connected with the spiritual experiences of Indian meditation and adoration, – those deep things of our self-discovery which our critic calls contemptuously Yogic hallucinations, – soul realisation is its method of creation and soul realisation must be the way of our response and understanding. And even with the figures of human beings or groups it is still a like inner aim and vision which governs the labour of the sculptor. The statue of a king or a saint is not meant merely to give the idea of a king or saint or to portray some dramatic action or to be a character portrait in stone, but to embody rather a soul-state or experience or deeper soul-quality, as for instance, not the outward emotion, but the inner soul-side of rapt ecstasy of adoration and God-vision in the saint or the devotee before the presence of the worshipped deity. This is the character of the task the Indian sculptor set before his effort and it is according to his success in that and not by the absence of something else, some quality or some intention foreign to his mind and contrary to his design, that we have to judge of his achievement and his labour.

Once we admit this standard, it is impossible to speak too highly of the profound intelligence of its conditions which was developed in Indian sculpture, of the skill with which its task was treated or of the consummate grandeur and beauty of its masterpieces. Take the great Buddhas – not the Gandharan, but the divine figures or groups in cave-cathedral or temple, the best of the later Southern bronzes of which there is a remarkable collection of plates in Mr. Gangoly's book on that sub-

ject, the Kalasanhara image, the Natarajas. No greater or finer work, whether in conception or execution, has been done by the human hand and its greatness is increased by obeying a spiritualised aesthetic vision. The figure of the Buddha achieves the expression of the infinite in a finite image, and that is surely no mean or barbaric achievement, to embody the illimitable calm of Nirvana in a human form and visage. The Kalasanhara Shiva is supreme not only by the majesty, power, calmly forceful control, dignity and kingship of existence which the whole spirit and pose of the figure visibly incarnates, – that is only half or less than half its achievement, – but much more by the concentrated divine passion of the spiritual overcoming of time and existence which the artist has succeeded in putting into eye and brow and mouth and every feature and has subtly supported by the contained suggestion, not emotional, but spiritual, of every part of the body of the godhead and the rhythm of his meaning which he has poured through the whole unity of his creation. Or what of the marvellous genius and skill in the treatment of the cosmic movement and delight of the dance of Shiva, the success with which the posture of every limb is made to bring out the rhythm of the significance, the rapturous intensity and abandon of the movement itself and yet the just restraint in the intensity of motion, the subtle variation of each element of the single theme in the seizing idea of these master sculptors? Image after image in the great temples or saved from the wreck of time shows the same grand traditional art and the genius which worked in that tradition and its many styles, the profound and firmly grasped spiritual idea, the consistent expression of it in every curve, line and mass, in hand and limb, in suggestive pose, in expressive rhythm, – it is an art which, understood in its own spirit, need fear no comparison with any other, ancient or modern, Hellenic or Egyptian, of the near or the far East or of the West in any of its creative ages. This sculpture passed through many changes, a more ancient art of extraordinary grandeur and epic power uplifted by the same spirit as reigned in the Vedic and Vedantic seers and in the epic poets, a later Puranic turn towards grace and beauty and rapture and an outburst of lyric ecstasy and movement, and last a rapid and vacant decadence; but throughout all the second period too the depth and greatness of sculptural motive supports and vivifies the work and in the very turn towards decadence something of it often remains to redeem from complete debasement, emptiness or insignificance.

Let us see then what is the value of the objections made to the spirit and style of Indian sculpture. This is the burden of the objurgations of the devil's advocate that his self-bound European mind finds the whole thing barbaric, meaningless, uncouth, strange, bizarre, the work of a distorted imagination labouring mid a nightmare of unlovely unrealities. Now there is, in the total of what survives to us, work that is less inspired or even work that is bad, exaggerated, forced or clumsy, the production of mechanic artificers mingled with the creation of great nameless artists, and an eye that does not understand the sense, the first conditions of the work, the mind of the race or its type of aesthesis, may well fail to distinguish between good and inferior execution, decadent work and the work of the great hands and the great eras. But applied as a general description the criticism is itself grotesque and distorted and it means only that here are conceptions and a figuring imagination strange to the western intelligence. The line and run and turn demanded by the Indian aesthetic sense are not the same as those demanded by the European. It would take too long to examine the detail of the difference which

we find not only in sculpture, but in the other plastic arts and in music and even to a certain extent in literature, but on the whole we may say that the Indian mind moves on the spur of a spiritual sensitiveness and psychic curiosity, while the aesthetic curiosity of the European temperament is intellectual, vital, emotional and imaginative in that sense, and almost the whole strangeness of the Indian use of line and mass, ornament and proportion and rhythm arises from this difference. The two minds live almost in different worlds, are either not looking at the same things or, even where they meet in the object, see it from a different level or surrounded by a different atmosphere, and we know what power the point of view or the medium of vision has to transform the object. And undoubtedly there is very ample ground for Mr. Archer's complaint of the want of naturalism in most Indian sculpture. The inspiration, the way of seeing is frankly not naturalistic, not, that is to say, the vivid, convincing and accurate, the graceful, beautiful or strong, or even the idealised or imaginative imitation of surface or terrestrial nature. The Indian sculptor is concerned with embodying spiritual experiences and impressions, not with recording or glorifying what is received by the physical senses. He may start with suggestions from earthly and physical things, but he produces his work only after he has closed his eyes to the insistence of the physical circumstances, seen them in the psychic memory and transformed them within himself so as to bring out something other than their physical reality or their vital and intellectual significance. His eye sees the psychic line and turn of things and he replaces by them the material contours. It is not surprising that such a method should produce results which are strange to the average western mind and eye when these are not liberated by a broad and sympathetic culture. And what is strange to us is naturally repugnant to our habitual mind and uncouth to our habitual sense, bizarre to our imaginative tradition and aesthetic training. We want what is familiar to the eye and obvious to the imagination and will not readily admit that there may be here another and perhaps greater beauty than that in the circle of which we are accustomed to live and take pleasure.

It seems to be especially the application of this psychic vision to the human form which offends these critics of Indian sculpture. There is the familiar objection to such features as the multiplication of the arms in the figures of gods and goddesses, the four, six, eight or ten arms of Shiva, the eighteen arms of Durga, because they are a monstrosity, a thing not in nature. Now certainly a play of imagination of this kind would be out of place in the representation of man or woman, because it would have no artistic or other meaning, but I cannot see, why this freedom should be denied in the representation of cosmic beings like the Indian godheads. The whole question is, first, whether it is an appropriate means of conveying a significance not otherwise to be represented with an equal power and force and, secondly, whether it is capable of artistic representation, a rhythm of artistic truth and unity which need not be that of physical nature. If not, then it is an ugliness and violence, but if these conditions are satisfied, the means are justified and I do not see that we have any right, faced with the perfection of the work, to raise a discordant clamour. Mr. Archer himself is struck with the perfection of skill and mastery with which these to him superfluous limbs are disposed in the figures of the dancing Shiva, and indeed it would need an eye of impossible blindness not to see that much, but what is still more important is the artistic significance which this skill is used to serve, and, if that is understood, we can at once see that the

spiritual emotion and suggestions of the cosmic dance are brought out by this device in a way which would not be as possible with a two-armed figure. The same truth holds as to the Durga with her eighteen arms slaying the Asuras or the Shivas of the great Pallava creations where the lyrical beauty of the Natarajas is absent, but there is instead a great epical rhythm and grandeur. Art justifies its own means and here it does it with a supreme perfection. And as for the "contorted" postures of some figures, the same law holds. There is often a departure in this respect from the anatomical norm of the physical body or else – and that is a rather different thing – an emphasis more or less pronounced on an unusual pose of limbs or body, and the question then is whether it is done without sense or purpose, a mere clumsiness or an ugly exaggeration, or whether it rather serves some significance and establishes in the place of the normal physical metric of Nature another purposeful and successful artistic rhythm. Art after all is not forbidden to deal with the unusual or to alter and overpass Nature, and it might almost be said that it has been doing little else since it began to serve the human imagination from its first grand epic exaggerations to the violences of modern romanticism and realism, from the high ages of Valmiki and Homer to the day of Hugo and Ibsen. The means matter, but less than the significance and the thing done and the power and beauty with which it expresses the dreams and truths of the human spirit.

The whole question of the Indian artistic treatment of the human figure has to be understood in the light of its aesthetic purpose. It works with a certain intention and ideal, a general norm and standard which permits of a good many variations and from which too there are appropriate departures. The epithets with which Mr. Archer tries to damn its features are absurd, captious, exaggerated, the forced phrases of a journalist trying to depreciate a perfectly sensible, beautiful and aesthetic norm with which he does not sympathise. There are other things here than repetition of hawk faces, wasp waists, thin legs and the rest of the ill-tempered caricature. He doubts Mr. Havell's suggestion that these old Indian artists knew the anatomy of the body well enough, as Indian science knew it, but chose to depart from it for their own purpose. It does not seem to me to matter much, since art is not anatomy, nor an artistic masterpiece necessarily a reproduction of physical fact or a lesson in natural science. I see no reason to regret the absence of telling studies in muscles, torsos, etc., for I cannot regard these things as having in themselves any essential artistic value. The one important point is that the Indian artist had a perfect idea of proportion and rhythm and used them in certain styles with nobility and power, in others like the Javan, the Gauda or the Southern bronzes with that or with a perfect grace added and often an intense and a lyrical sweetness. The dignity and beauty of the human figure in the best Indian statues cannot be excelled, but what was sought and what was achieved was not an outward naturalistic, but a spiritual and a psychic beauty, and to achieve it the sculptor suppressed, and was entirely right in suppressing, the obtrusive material detail and aimed instead at purity of outline and fineness of feature. And into that outline, into that purity and fineness he was able to work whatever he chose, mass of force or delicacy of grace, a static dignity or a mighty strength or a restrained violence of movement or whatever served or helped his meaning. A divine and subtle body was his ideal; and to a taste and imagination too blunt or realistic to conceive the truth and beauty of his idea, the ideal itself may be a stumbling-block, a thing of offence. But the triumphs of art are not to be limited by the

narrow prejudices of the natural realistic man; that triumphs and endures which appeals to the best, *sadhu-sammatam*, that is deepest and greatest which satisfies the profoundest souls and the most sensitive psychic imaginations.

Each manner of art has its own ideals, traditions, agreed conventions; for the ideas and forms of the creative spirit are many, though there is one ultimate basis. The perspective, the psychic vision of the Chinese and Japanese painters are not the same as those of European artists; but who can ignore the beauty and the wonder of their work? I dare say Mr. Archer would set a Constable or a Turner above the whole mass of Far Eastern work, as I myself, if I had to make a choice, would take a Chinese or Japanese landscape or other magic transmutation of Nature in preference to all others; but these are matters of individual, national or continental temperament and preference. The essence of the question lies in the rendering of the truth and beauty seized by the spirit. Indian sculpture, Indian art in general follows its own ideal and traditions and these are unique in their character and quality. It is the expression, great as a whole through many centuries and ages of creations, supreme at its best, whether in rare early pre-Asokan, in Asokan or later work of the first heroic age or in the magnificent statues of the cave-cathedrals and Pallava and other southern temples or the noble, accomplished or gracious imaginations of Bengal, Nepal and Java through the after centuries or in the singular skill and delicacy of the bronze work of the southern religions, a self-expression of the spirit and ideals of a great nation and a great culture which stands apart in the cast of its mind and qualities among the earth's peoples, famed for its spiritual achievement, its deep philosophies and its religious spirit, its artistic taste, the richness of its poetic imagination, and not inferior once in its dealings with life and its social endeavour and political institutions. This sculpture is a singularly powerful, a seizing and profound interpretation in stone and bronze of the inner soul of that people. The nation, the culture failed for a time in life after a long greatness as others failed before it and others will yet fail that now flourish; the creations of its mind have been arrested, this art like others has ceased or fallen into decay, but the thing from which it rose, the spiritual fire within still burns and in the renascence that is coming it may be that this great art too will revive, not saddled with the grave limitations of modern western work in the kind, but vivified by the nobility of a new impulse and power of the ancient spiritual motive. Let it recover, not limited by old forms, but undeterred by the cavillings of an alien mind, the sense of the grandeur and beauty and the inner significance of its past achievement; for in the continuity of its spiritual endeavour lies its best hope for the future.

Excerpts from
Indian Art 1

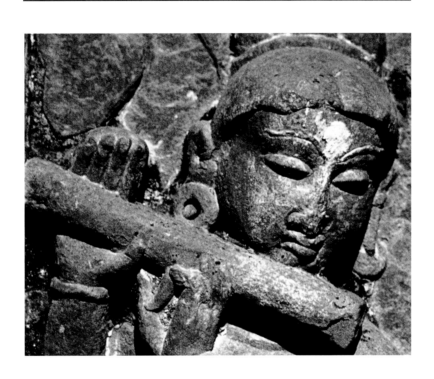

One may well say that beyond the ordinary cultivation of the aesthetic instinct necessary to all artistic appreciation, there is a spiritual insight or culture needed if we are to enter into the whole meaning of Indian artistic creation, otherwise we get only at the surface external things or at the most at things only just below the surface. It is an intuitive and spiritual art and must be seen with the intuitive and spiritual eye.

This is the distinctive character of Indian art and to ignore it is to fall into total incomprehension or into much misunderstanding. Indian architecture, painting, sculpture are not only intimately one in inspiration with the central things in Indian philosophy, religion, Yoga, culture, but a specially intense expression of their significance. There is much in the literature which can be well enough appreciated without any very deep entry into these things, but it is comparatively a very small part of what is left of the other arts, Hindu or Buddhistic, of which this can be said. They have been very largely a hieratic aesthetic script of India's spiritual, contemplative and religious experience...

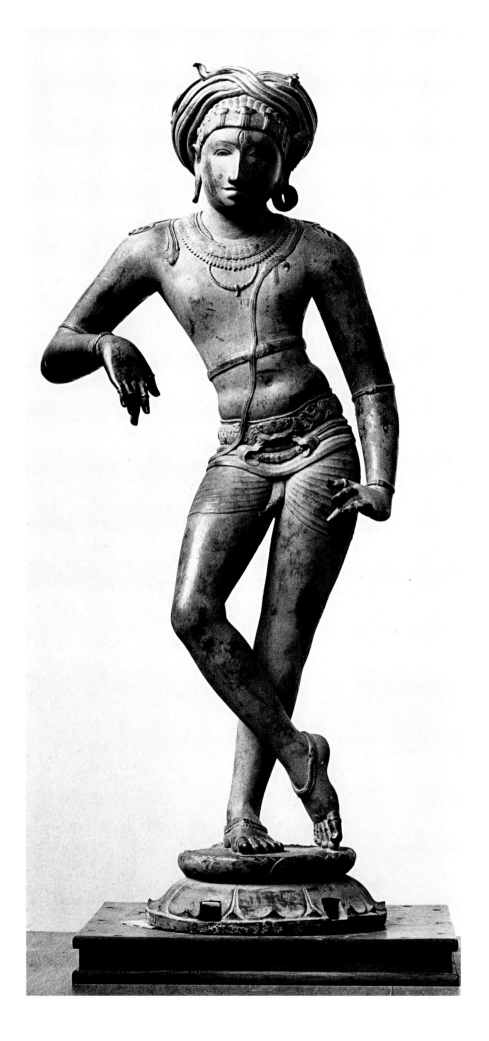

*T*he Indian ideal figure of the masculine body insists on two features among many, a characteristic width at the shoulders and slenderness in the middle.

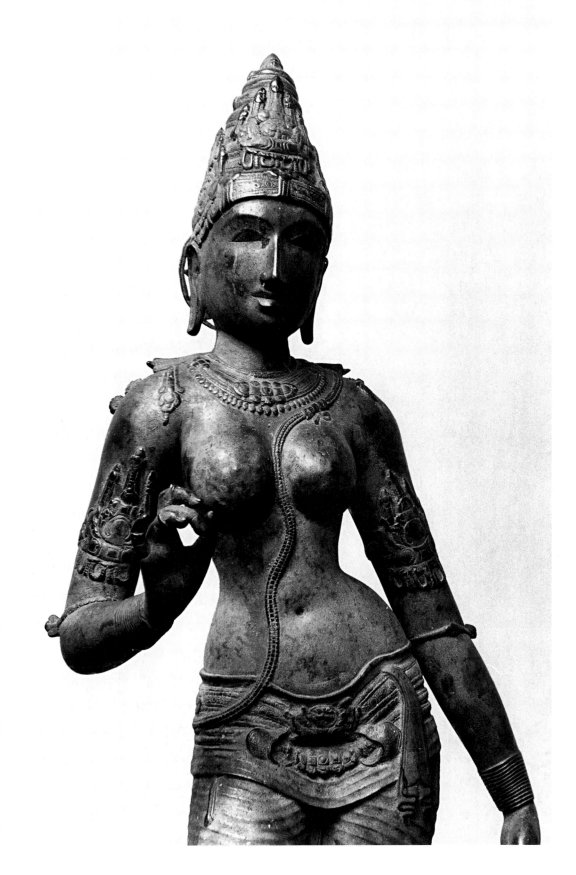

Opposite page:
Shiva Vrishvahana,
bronze,
Thiruvenkadu, now in the
Tanjore museum.
Chola-dynasty,
tenth-eleventh century

Uma, bronze,
Thiruvenkadu, now in the
Tanjore museum.
Chola-dynasty,
tenth-eleventh century.
For the female body in
Indian art the ideal is a
slender waist balanced by
full breasts and hips.

The Greek figure stresses no doubt the body, but appeals through it to an imaginative seeing inspiration which aims at expressing a certain divine power of beauty and gives us therefore something which is much more than a merely sensuous aesthetic pleasure.... The Indian sculptor stresses something behind, something more remote to the surface imagination, but nearer to the soul, and subordinates to it the physical form... when he wholly succeeds, then his work too is a masterpiece, and we may prefer it with a good conscience, if the spiritual, the higher intuitive vision is what we most demand from art. This however need not interfere with an appreciation of both kinds in their own order.

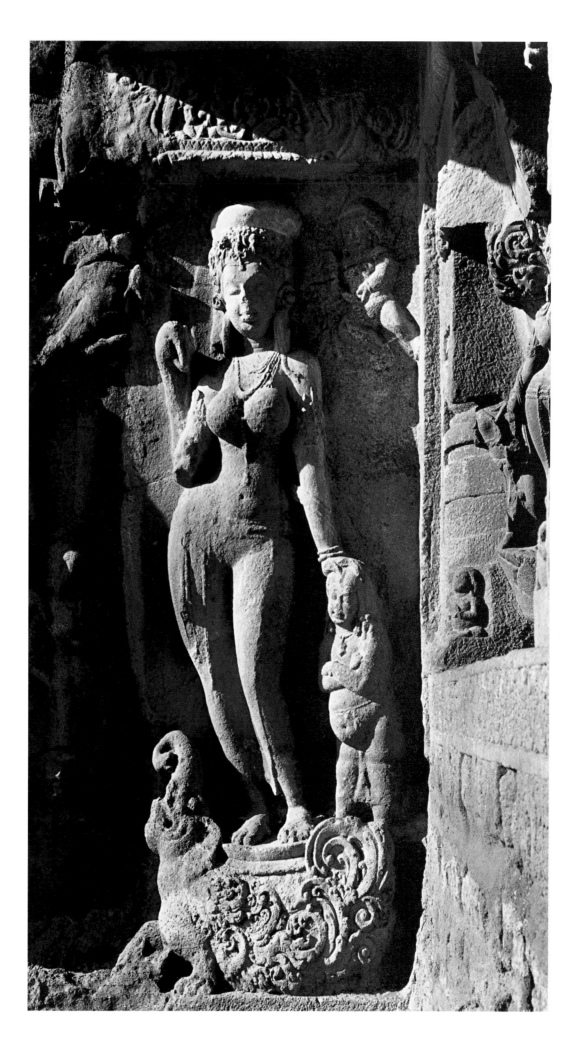

Ganga on her vehicle, the
makara, supporting
herself on a little *gana*.
Rameshvara cave-temple,
Ellora, Vakataka-dynasty,
6th-7th century.

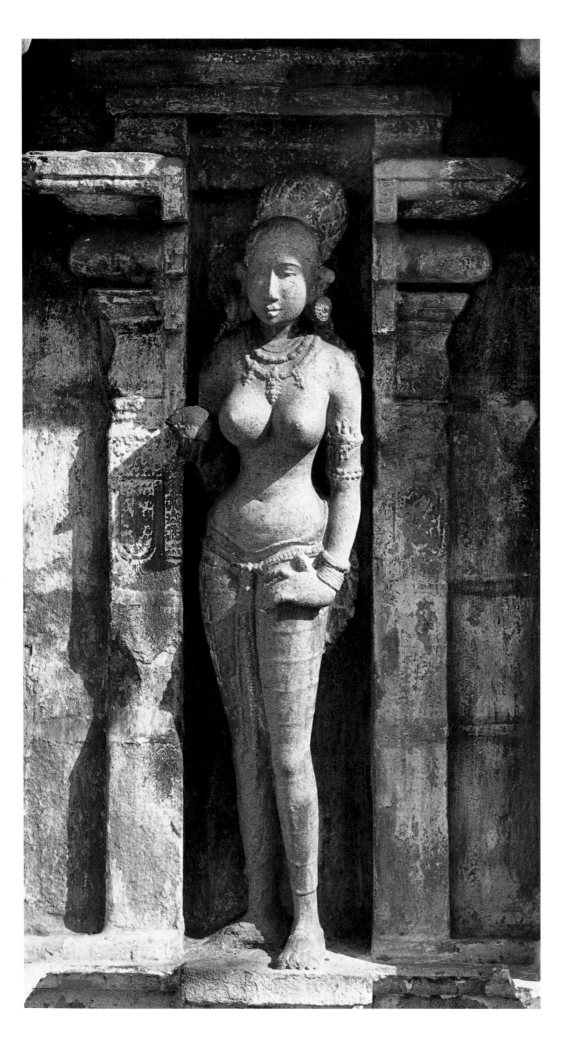

Pages 52-53:
Apsara at the
Nageshvaraswami temple
at Kumbakonam.
This is an exceptionally
well preserved and
beautiful sculpture.

Following pages:
Four-armed Durga on the
head of the buffalo
demon.
Jalanatheshvara temple,
Takkolam, late Pallava,
9th century.

"...The Indian sculptor
stresses something
behind, something more
remote to the surface
imagination..."

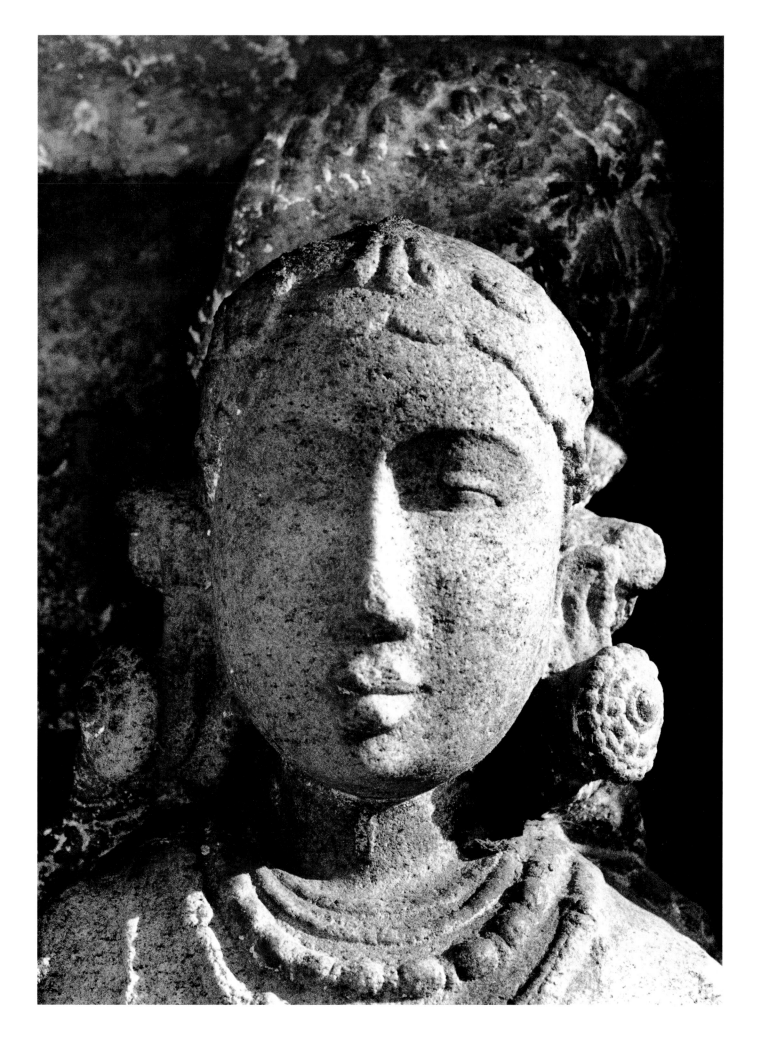

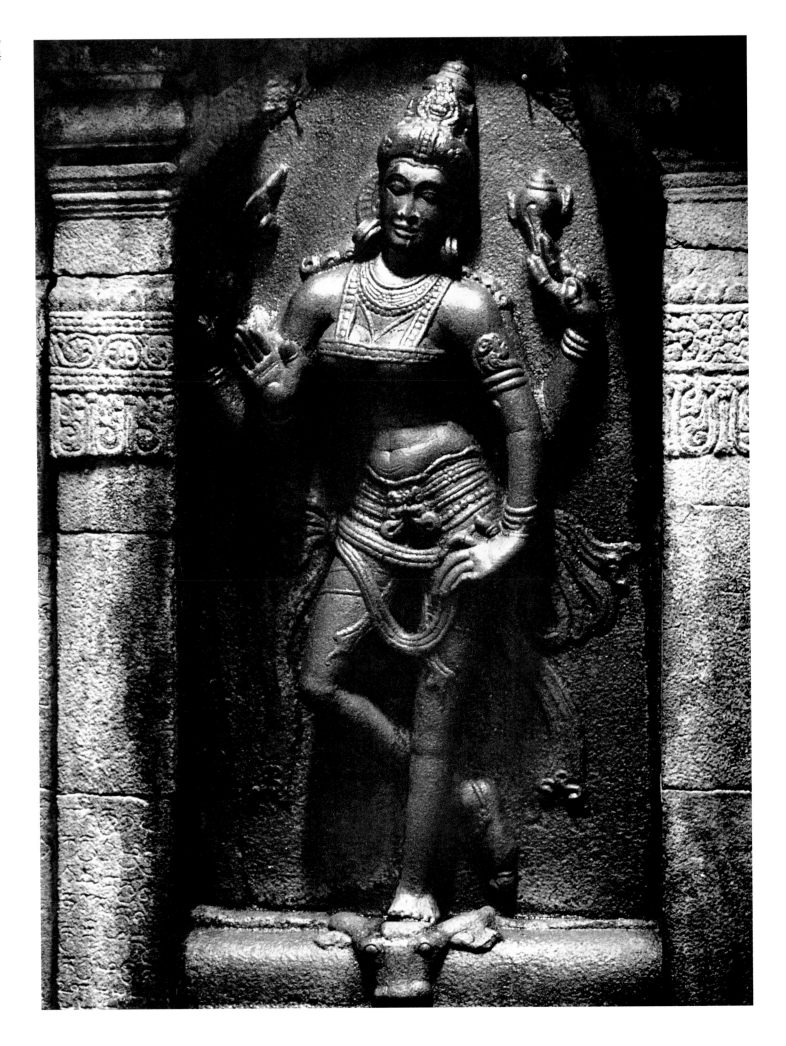

The theory of ancient Indian art at its greatest – and the greatest gives its character to the rest and throws on it something of its stamp and influence – is of another kind. Its highest business is to disclose something of the Self, the Infinite, the Divine to the regard of the soul,... Or the Godheads are to be revealed, luminously interpreted or in some way suggested to the soul's understanding or to its devotion or at the very least to a spiritually or religiously aesthetic emotion. When this hieratic art comes down from these altitudes to the intermediate worlds behind ours, to lesser godheads and genii, it still carries into them some power or some hint from above. And when it comes quite down to the material world and the life of man and the things of external Nature, it does not altogether get rid of the greater vision, the hieratic stamp, the spiritual seeing, and in most good work...there is always something more in which the seeing presentation of life floats as in an immaterial atmosphere....Indian art in fact is identical in its spiritual aim and principle with the rest of Indian culture.

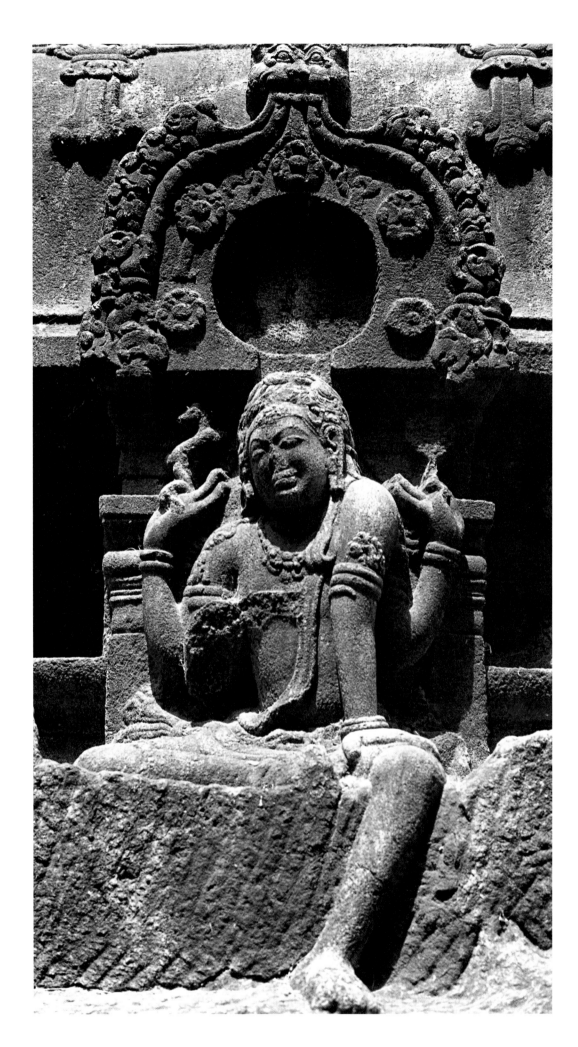

Shiva Dakshinamurti, the
supreme Teacher who
teaches in Silence.
Rock-temple of
Kalugumalai.
Pandya-dynasty,
8th century.

Following pages:
Left
Vishnu, covered by
century-old layers of oil.
Detail. Jalanatheshvara
temple, Takkolam
Pallava, 9th century.

Right
Vishnu. Detail.
Arjuna Ratha,
Mamallapuram, Pallava
7th-8th century.

"...Or the Godheads are
to be revealed,
luminously interpreted..."

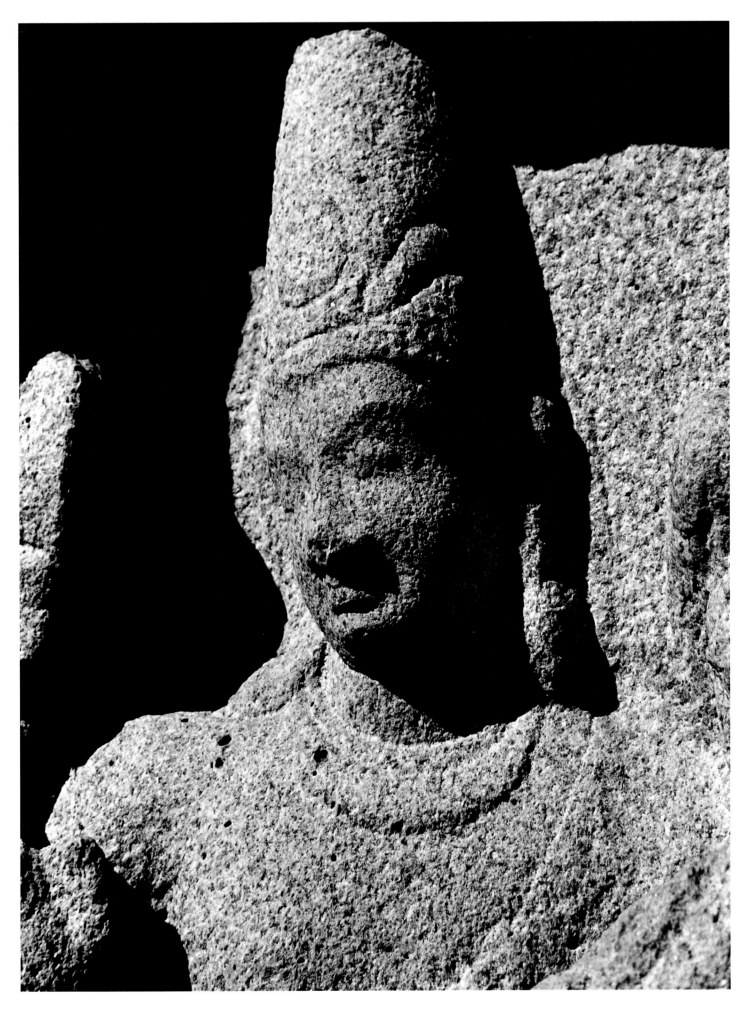

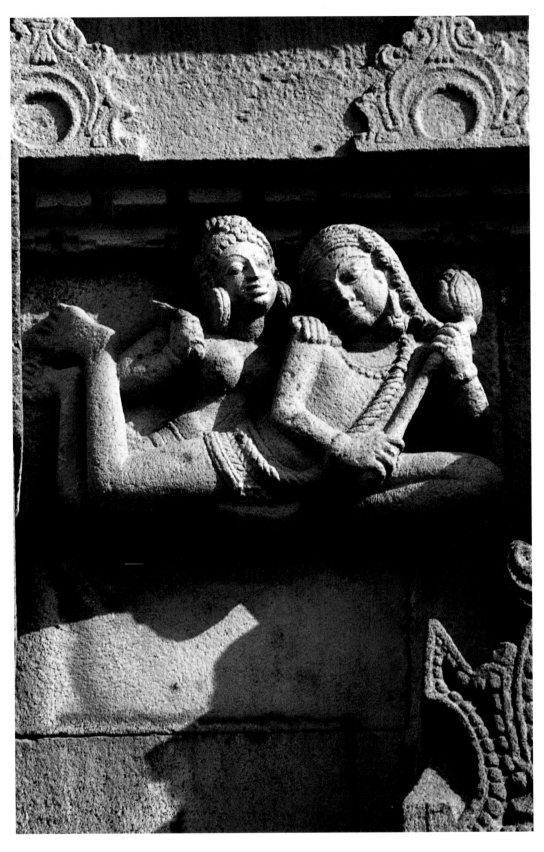

Pages 60-61:
Vidhyadharas (celestial
beings), floating as it were
on the walls of the
Garuda Brahma temple at
Alampur.
Chalukya-dynasty,
8th century.

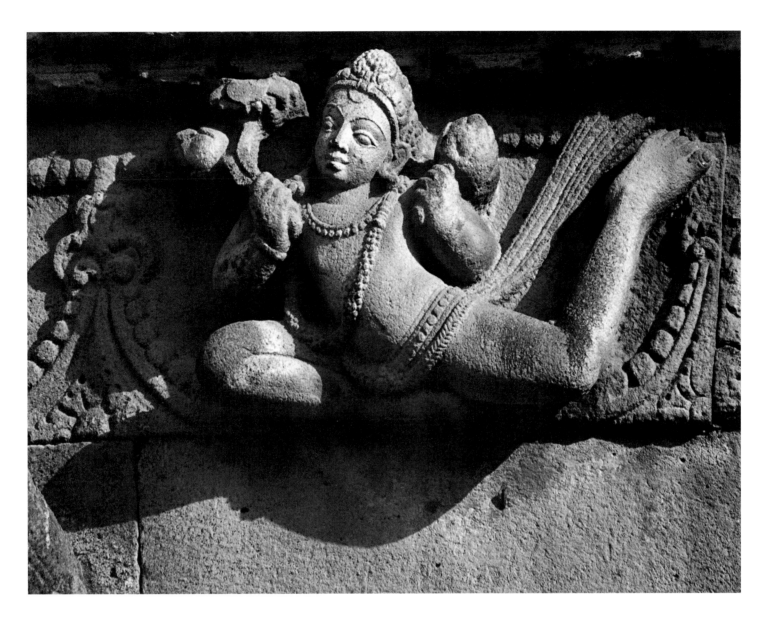

"For it is our evolutionary push towards the future that will give to our past and present their true value and significance. India's nature, her mission, the work that she has to do, her part in the earth's destiny, the peculiar power for which she stands is written there in her past history and is the secret purpose behind her present sufferings and ordeals. A reshaping of the forms of our spirit will have to take place; but it is the spirit itself behind past forms that we have to disengage and preserve and to give to it new and powerful thought-significances, culture-values, a new instrumentation, greater figures."

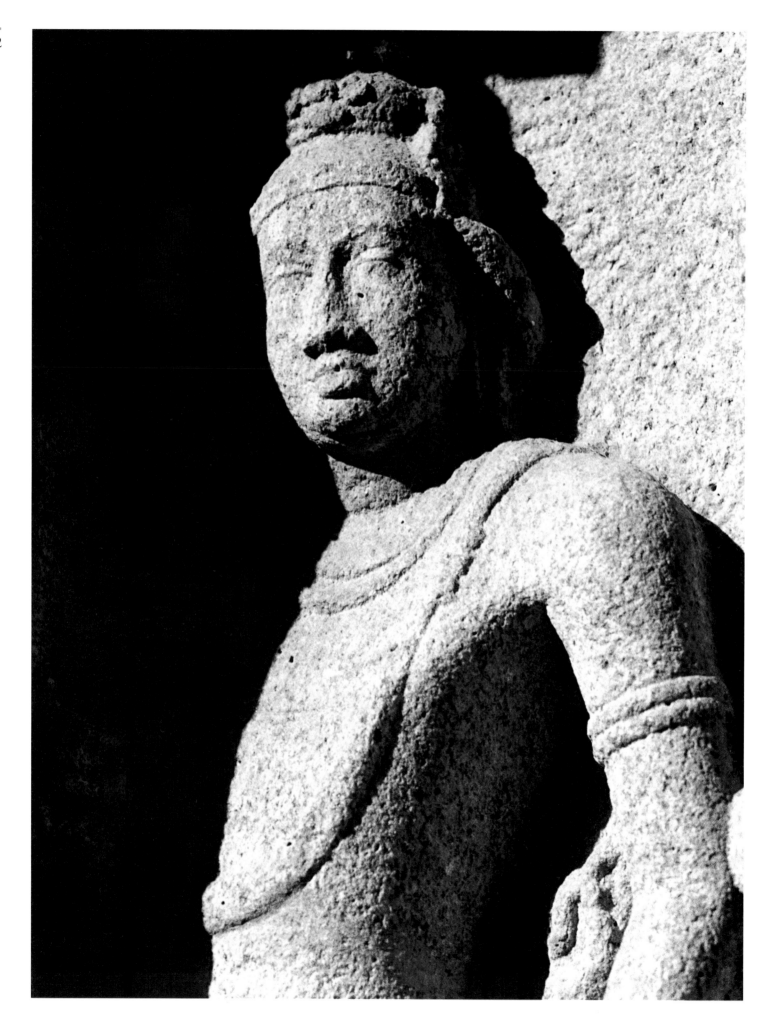

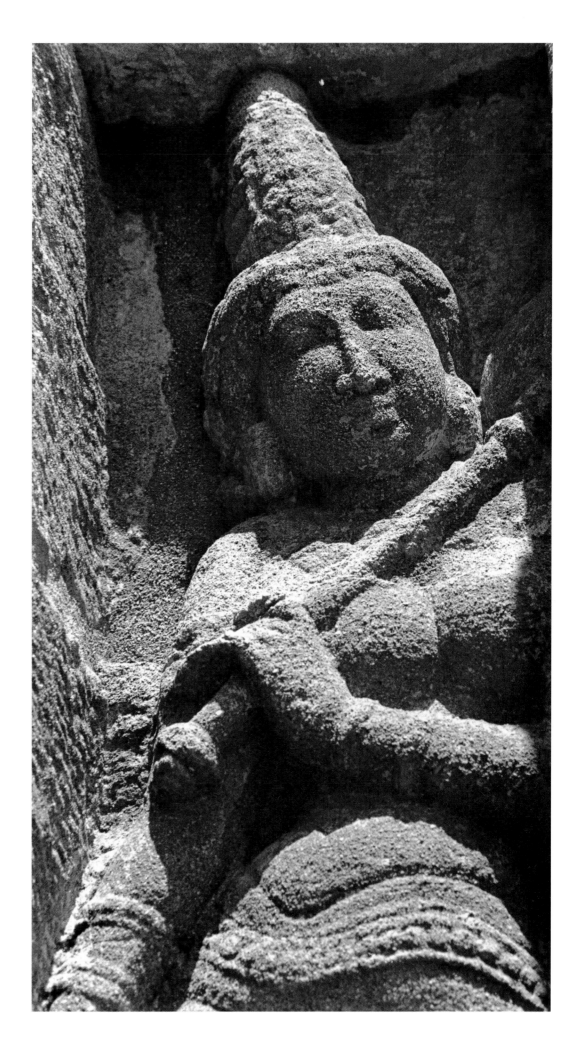

Opposite page:
A Pallava king, Arjuna
Ratha, Mamallapuram,
7th century.

Lady with fly-whisk,
Kailasanatha temple,
Kancipuram, Pallava,
8th century.

"...When this hieratic art
comes down from these
altitudes...it still carries
... some power or some
hint from above."

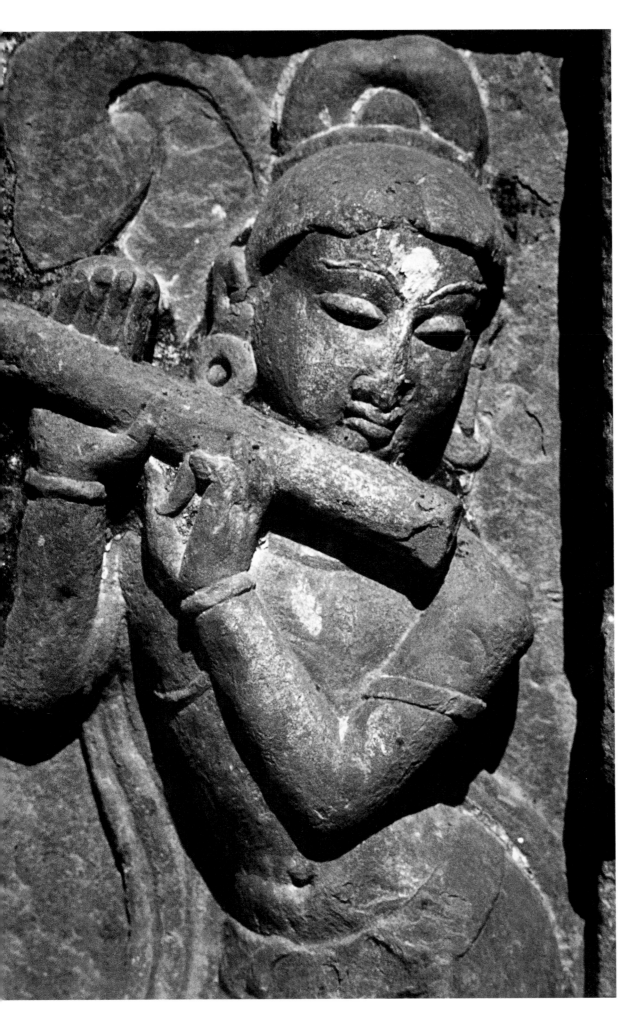

Flute-player, temple at
Bijolia, Rajasthan,
probably eleventh
century.

Opposite page:
Dancer, temple at Bijolia,
Rajasthan, probably
eleventh century.

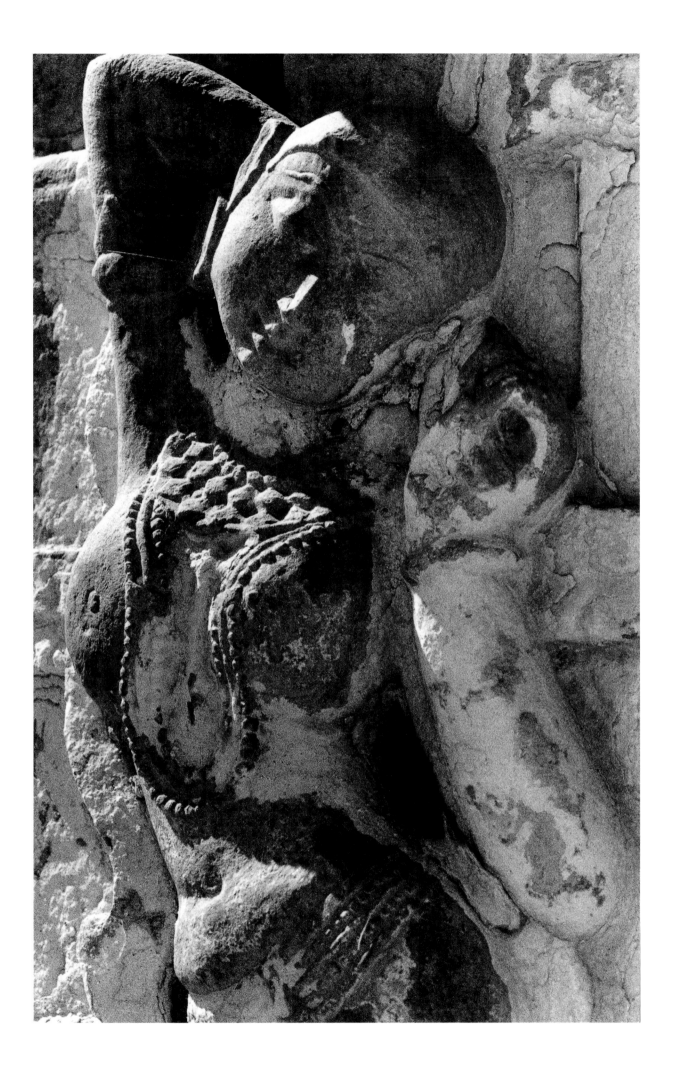

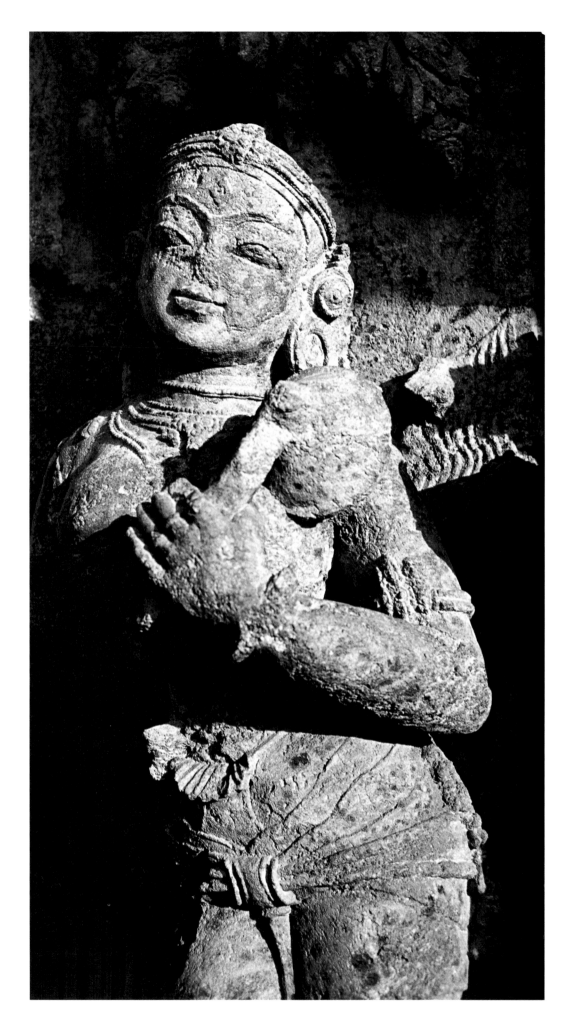

Young woman,
Sun-Temple of Konarak
thirteenth century.

"...And when it comes
quite down to the
material...there is always
something more in which
the seeing presentation of
life floats as in an
immaterial atmosphere..."

Excerpts from
Indian Art 2
Architecture

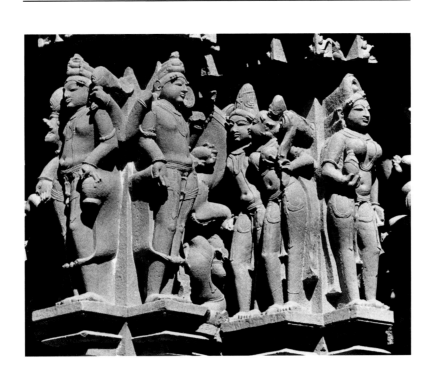

The western mind is arrested and attracted by the form, lingers on it and cannot get away from its charm, loves it for its own beauty, rests on the emotional, intellectual, aesthetic suggestions that arise directly from its most visible language, confines the soul in the body; it might almost be said that for this mind form creates the spirit, the spirit depends for its existence and for everything it has to say on the form. The Indian attitude to the matter is at the opposite pole to this view. For the Indian mind form does not exist except as a creation of the spirit and draws all its meaning and value from the spirit. Every line, arrangement of mass, colour, shape, posture, every physical suggestion, however many, crowded, opulent they may be, is first and last a suggestion, a hint, very often a symbol which is in its main function a support for a spiritual emotion, idea, image that again goes beyond itself to the less definable, but more powerfully sensible reality of the spirit which has excited these movements in the aesthetic mind and passed through them into significant shapes.

...Here the only right way is it to get at once through a total intuitive or revelatory impression or by some meditative dwelling on the whole, dhyana in the technical Indian term, to the spiritual meaning and atmosphere, make ourselves one with that as completely as possible, and then only the helpful meaning and value of all the rest comes out with a complete and revealing force. For here it is the spirit that carries the form, while in most western art it is the form that carries whatever there may be of spirit.

A great oriental work of art does not easily reveal its secret to one who comes to it solely in a mood of aesthetic curiosity or with a considering critical objective mind, still less as the cultivated and interested tourist passing among strange and foreign things; but it has to be seen in loneliness, in the solitude of one's self, in moments when one is capable of long and deep meditation and as little weighted as possible with the conventions of material life.

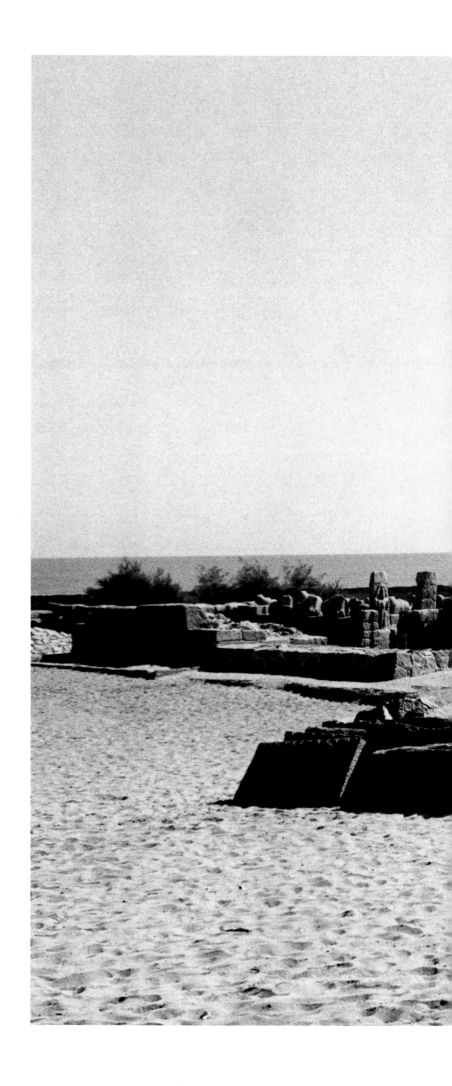

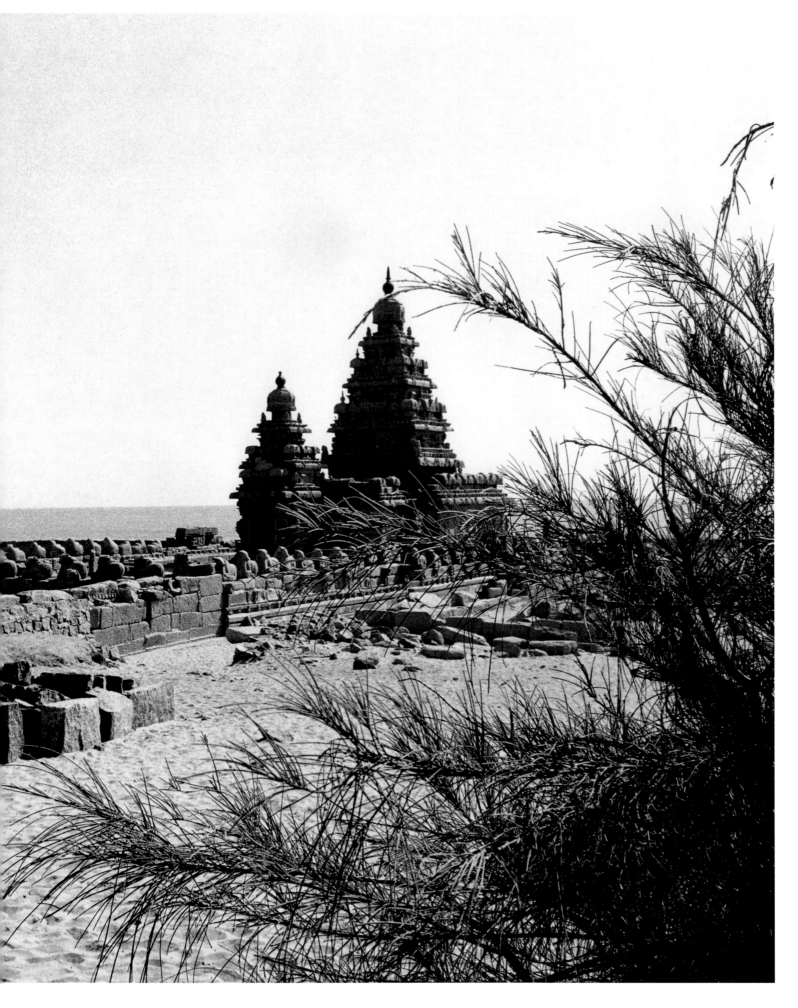

Previous page:
The Shore-temple at
Mamallapuram, solitary
witness of a heroic time.
Pallava dynasty,
8th century.

The sacred river
Tungabhadra at Pattadakal,
Andhra Pradesh.

Opposite page:
Morning at the
Sangameshvara and
Virupaksha temple
situated on the banks of
the Tungabhadra river at
Pattadakal.
Chalukya dynasty,
8th century.

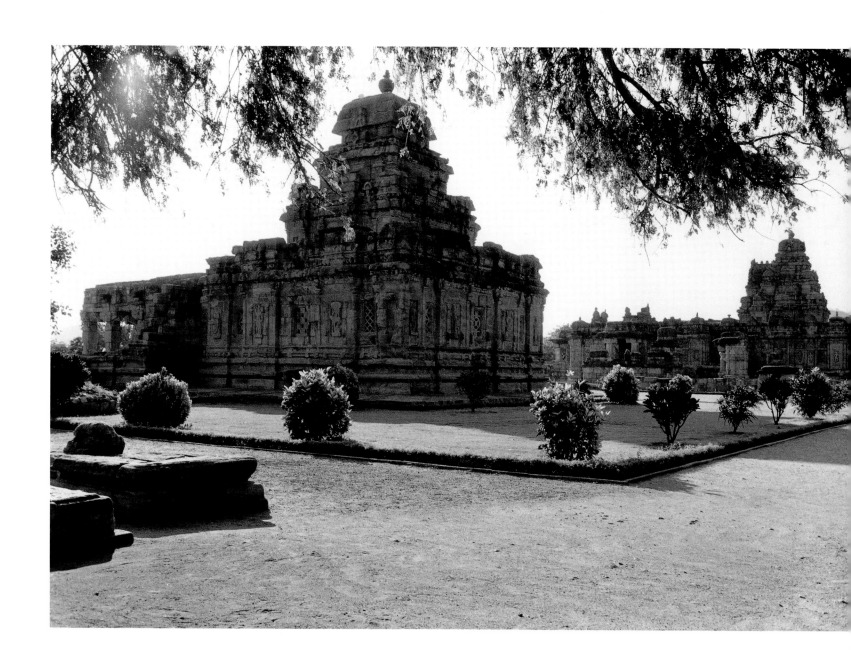

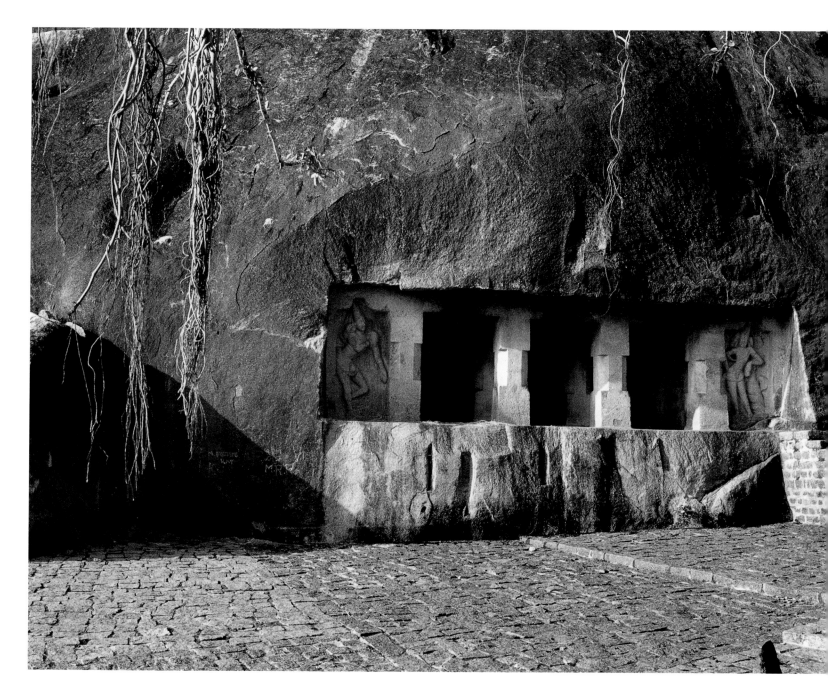

The first cave-temple in South India, sculpted from the living rock by Pallava king Mahendravarman at Mandagapattu. The weather-beaten Banyan tree in front of it is an example for the age-old association of tree and temple in the South. Early 7th century.

Following page:
Sunset at the Stupa of Sanchi.
Satavahana dynasty, 2nd-1st century B.C.

"... but it has to be seen in loneliness, in the solitude of one's self..."

"Art can create the past, the present and the future. It can re-manifest that which was and has passed away, it can fix for us that which is, it can prophesy that which will be."

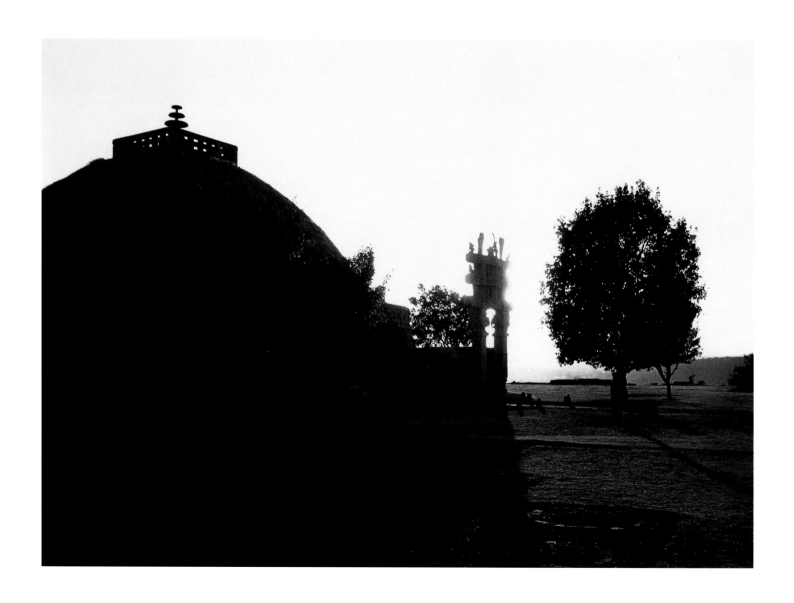

Indian architecture especially demands this kind of inner study and this spiritual self-identification with its deepest meaning and will not otherwise reveal itself to us. The secular buildings of ancient India, her palaces and places of assembly and civic edifices have not outlived the ravage of time; what remains to us is mostly something of the great mountain and cave temples, something too of the temples of her ancient cities of the plains, and for the rest we have the fanes and shrines of her later times, whether situated in temple cities and places of pilgrimage like Srirangam and Rameshwaram or in her great once regal towns like Madura, when the temple was the centre of life. It is then the most hieratic side of a hieratic art that remains to us. These sacred buildings are the signs, the architectural self-expression of an ancient spiritual and religious culture. Ignore the spiritual suggestion, the religious significance, the meaning of the symbols and indications, look only with the rational and secular aesthetic mind, and it is vain to expect that we shall get to any true and discerning appreciation of this art.

The Satrumalleshvara
cave-temple at
Dalavanur, embedded
between gigantic granite
boulders.
Pallava, 7th century.

Following pages:
Left
The Talagirishvara temple
on top of the rock-hill at
Panamalai.
Pallava, 8th century.

"...what remains to us is
mostly something of the
great mountain – and
cave temples..."

Right
The ancient temple-town
of Pattadakal in
Andhra Pradesh.

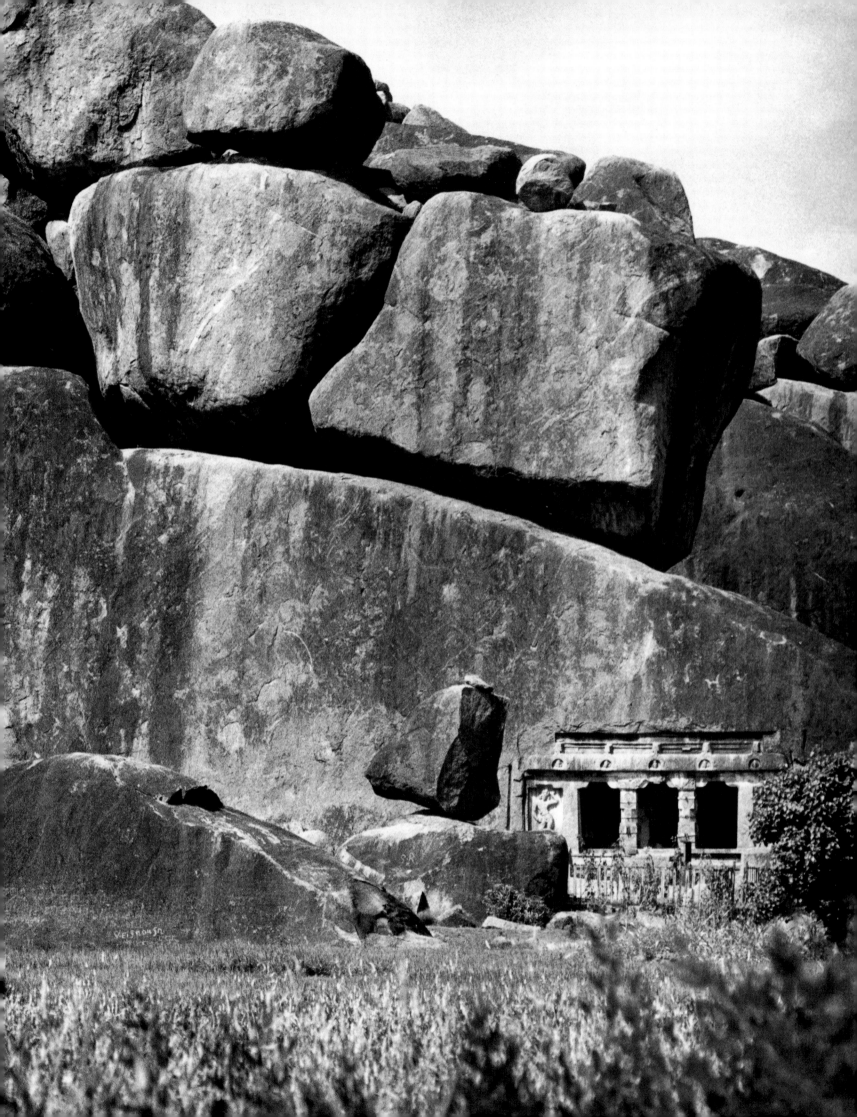

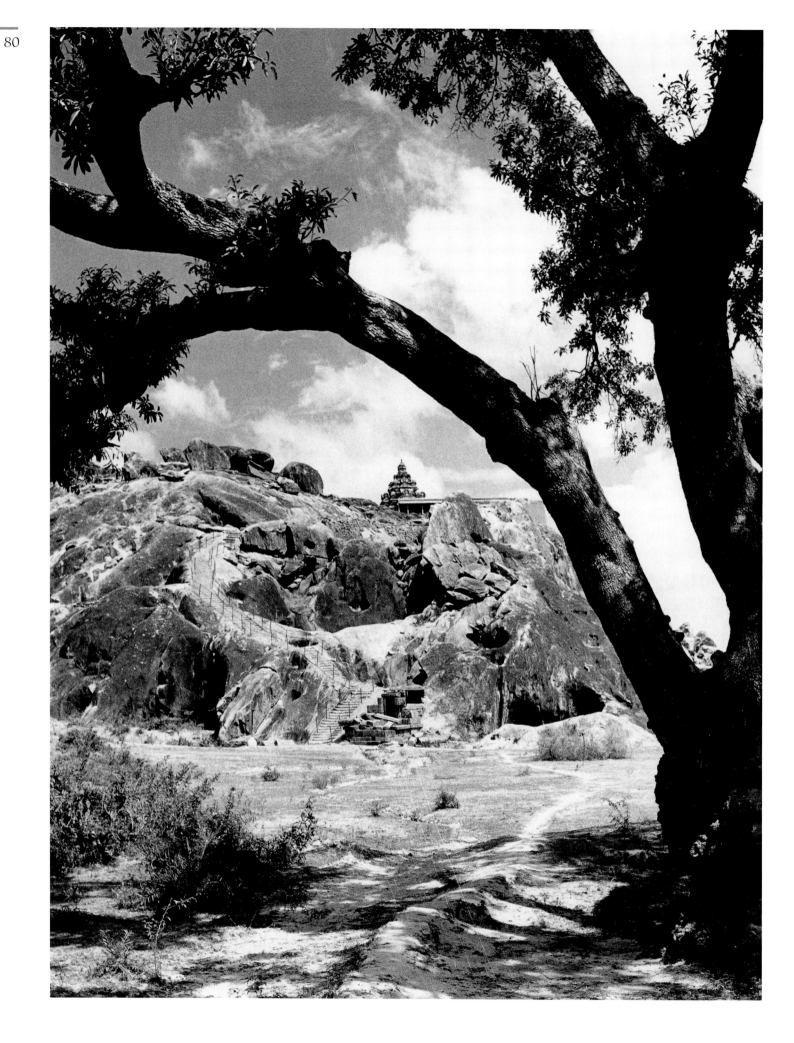

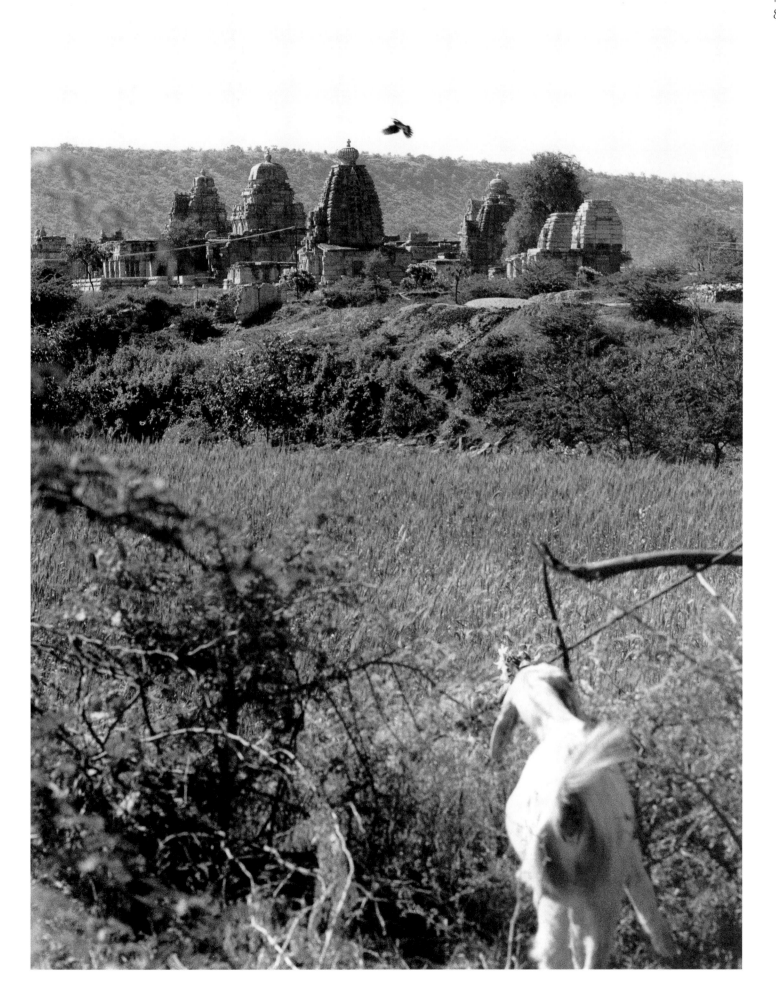

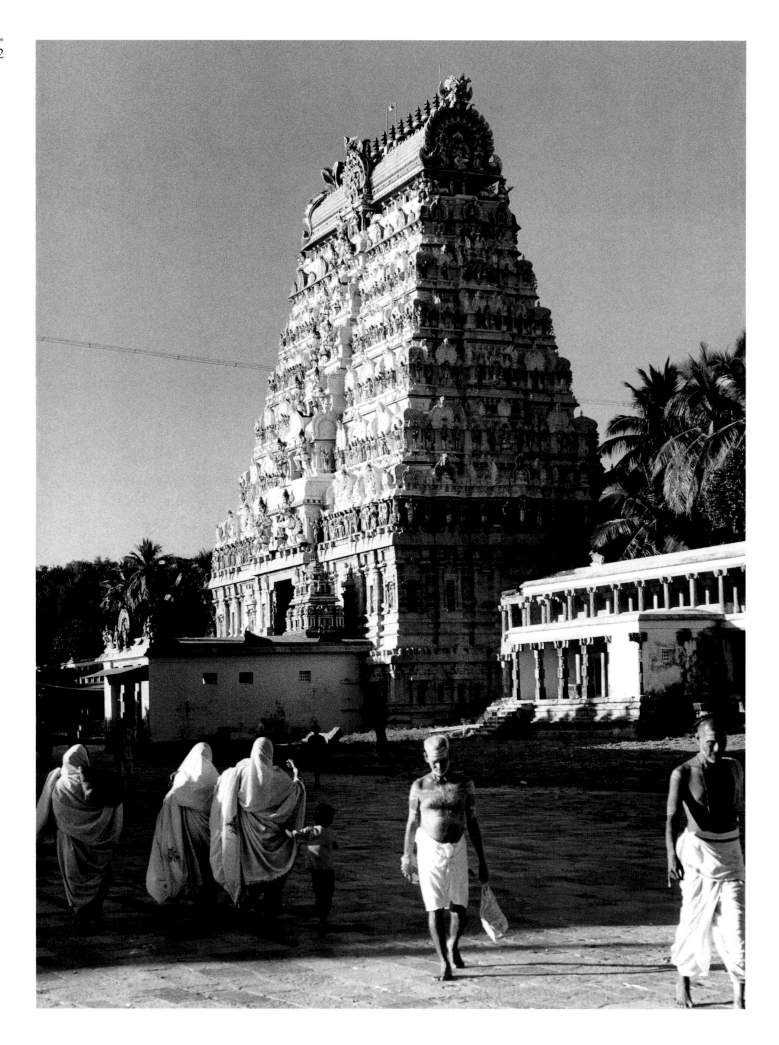

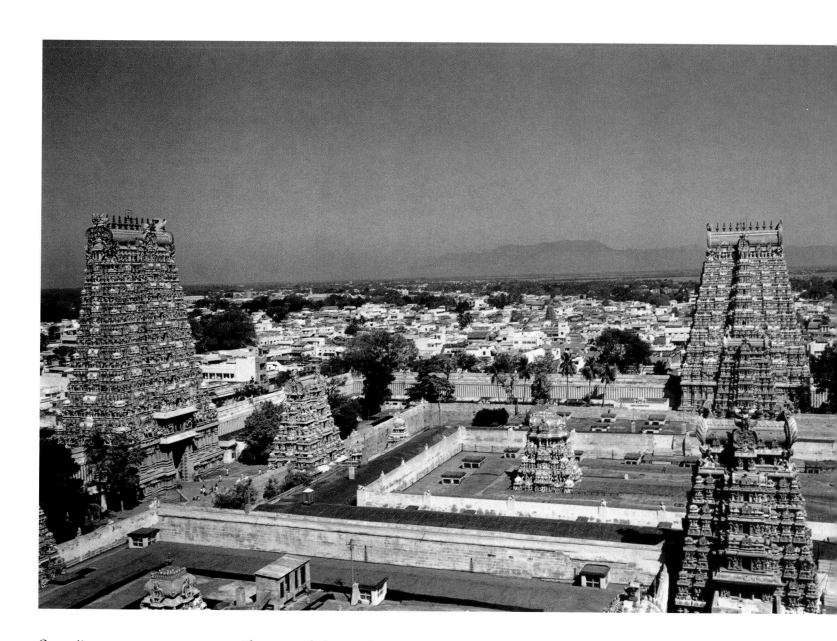

Opposite page:
Chidambaram, the age-old and vast temple complex in the South, where Shiva is worshipped as the cosmic dancer, is a centre of intense religious and cultural life.

The Meenakshi temple further south at Madurai is to the present day fully integrated with the life of the people as a centre of pilgrimage, worship and learning.

"...when the temple was the centre of life..."

To bring in into the artistic look on an Indian temple occidental memories or a comparison with the Greek Parthenon or Italian church or Duomo or Campanile or even the great Gothic cathedrals of mediaeval France, though these have in them something much nearer to the Indian mentality, is to intrude a fatally foreign and disturbing element or standard in the mind. But this consciously or else subconsciously is what almost every European mind does to a greater or less degree, – and it is here a pernicious immixture, for it subjects the work of a vision that saw the immeasurable to the tests of an eye that dwells only on the measure.

Indian sacred architecture of whatever date, style or dedication goes back to something timelessly ancient and now outside India almost wholly lost, something which belongs to the past, and yet it goes forward too, though this the rationalistic mind will not easily admit, to something which will return upon us and is already beginning to return, something which belongs to the future. An Indian temple, to whatever godhead it may be built, is in its inmost reality an altar raised to the divine Self, a house of the Cosmic Spirit, an appeal and aspiration to the Infinite. As that and in the light of that seeing and conception it must in the first place be understood, and everything else must be seen in that setting and that light, and then only can there be any real understanding.

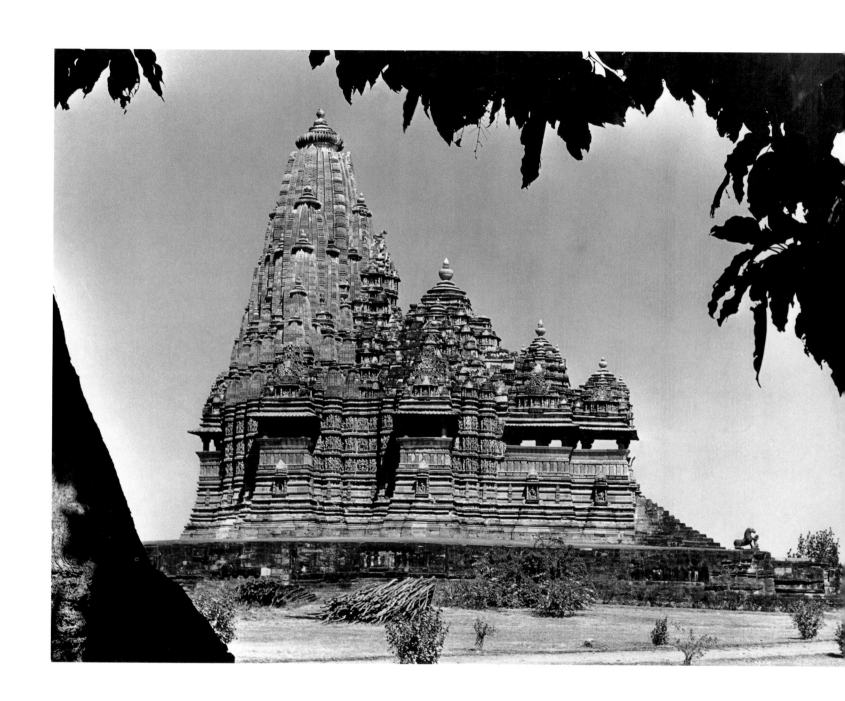

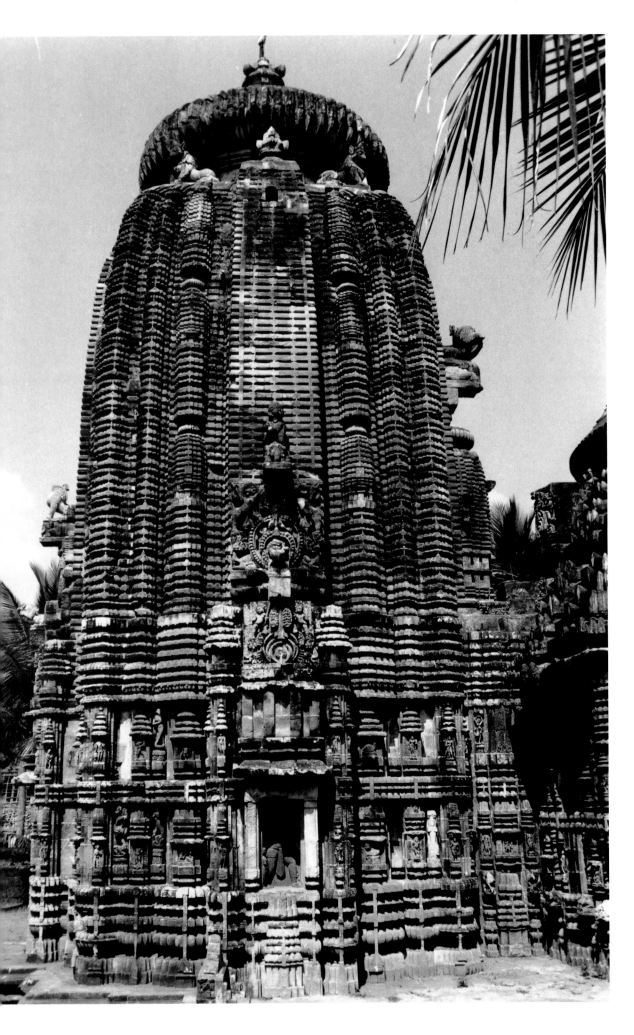

Previous page:
In the Khandarya Mahadeva temple with its soaring superstructure the ancient image of the Mountain which is the axis of the world (Meru, Mandara, Kailas) takes shape. Khajuraho, Chandella period, North Indian style, eleventh century.

"Indian sacred architecture of whatever date, style or dedication goes back to something time-lessly ancient ..."

Deul of the Madhavananda temple which houses the *garbhagriha* or sanctum. In all Indian temples it is a cube-like chamber, bare and dark as a cave in a mountain. Prachi-valley, Orissa, thirteenth century.

Opposite page:
Jagamohana or frontal porch of the Madhavananda temple, characterised by a pyramidal roof of receding steps. Deul and Jagamohana are the two typical components of the Orissan temple.

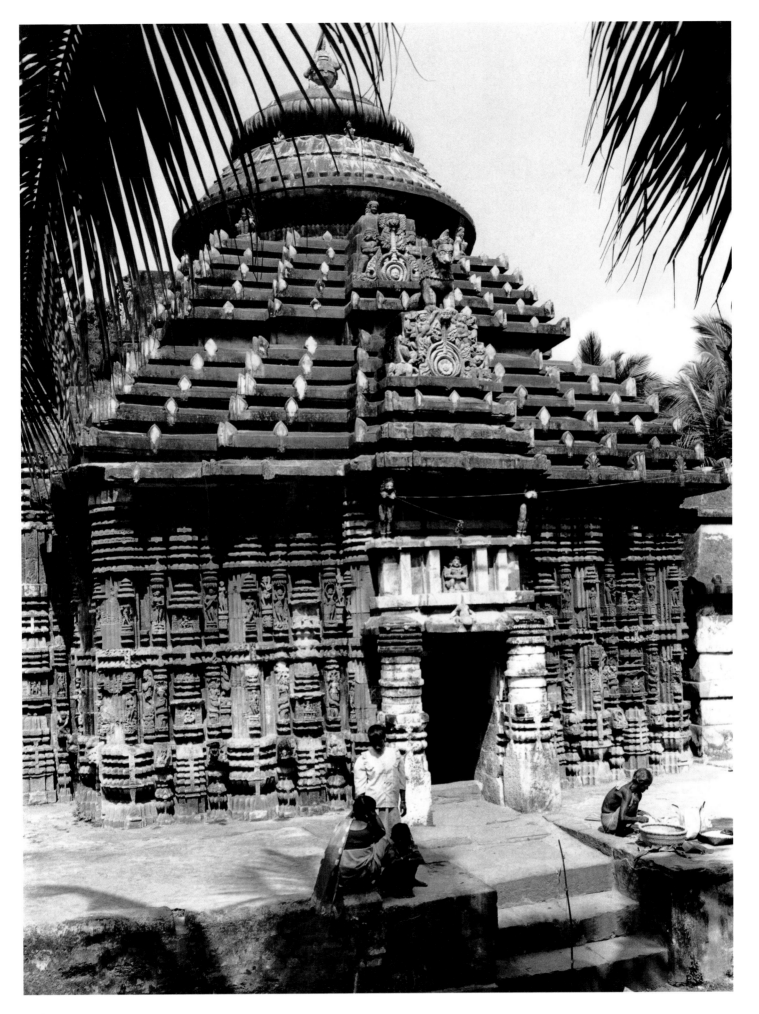

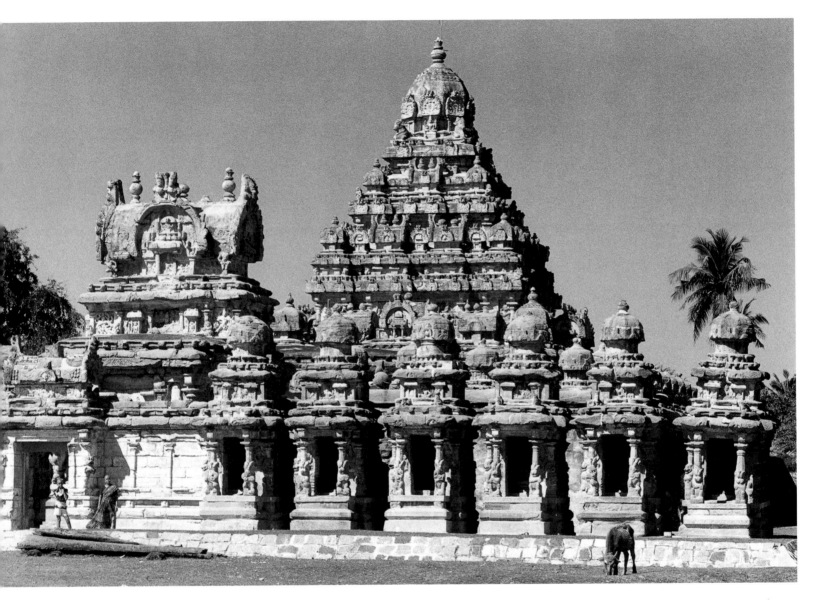

The Kailasanatha temple,
an example of the
Dravidian or South Indian
style. Kanchipuram,
Pallava, 8th century.

Opposite page:
The Khandarya Mahadeva
and Devi Jagadambi
temple. Khajuraho,
Chandella dynasty,
eleventh century.

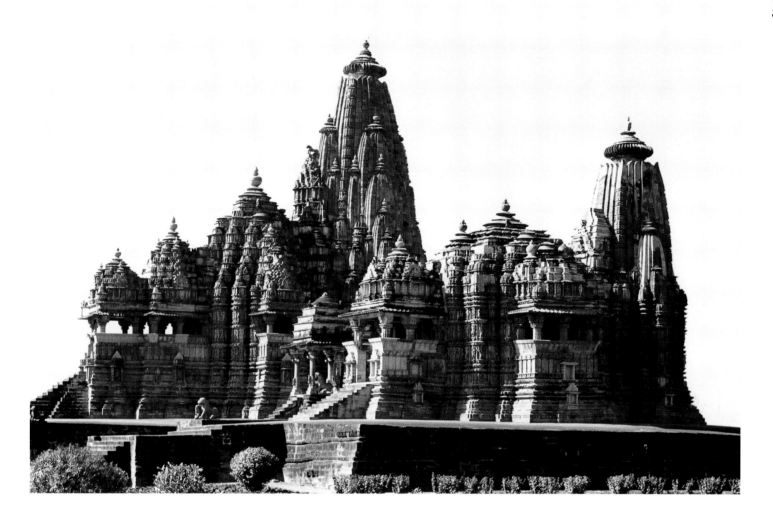

*Now it may readily be admitted that the failure to see at once the
unity of this architecture is perfectly natural to a European eye,
because unity in the sense demanded by the western conception,
the Greek unity gained by much suppression and a sparing use of
detail and circumstance or even the Gothic unity got by casting
everything into the mould of a single spiritual aspiration, is not
there. And the greater unity that really is there can never be
arrived at at all, if the eye begins and ends by dwelling on form
and detail and ornament, because it will then be obsessed by these
things and find it difficult to go beyond to the unity which all this
in its totality serves...*

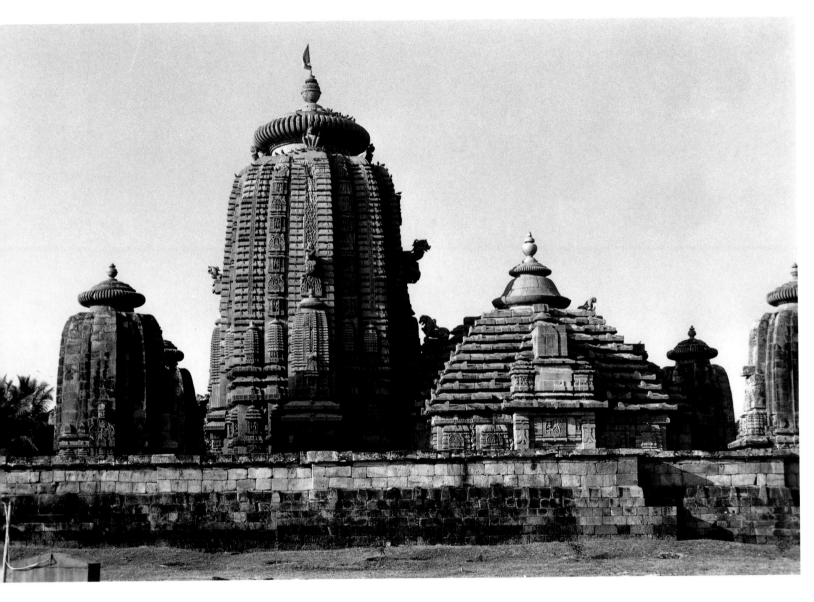

The Brahmeshvara temple in its complex and mature form with Deul, Jagamohana, corner shrines and compound wall. Bhubaneshvar, eleventh century.

Opposite page:
Detail.

"... And the greater unity that is really there can never be arrived at at all if the eye begins and ends by dwelling on form and detail and ornament."

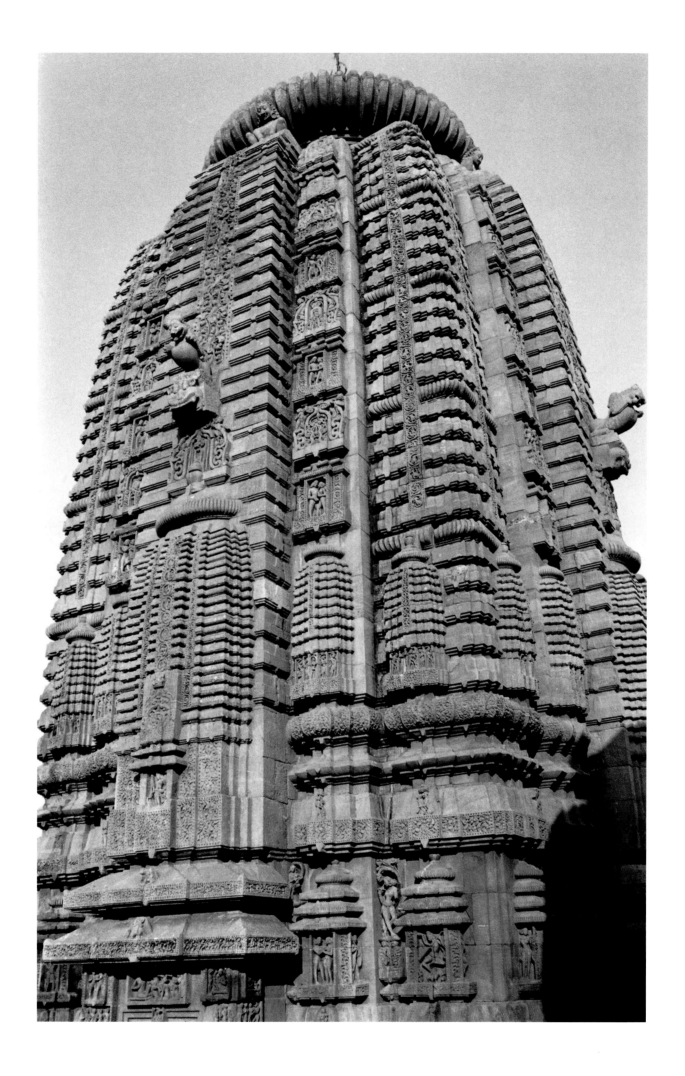

*T*he straight way here is not to detach the temple from its surroundings, but to see it in unity with the sky and low-lying landscape or with the sky and hills around and feel the thing common to both, the construction and its environment, the reality in Nature, the reality expressed in the work of art.

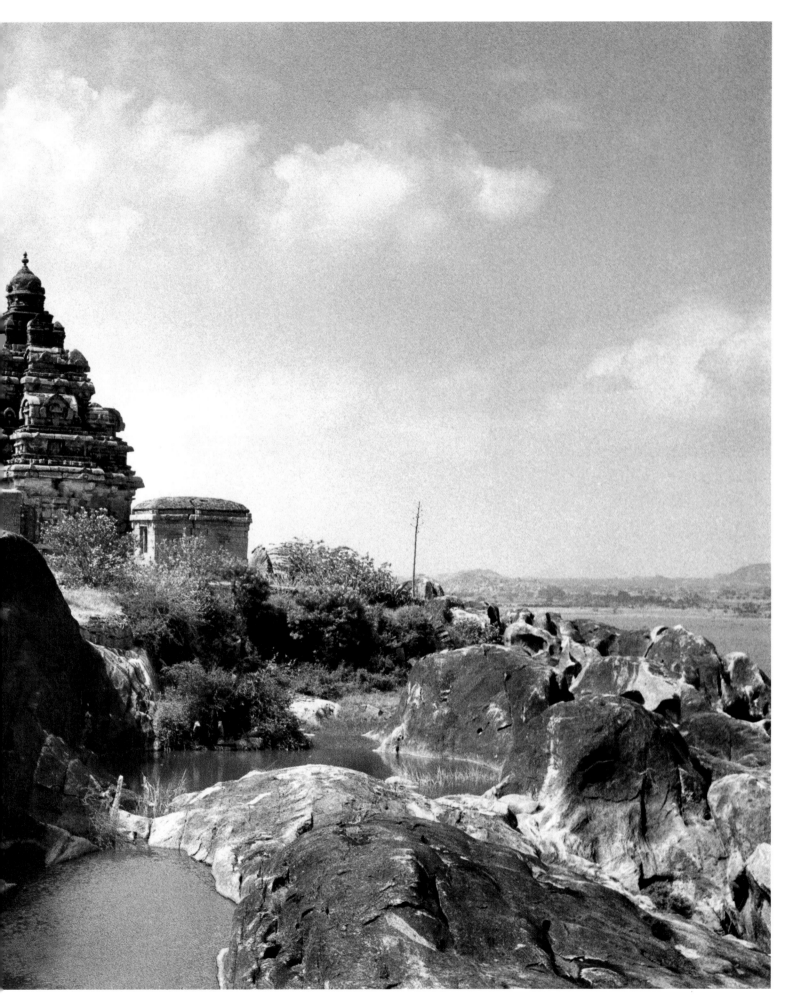

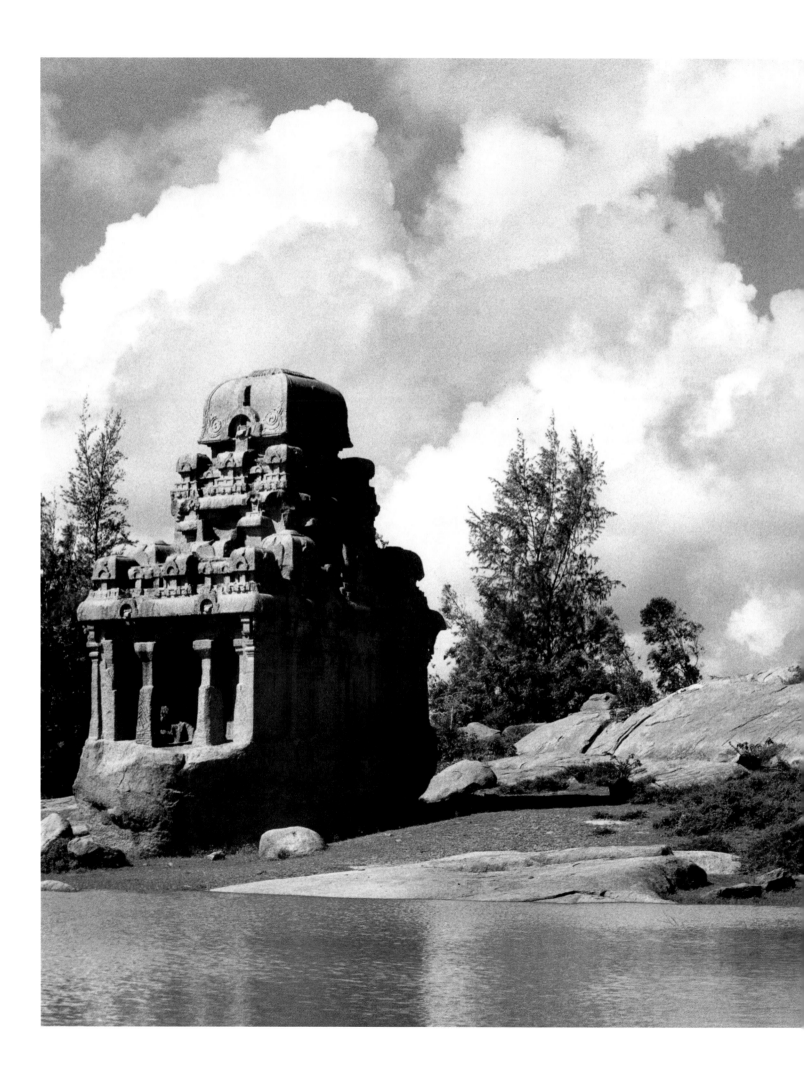

Previous pages:
The Talagirishvara temple
on top of the hill at
Pannamalai, "...in unity
with the sky and low lying
landscape... ." Pallava,
8th century.

The Valayankuttai Ratha
at Mamallapuram,
situated by the side of a
lake, an ideal spot for an
ancient place of worship.
Pallava, 7th century.

Following pages:
Left
Steps hewn into the rock
near the Ranganatha cave
temple at Singavaram are
part of a precarious
pradakshina path around
the temple. South India.

Right
A Gopuram, visible from
afar, marks the site of the
Ranganatha cave-temple
at Singavaram.

Page 98:
The Pidari Rathas, two
monolithic temples
embedded beautifully in
their surroundings,
Mamallapuram
Pallava, 7th century.

"Behind a few figures, a few trees and rocks the supreme Intelligence, the supreme Imagination, the supreme Energy lurks, acts, feels, is, and, if the artist has the spiritual vision, he can see it and suggest perfectly the great mysterious life in its manifestations, brooding in action, active in thought, energetic in stillness, creative in repose, full of a mastering intention in that which appears blind and unconscious."

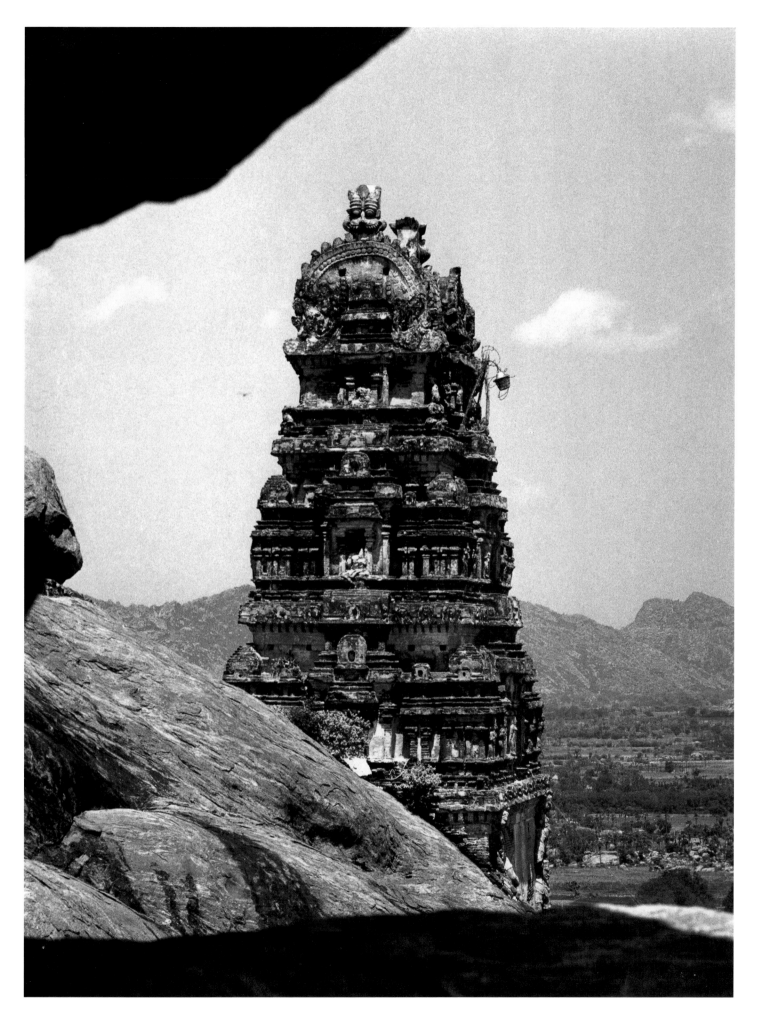

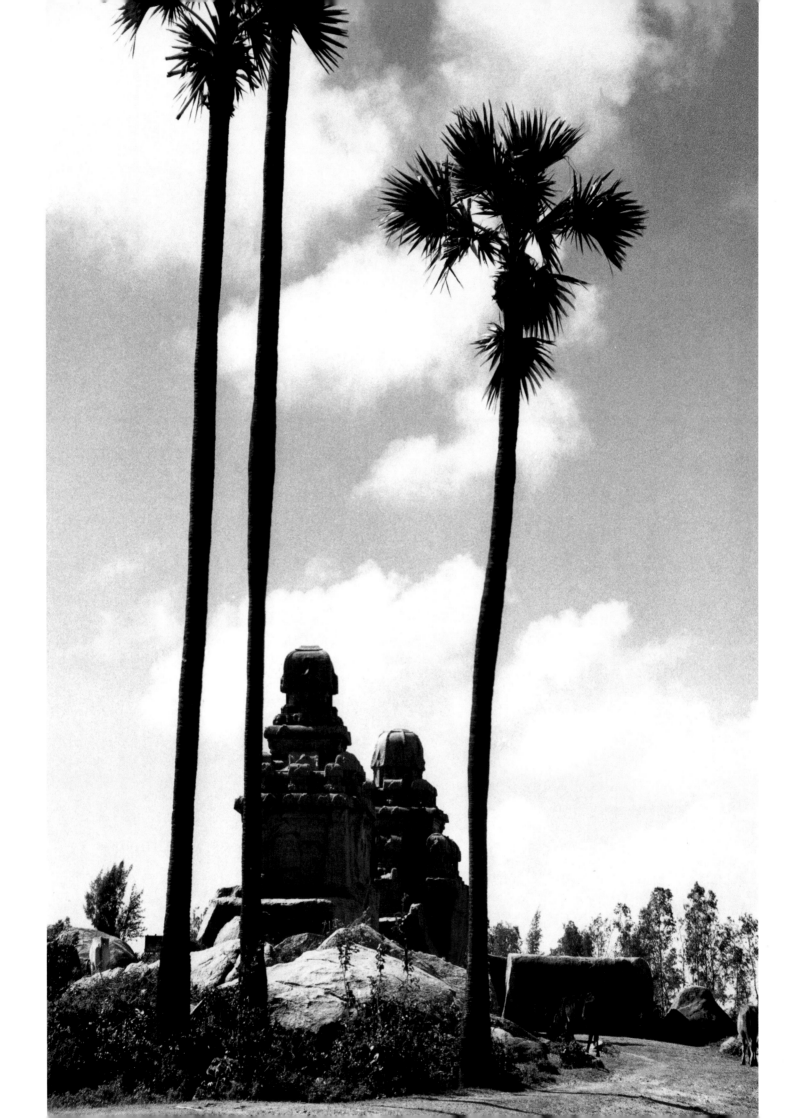

One of these buildings climbs up bold, massive in projection, up-piled in the greatness of a forceful but sure ascent, preserving its range and line to the last, the other soars from the strength of its base, in the grace and emotion of a curving mass to a rounded summit and crowning symbol. There is in both a constant, subtle yet pronounced lessening from the base towards the top, but at each stage a repetition of the same form, the same multiplicity of insistence, the same crowded fullness and indented relief, but one maintains its multiple endeavour and indication to the last, the other ends in a single sign.

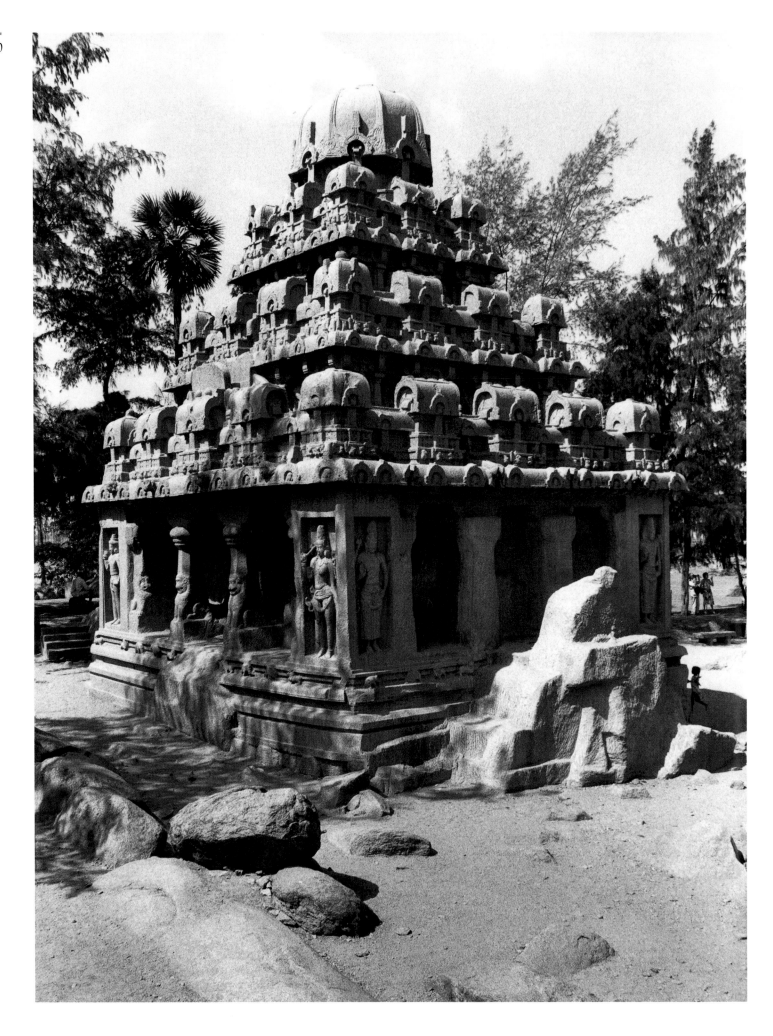

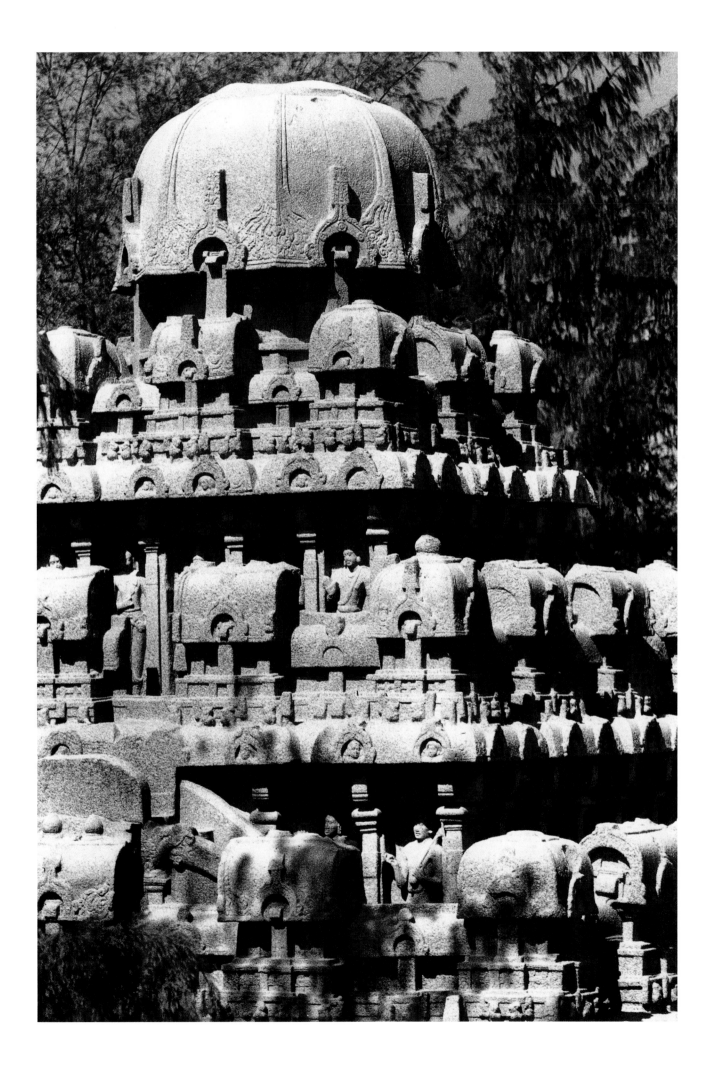

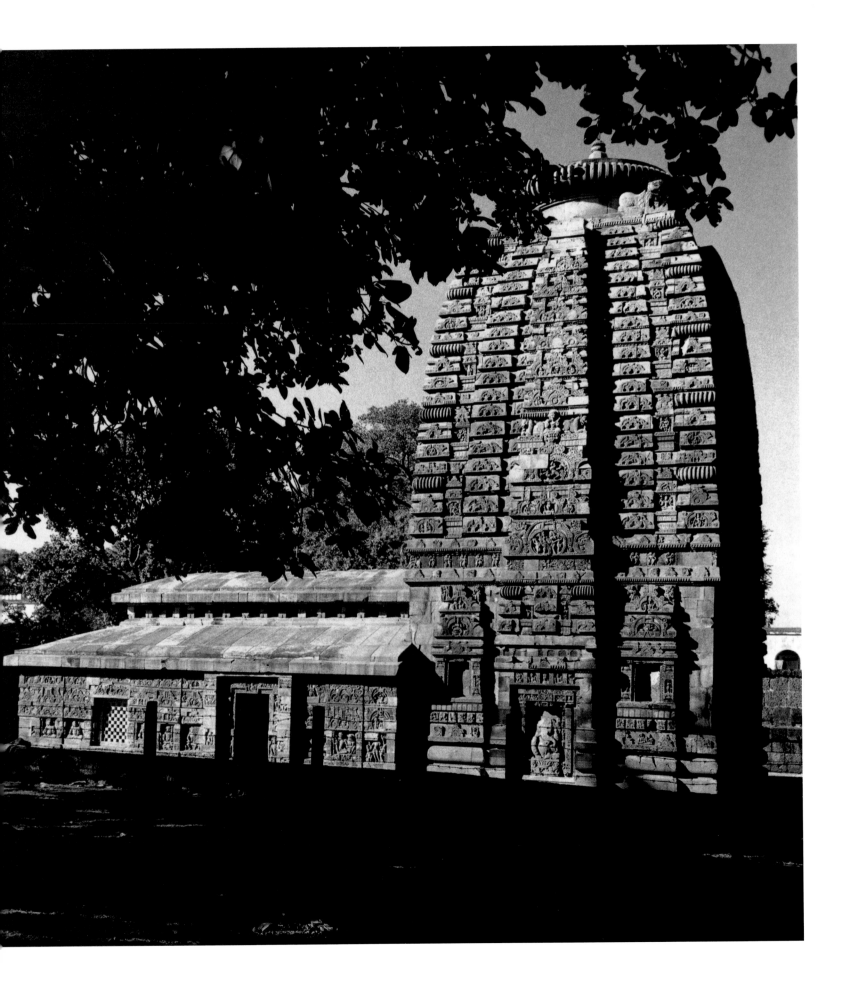

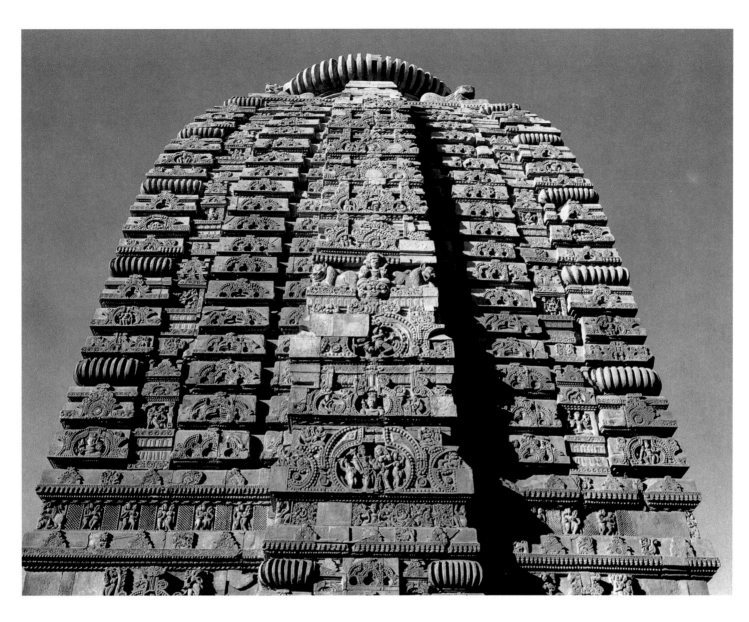

Previous pages:
The Dharmaraja Ratha
with its receding *talas*
(storeys) and the
marvellous cupola which
tops it, is an outstanding
example of the Dravidian
style. Mamallapuram,
Pallava, 7th century.

"...up-piled in the
greatness of a forceful but
sure ascent..."

Page 102-103:
The Parasurameshvara
temple is one of the
earliest surviving and
most beautiful temples at
Bhubaneshvar.
7th century.

"...the other soars from
the strength of its base, in
the grace and emotion of
a curving mass to a
rounded summit and
crowning symbol."

Following pages:
Khandariya Mahadeva
temple, North Indian
style, Khajuraho.

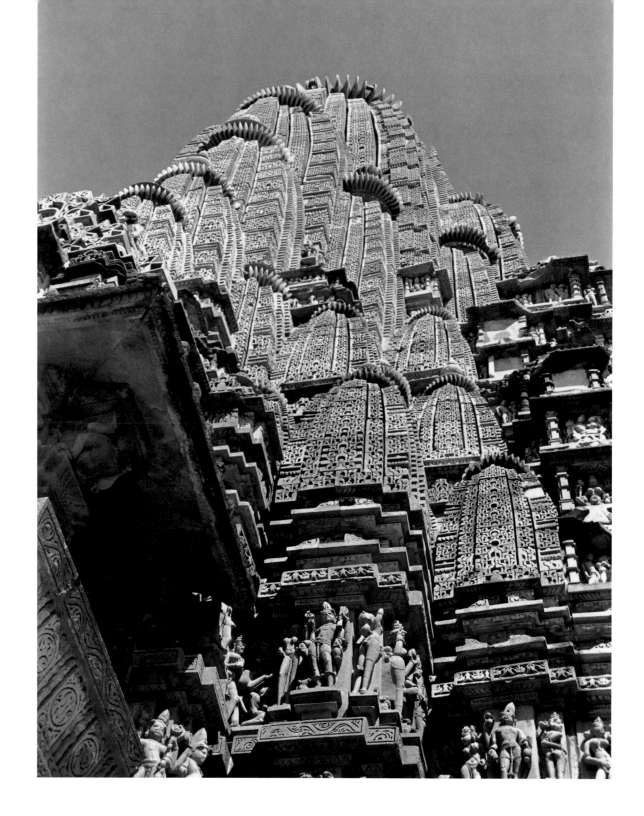

*T*o *find the significance we have first to feel the oneness of the infinity in which this nature and this art live, then see this thronged expression as the sign of the infinite multiplicity which fills this oneness, see in the regular lessening ascent of the edifice the subtler and subtler return from the base on earth to the original unity and seize on the symbolic indication of its close at the top. Not absence of unity, but a tremendous unity is revealed.*

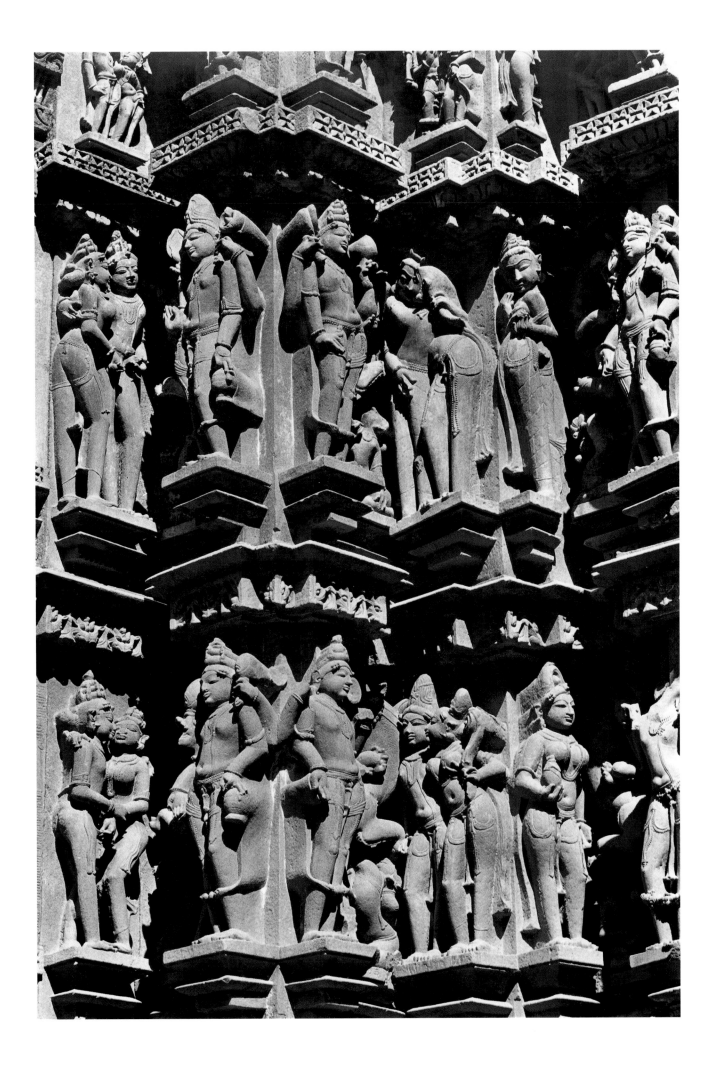

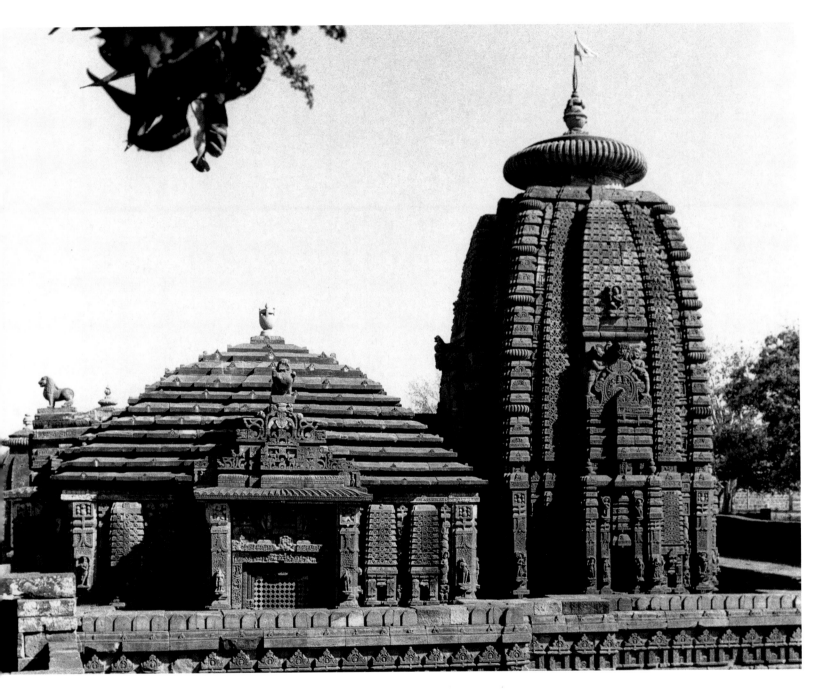

Pages 106-107:
Mukteshvara temple
Orissan style,
Bhubaneshvar,
10th century.

"...Not absence of unity,
but a tremendous unity is
revealed."

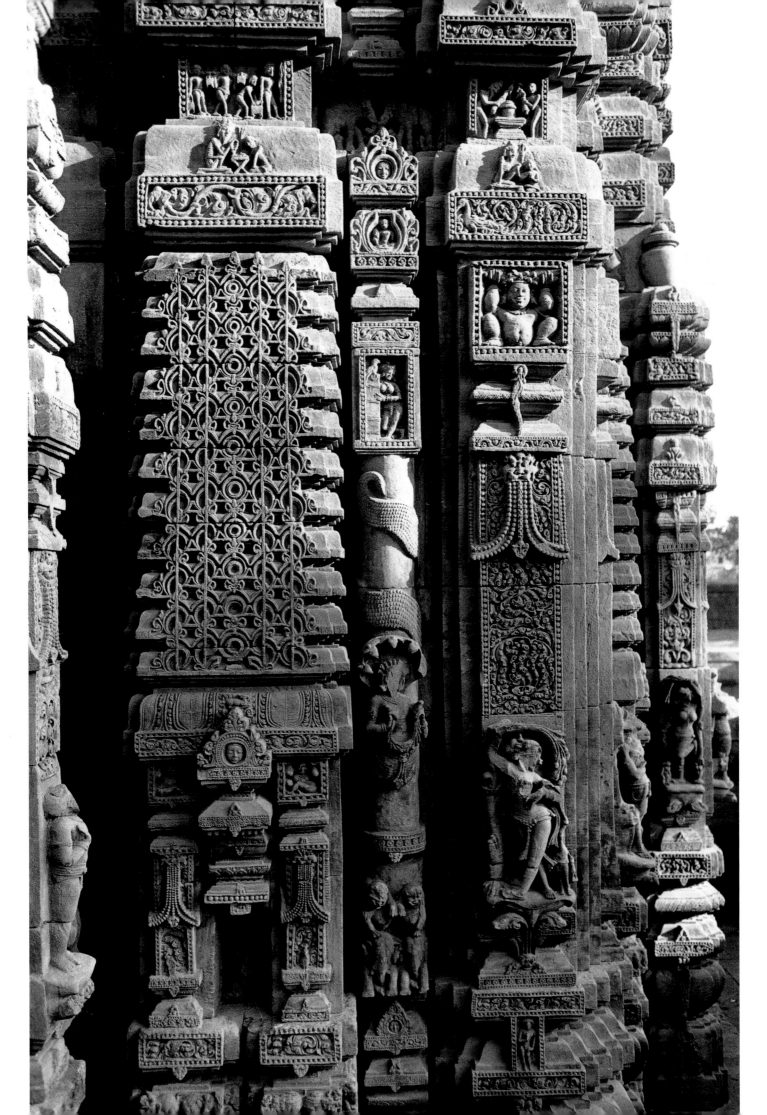

The objection that an excess of thronging detail and ornament hides, impairs or breaks up the unity is advanced only because the eye has made the mistake of dwelling on the detail first without relation to this original spiritual oneness, which has first to be fixed in an intimate spiritual seeing and union and then all else seen in that vision and experience. When we look on the multiplicity of the world, it is only a crowded plurality that we can find and to arrive at unity we have to reduce, to suppress what we have seen or sparingly select a few indications or to be satisfied with the unity of this or that separate idea, experience or imagination; but when we have realised the Self, the infinite unity and look back on the multiplicity of the world, then we find that oneness able to bear all the infinity of variation and circumstance we can crowd into it and its unity remains unabridged by even the most endless self-multiplication of its informing creation. We find the same thing in looking at this architecture. The wealth of ornament, detail, circumstance in Indian temples represents the infinite variety and repetition of the worlds, – not our world only, but all the planes, – suggests the infinite multiplicity in the infinite oneness.

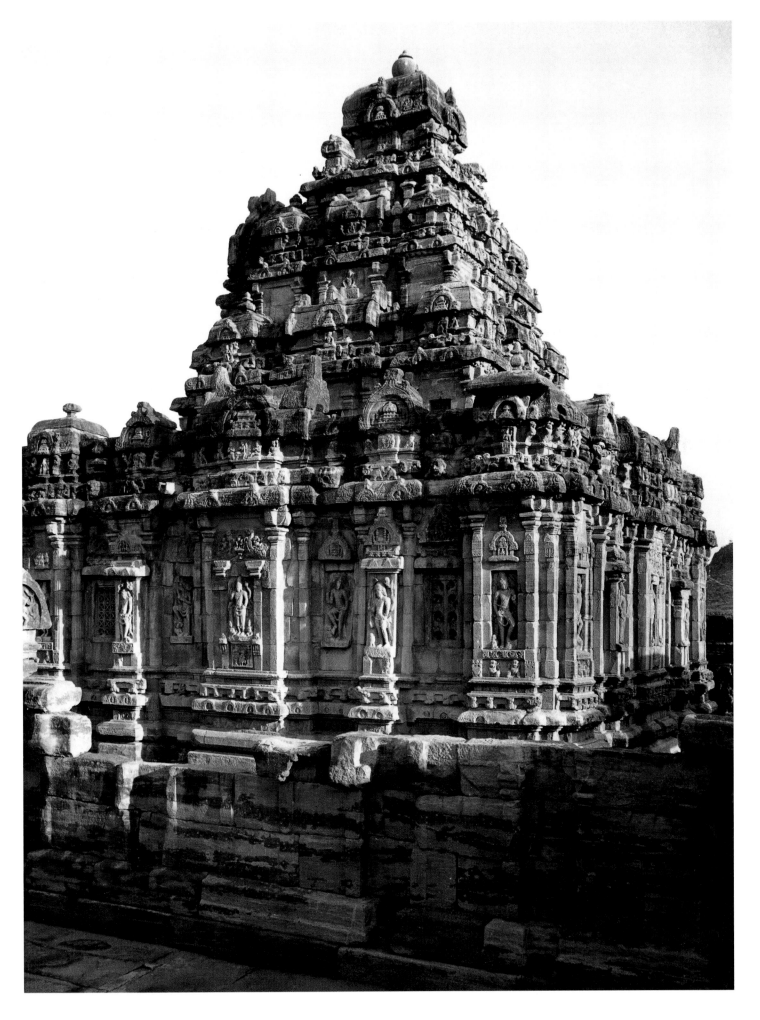

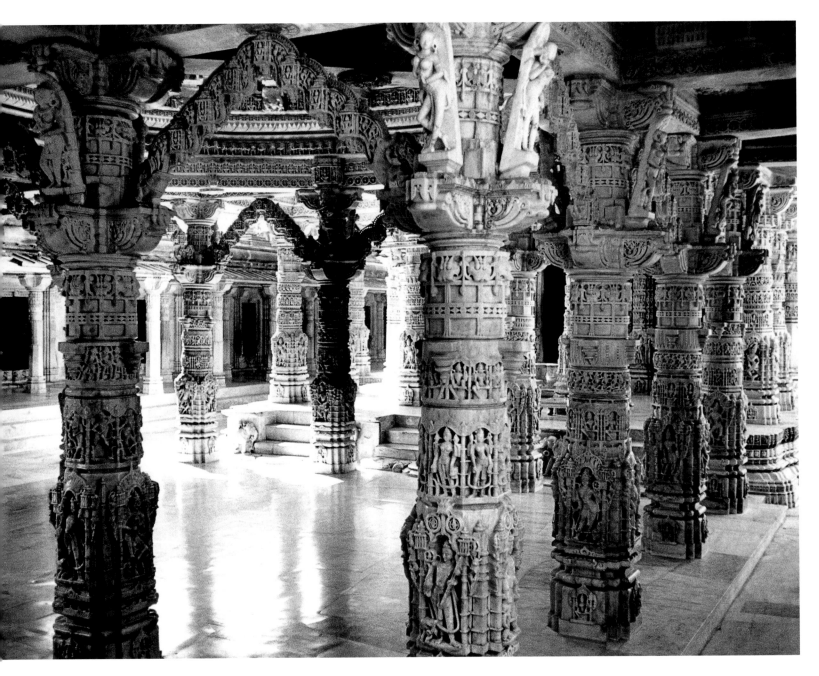

Previous page:
The Virupaksha temple at
Pattadakal. Chalukya,
8th century.

"The wealth of ornament,
detail and circumstance in
Indian temples represents
the infinite variety and
repetition of the worlds."

Pages 110-111:
The interior of the Vimala
Shah temple at Mt. Abu,
eleventh century. The
delicacy and wealth of
ornament in these Jain
temples had become an
end in itself, yet never
disturbs the unity of the
whole.

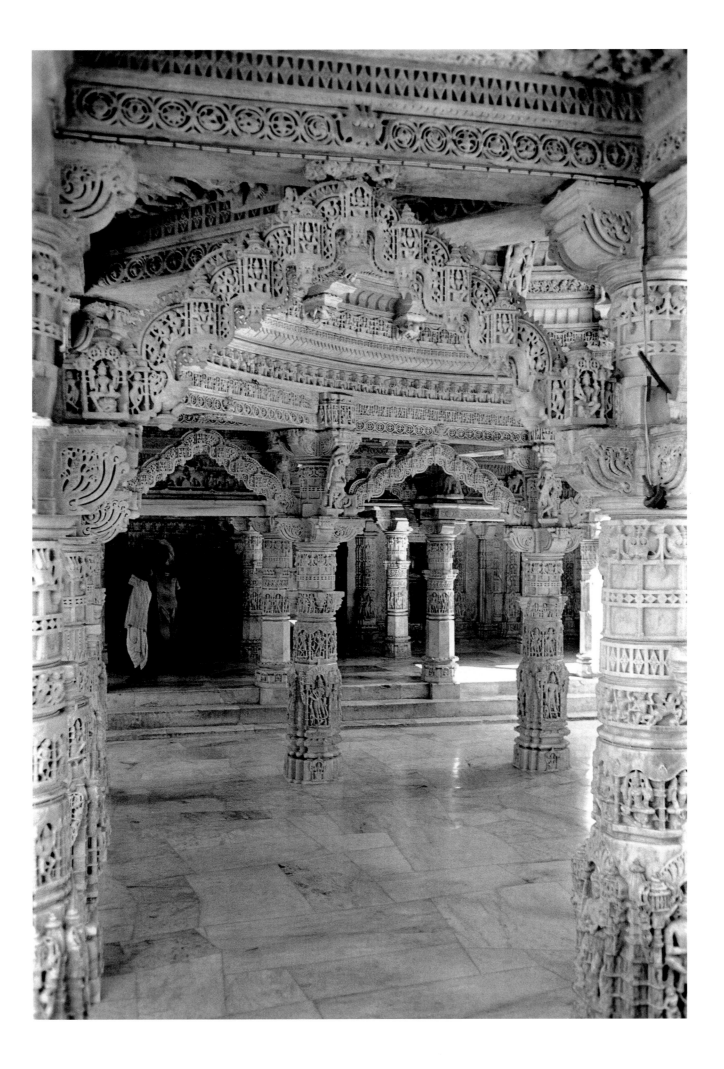

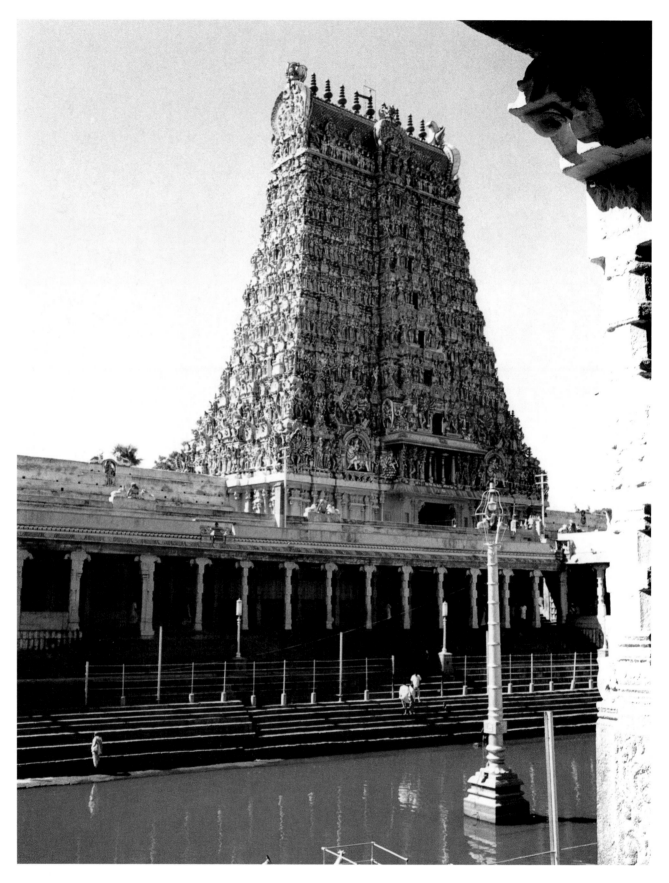

Gopuram of the
Meenakshi temple at
Madurai.

Opposite page:
Gopuram of the
Sarangapani temple at
Kumbakonam.

"... the infinite multiplicity
in the infinite *oneness...*"

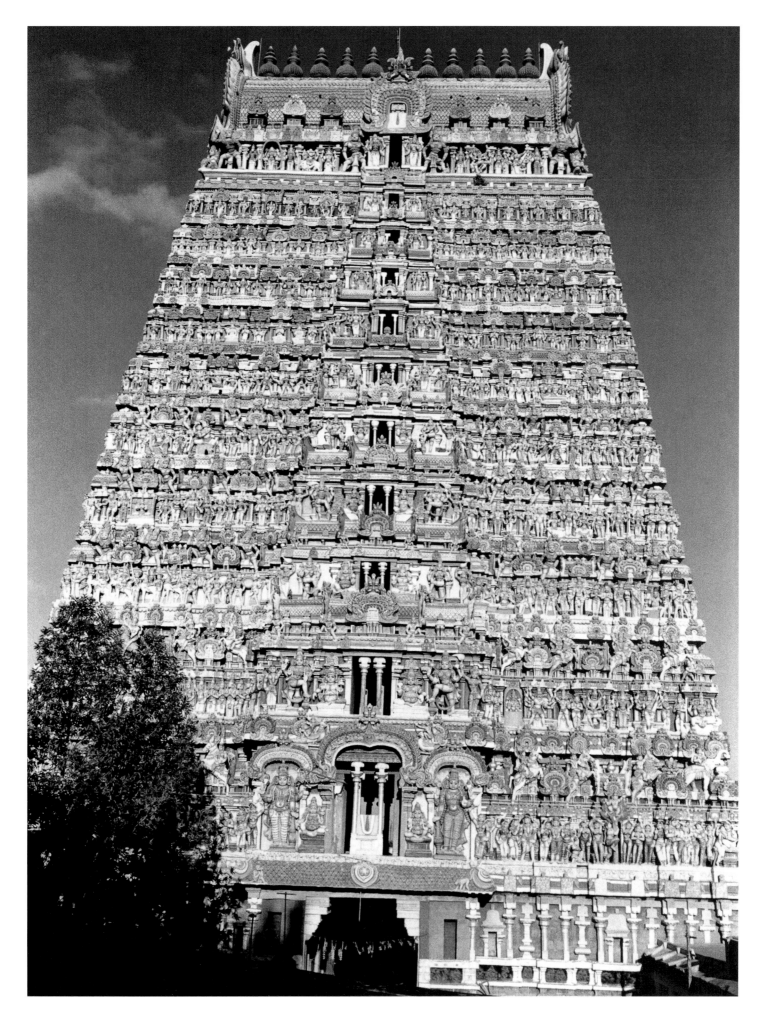

As for the objection in regard to Dravidian architecture to its massiveness and its titanic construction, the precise spiritual effect intended could not be given otherwise; for the infinite, the cosmic seen as a whole in its vast manifestation is titanic, is mighty in material and power. It is other and quite different things also, but none of these are absent from Indian construction. The great temples of the north have often in spite of Mr. Archer's dictum, a singular grace in their power, a luminous lightness relieving their mass and strength, a rich delicacy of beauty in their ornate fullness. It is not indeed the Greek lightness, clarity or naked nobleness, nor is it exclusive, but comes in a fine blending of opposites which is in the very spirit of the Indian religious, philosophical and aesthetic mind.

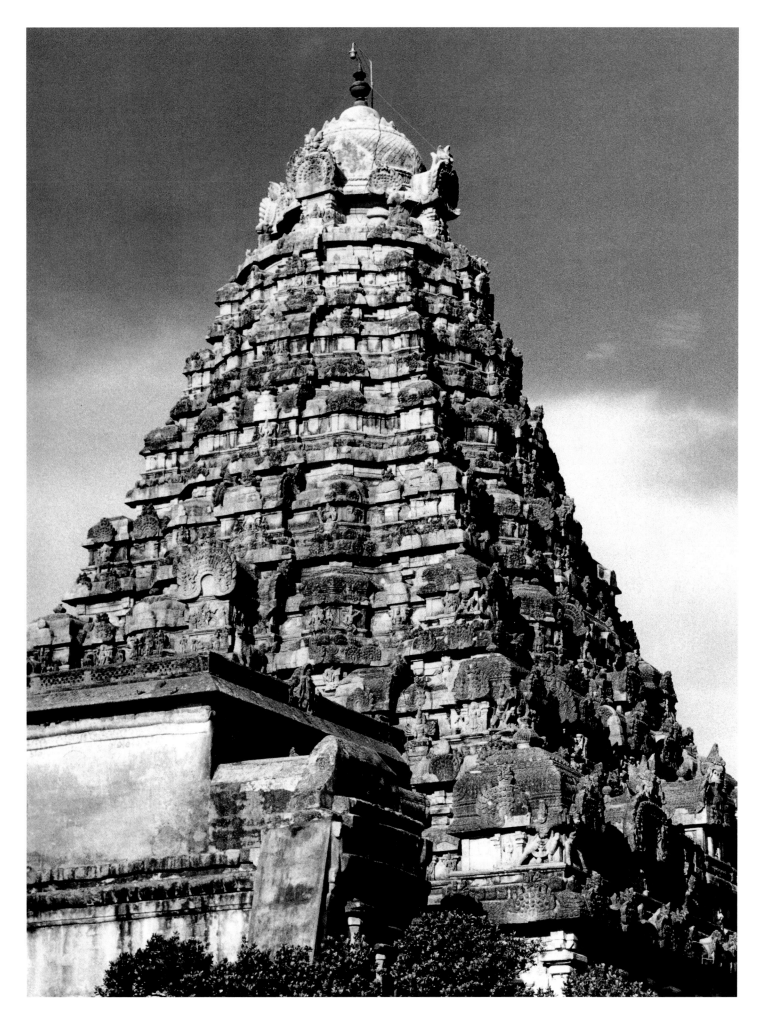

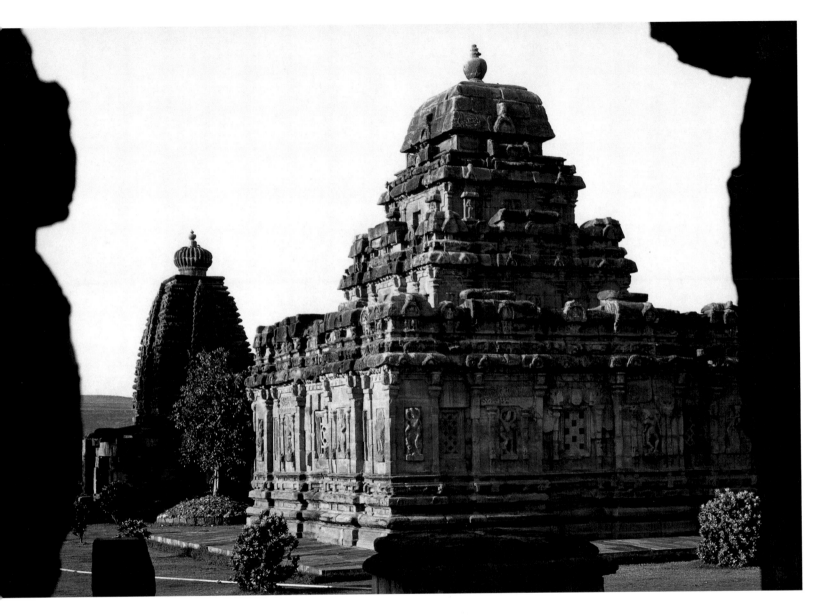

Previous page:
The Brihadeshvara temple at Gangaikondacholapuram, Chola, eleventh century.

"... for the infinite, the cosmic seen as a whole in its vast manifestation is titanic, is mighty in material and power."

The Sangameshvara temple, Dravidian style. Behind it, the Galaganatha temple, North Indian style. Pattadakal, Chalukya dynasty, 8th century.

Opposite page:
Temple at Bijolia, Rajasthan, eleventh century.

"The great temples of the north have often... a singular grace in their power, a luminous lightness..."

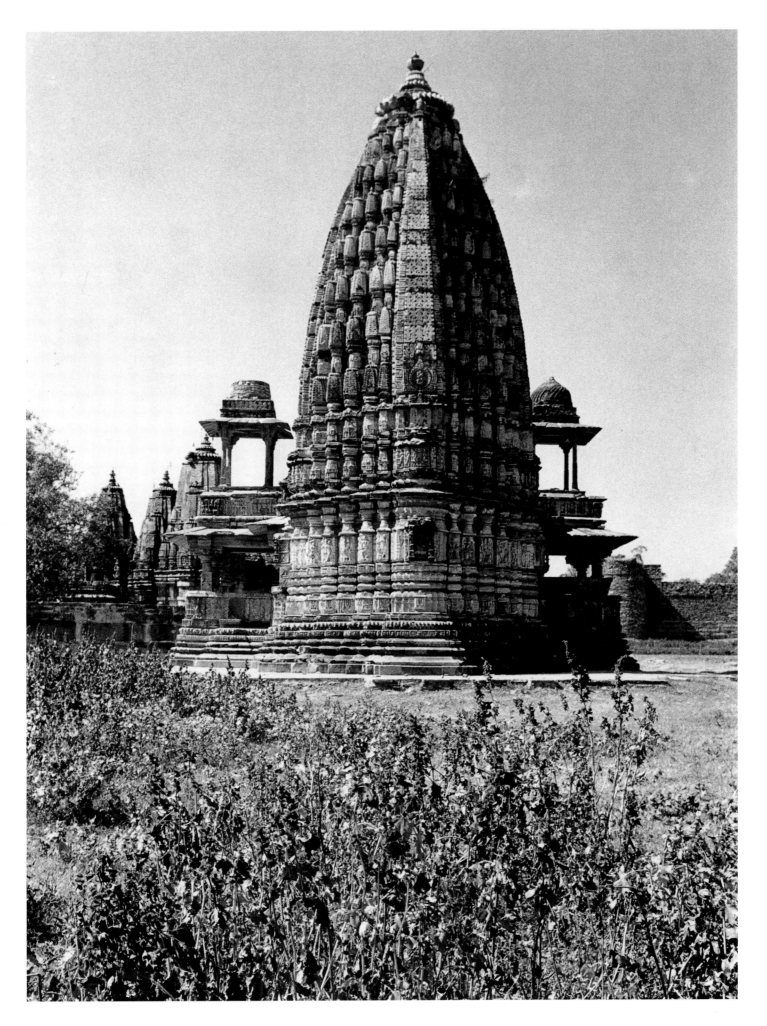

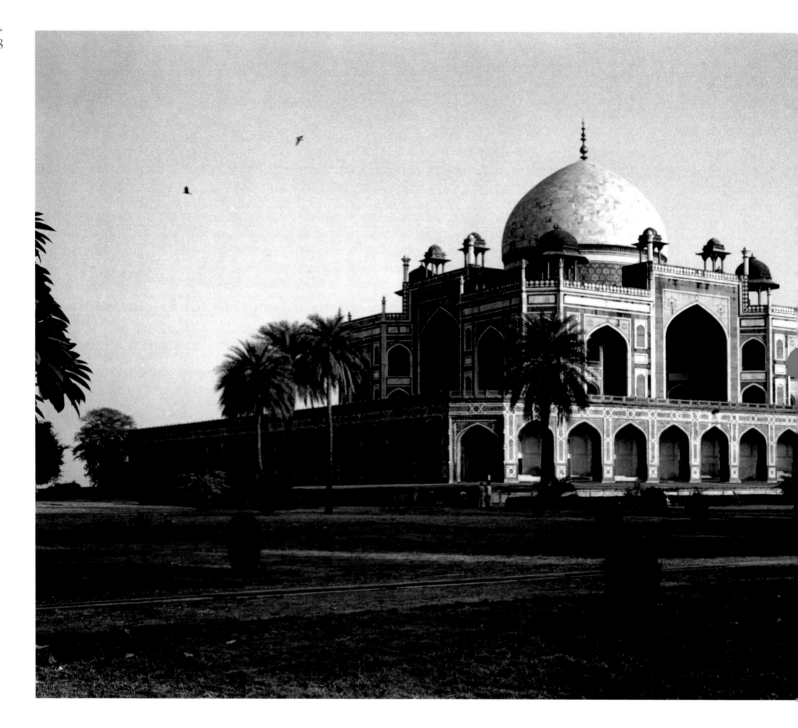

Tomb of Humayun, one of the first Moghul emperors of India, Delhi. Humayun fell to his death, when he hurried down the steps of his library, hearing the call of the *muezzin* (AD 1530). The tomb was built by his widow Haji Begum around 1560.

"...but it is the same skill which we find in the northern Hindu temples..."

...a word too may be said about Indo-Moslem architecture. I am not concerned to defend any claim for the purely indigenous origin of its features. It seems to me that here the Indian mind has taken in much from the Arab and Persian imagination and in certain mosques and tombs I seem to find an impress of the robust and bold Afghan and Moghul temperament; but it remains clear enough that it is still on the whole a typically Indian creation with the peculiar Indian gift. The richness of decorative skill and imagination has been turned to the uses of another style, but it is the same skill which we find in the northern Hindu temples, and in the ground we see, however toned down, something sometimes of the old epic mass and power, but more often that lyric grace which we see developing before the Mahomedan advent in the indigenous sculpture...

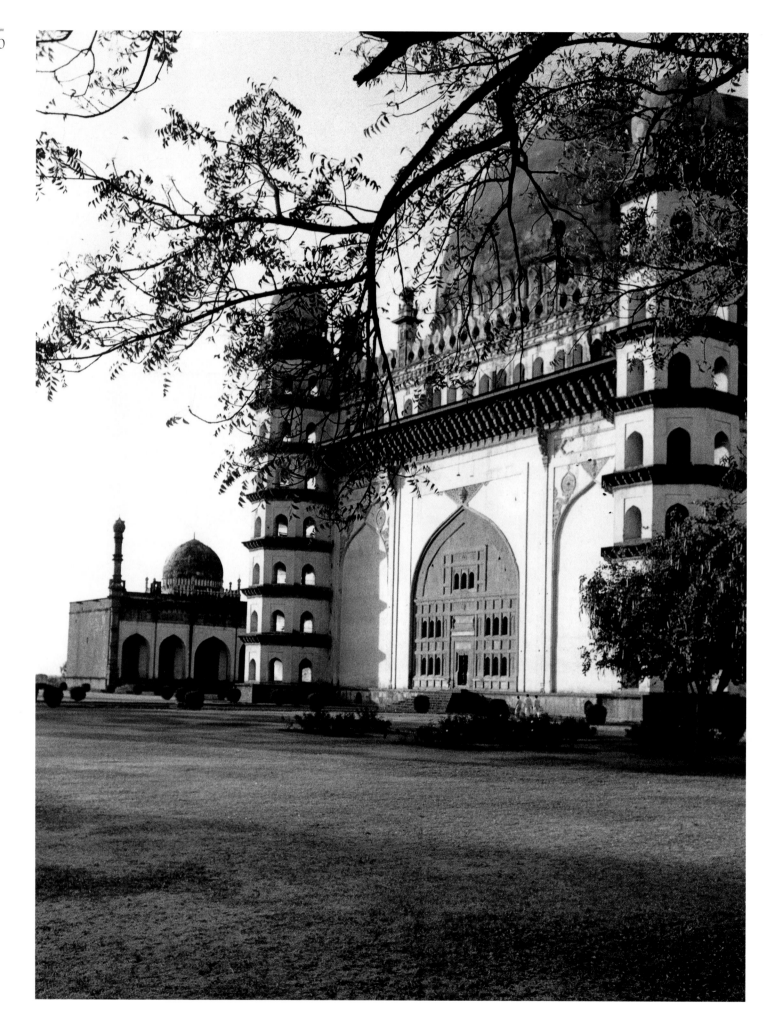

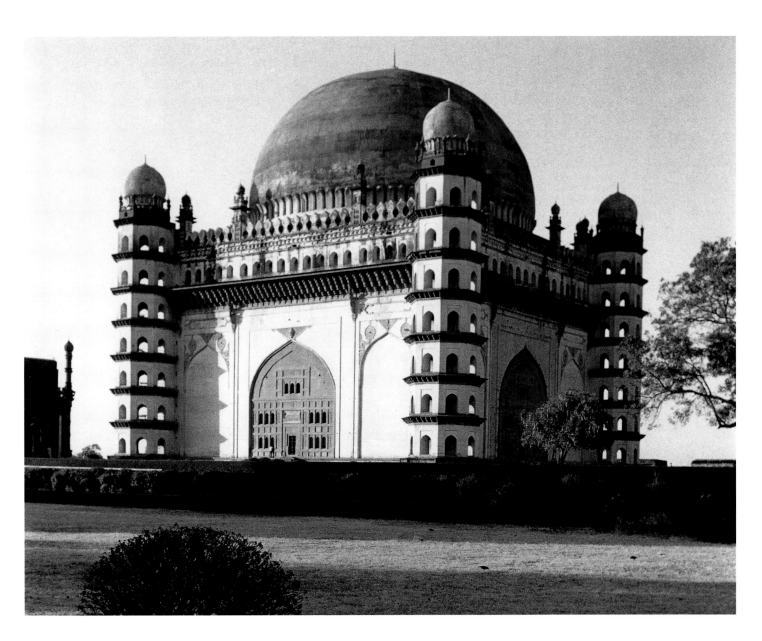

Pages 120-121:
The Gol Gumbaz at
Bijapur, tomb of
Mohammad Adil Shah
(1626-1656). The dome is
said to be second in size
only to St. Peter's in Rome.

"...and in certain mosques
and tombs I seem to find
an impress of the robust
and bold Afghan and
Moghul temperament."

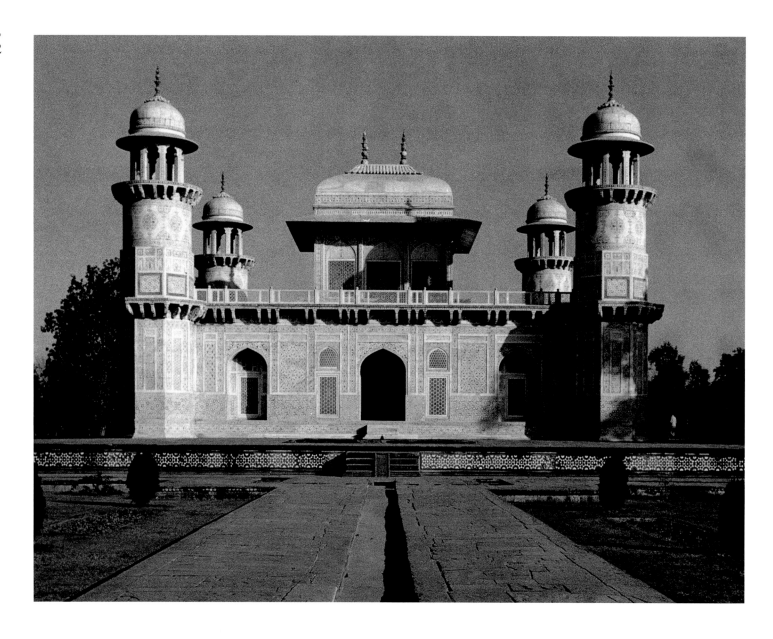

*N*ot rational but magical beauty satisfying and enchanting to some deeper quite suprarational aesthetic soul in us is the inexpressible charm of these creations.

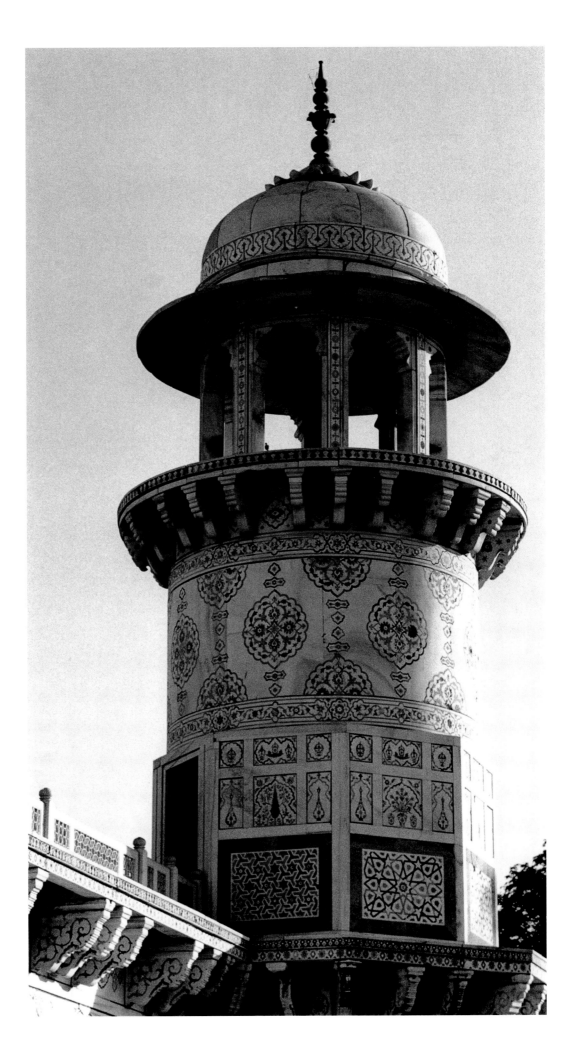

Pages 122-123:
Tomb of Itimad-ud-Daulah, a prominent courtier at the Mughal court. The surface of the building is entirely coated in white marble, inlaid with semi-precious stones (*pietra dura* work). Agra, seventeenth century.

Following page:
The high craftsmanship of this work and the masterly perforated stone-windows (*jalis*) makes it the most lavishly decorated building of the Mughal period.

"Not rational but magical beauty... is the inexpressible charm of these creations."

The Taj is not merely a sensuous reminiscence of an imperial amour or a fairy enchantment hewn from the moon's lucent quarries, but the eternal dream of a love that survives death. The great mosques embody often a religious aspiration lifted to a noble austerity which supports and is not lessened by subordinated ornament and grace. The tombs reach beyond death to the beauty and joy of Paradise. The buildings of Fatehpur-Sikri are not monuments of an effeminate luxurious decadence, – an absurd description for the mind of the time of Akbar, – but give form to a nobility, power and beauty which lay hold upon but do not wallow on the earth. There is not here indeed the vast spiritual content of the earlier Indian mind, but it is still an Indian mind which in these delicate creations absorbs the West Asian influence, and lays stress on the sensuous as before in the poetry of Kalidasa, but uplifts it to a certain immaterial charm, rises often from the earth without quite leaving it into the magical beauty of the middle world and in the religious mood touches with a devout hand the skirts of the Divine. The all-pervading spiritual obsession is not there, but other elements of life not ignored by Indian culture and gaining on it since the classical times are here brought out under a new influence and are still penetrated with some radiant glow of a superior lustre.

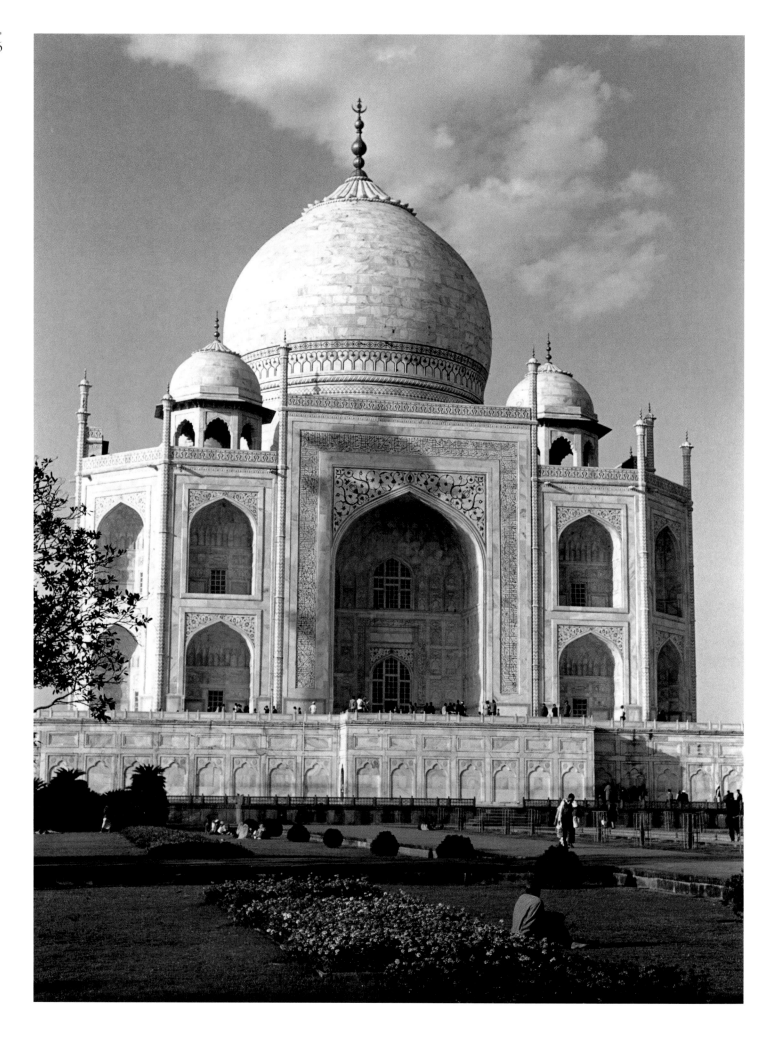

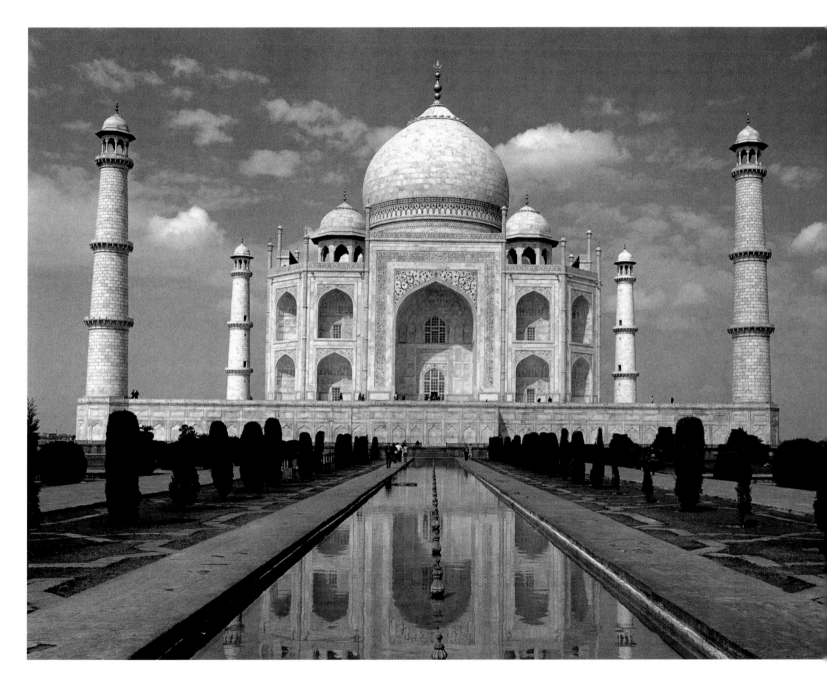

Pages 126-127:
The Taj Mahal at Agra,
tomb of Mumtaz Mahal,
wife of Emperor Shah
Jahan, surpasses all other
architectural
achievements of the
Mughal time by its
ethereal beauty.
Seventeenth century.

"... the eternal dream of
love that survives death."

Following pages:
The interior of the Moti
Masjid or Pearl Mosque
at Agra with its lofty
arches is much admired
for its clear design.
Seventeenth century.

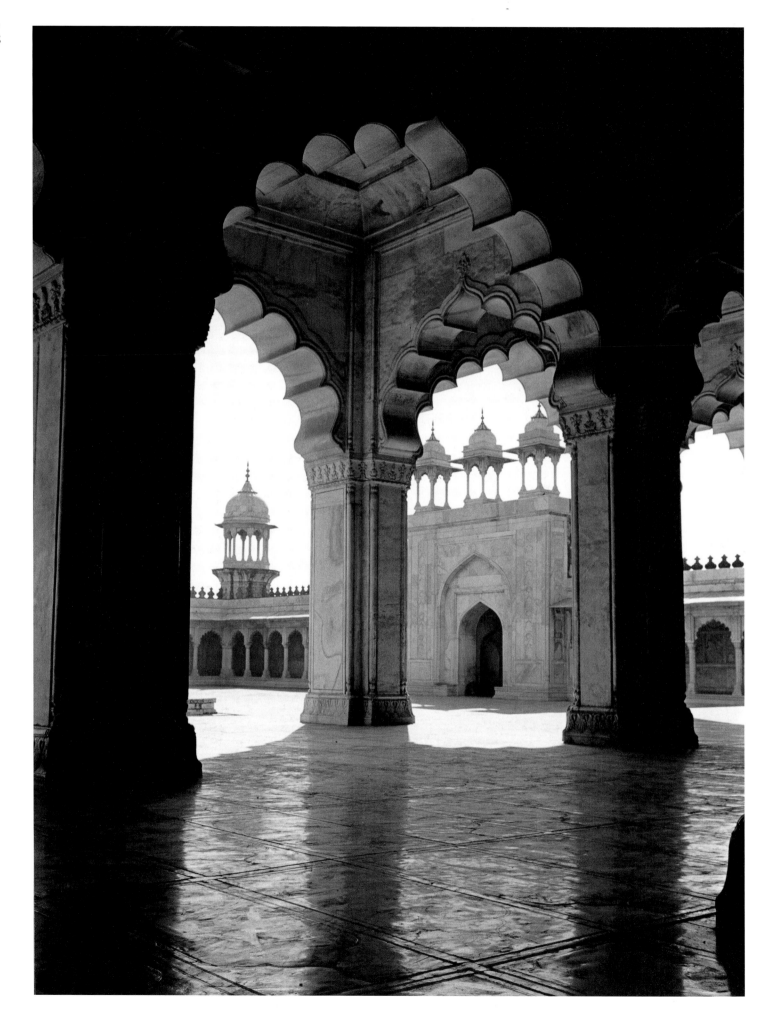

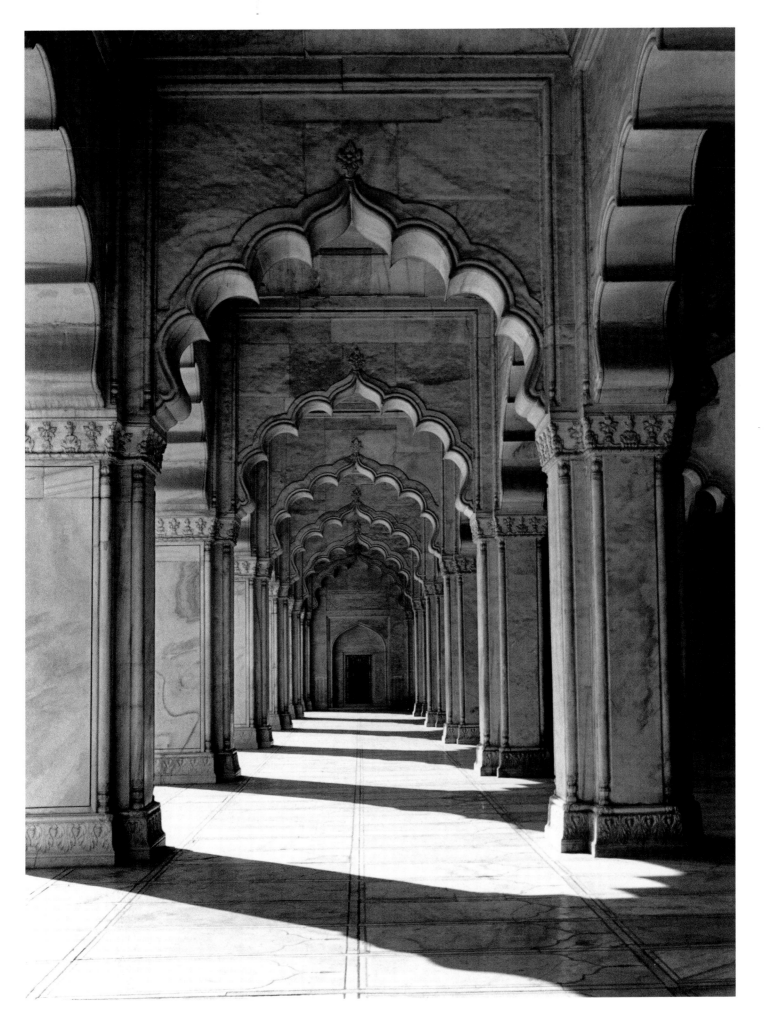

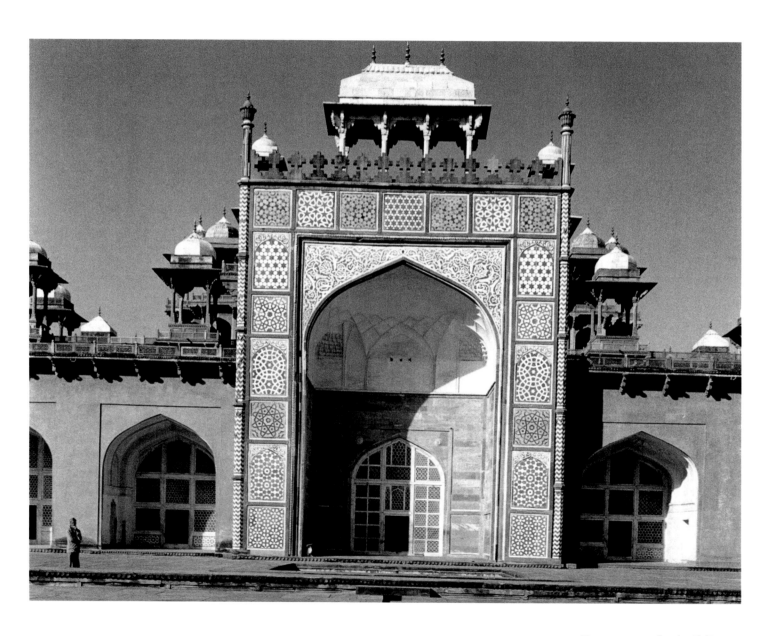

Entrance to the building
which houses the tomb of
Emperor Akbar at
Sikandra, near Agra.
Seventeenth century.

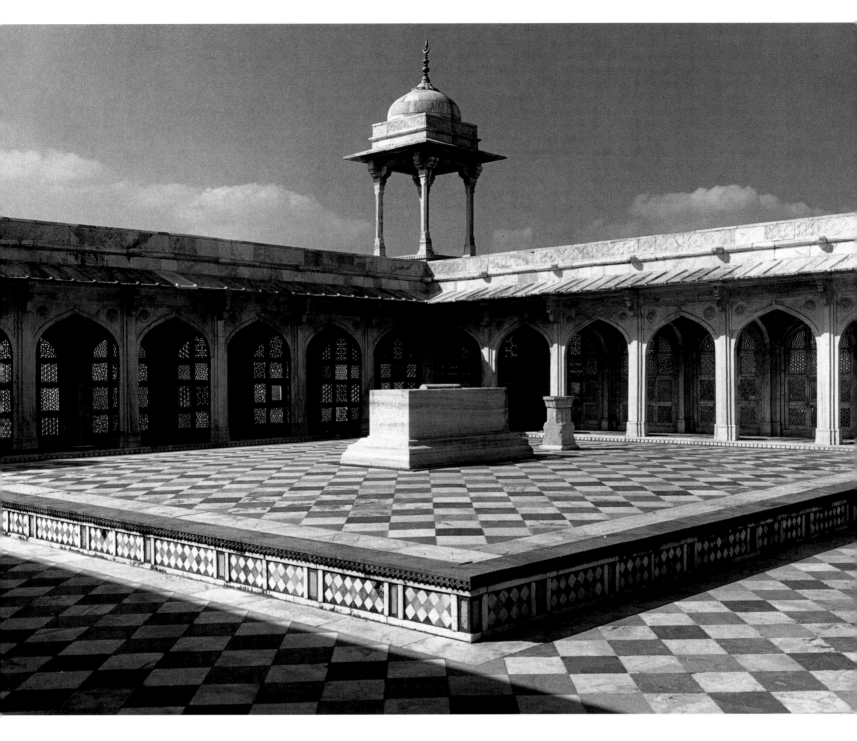

The courtyard on top of it has, at its centre, a simple cenotaph open to the sky, whereas Akbar's remains are placed far below it in a crypt beneath the building.

"...and in the religious mood touches with a devout hand the skirts of the Divine."

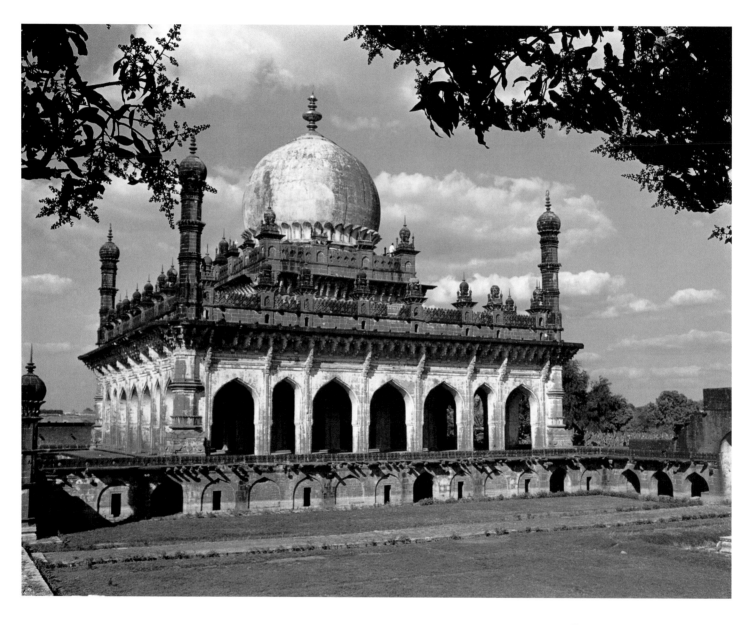

Pages 132-133:
Tomb and mosque of
Ibrahim Adil Shah II,
called the 'Ibrahim
Rauza'. Bijapur.
Seventeenth century.

"The tombs reach beyond
death to the beauty and
joy of paradise."

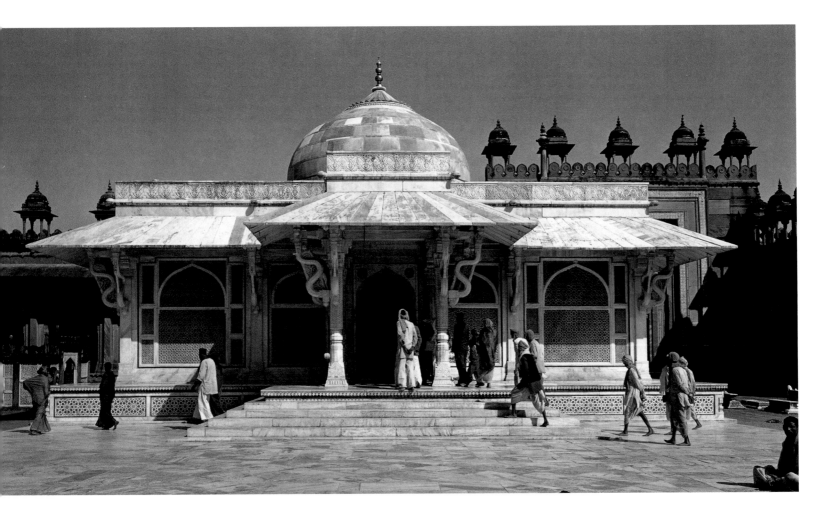

The graceful tomb of
Shaikh Salim Chishti. It
is famous for its fine
perforated window
screens in white marble.
Fatehpur Sikri.

Excerpts from
Indian Art 3
Sculpture

... the sculpture of ancient and mediaeval India claims its place on the very highest levels of artistic achievement. I do not know where we shall find a sculptural art of a more profound intention, a greater spirit, a more consistent skill of achievement. Inferior work there is, work that fails or succeeds only partially, but take it in its whole, in the long persistence of its excellence, in the number of its masterpieces, in the power with which it renders the soul and the mind of a people, and we shall be tempted to go further and claim for it a first place. The art of sculpture has indeed flourished supremely only in ancient countries where it was conceived against its natural background and support, a great architecture.

An assured history of two millenniums of accomplished sculptural creation is a rare and significant fact in the life of a people.

This greatness and continuity of Indian sculpture is due to the close connection between the religious and philosophical and the aesthetic mind of the people. Its survival into times not far from us was possible because of the survival of the cast of the antique mind in that philosophy and religion, a mind familiar with eternal things, capable of cosmic vision, having its roots of thought and seeing in the profundities of the soul, in the most intimate, pregnant and abiding experiences of the human spirit.

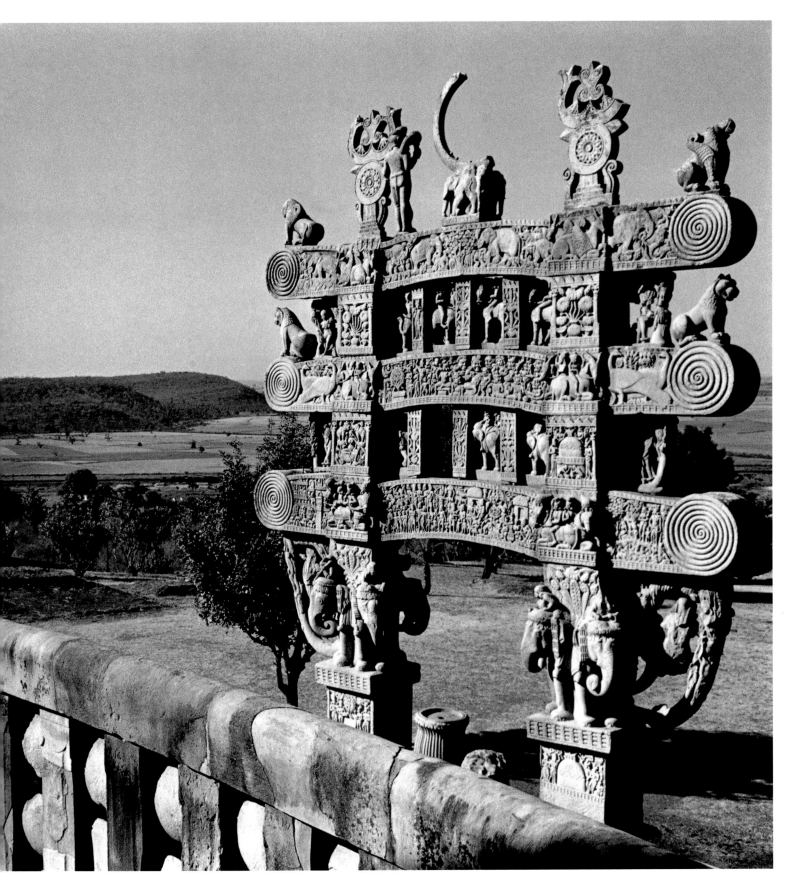

Stupa of Sanchi, northern gateway
with balustrade around the upper
pradaksina or circumambulatory
path, overlooking a wide
landscape. Satavahana dynasty,
2nd-1st century BC.

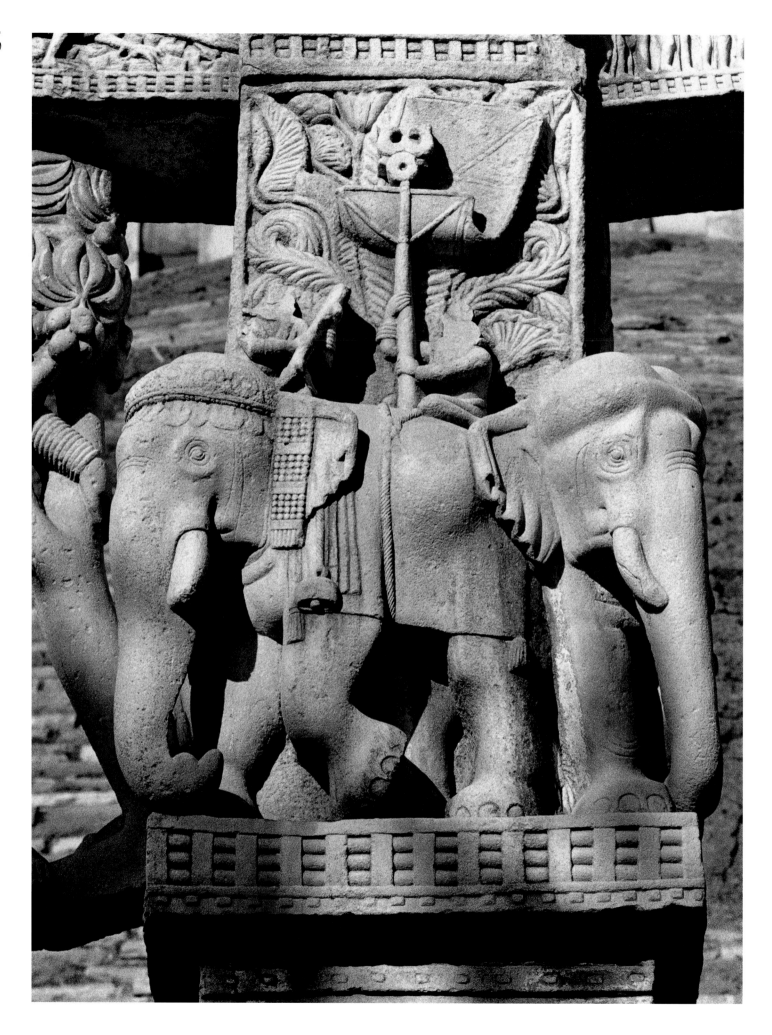

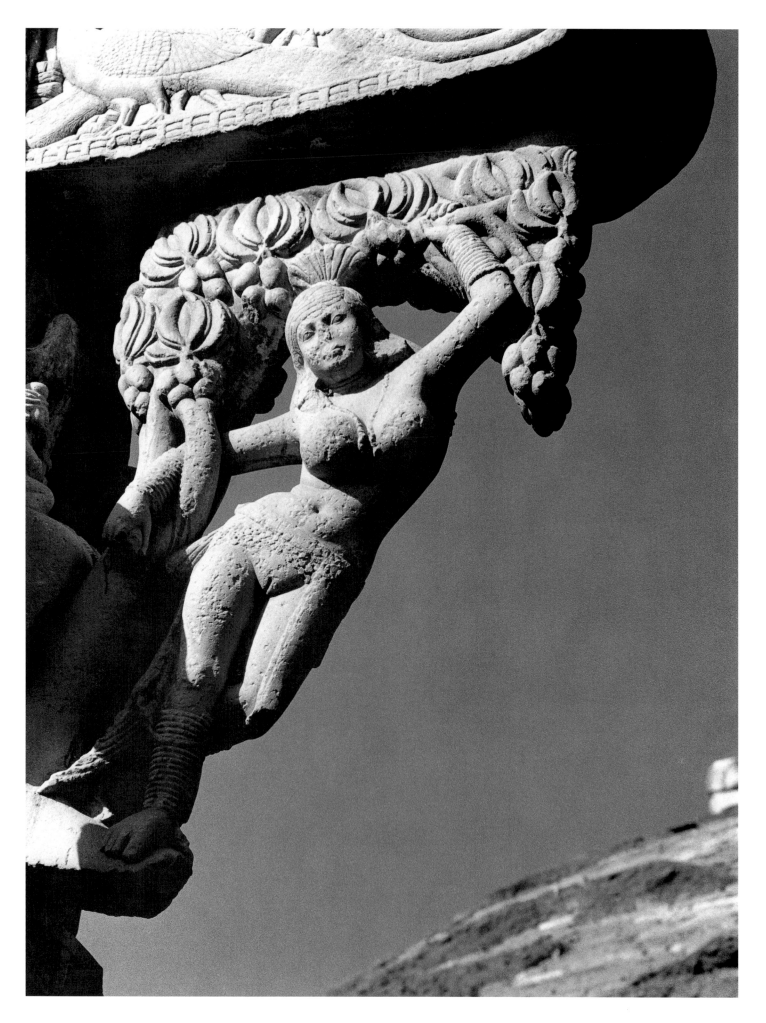

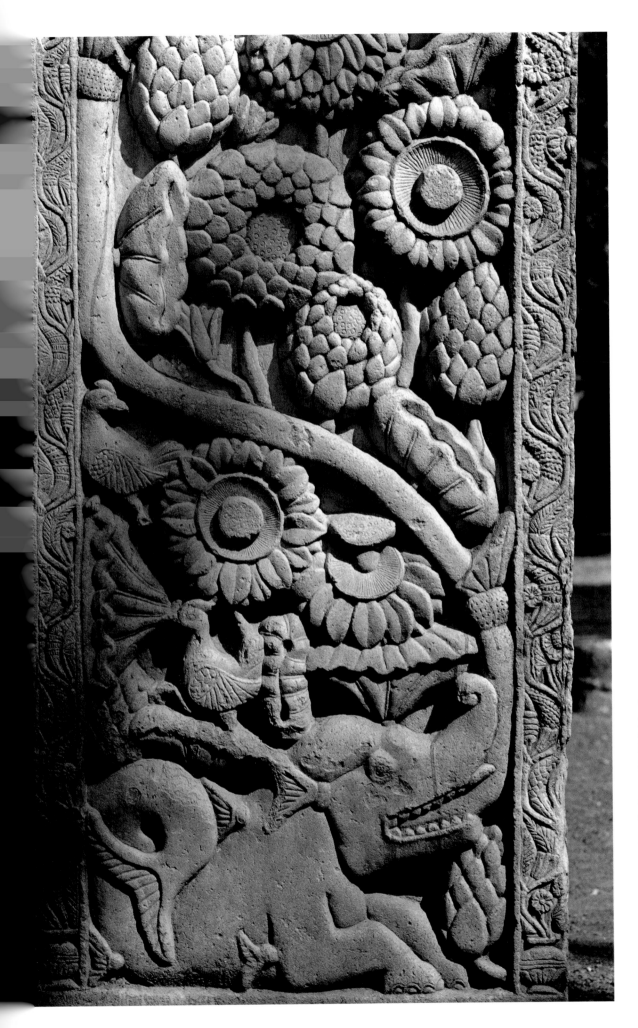

Previous pages:
Left
Elephants with standard
bearers, eastern gateway,
Stupa of Sanchi.

Right:
Salabhanjika or *yakshi*
(tree-goddess), holding the
branch of a *kalpavriksa*
or wish-fulfilling tree.
Stupa of Sanchi.

Lotus-pond with *makara*,
a mythological animal
associated with water.
Detail. Jamb of eastern
gateway, Stupa of Sanchi.

The material in which we work makes its own peculiar demand on the creative spirit, lays down its own natural conditions... and the art of making in stone or bronze calls for a cast of mind which the ancients had and the moderns have not or have had only in rare individuals, an artistic mind not too rapidly mobile and self-indulgent, not too much mastered by its own personality and emotion and the touches that excite and pass, but founded rather on some great basis of assured thought and vision, stable in temperament, fixed in its imagination on things that are firm and enduring. One can not trifle with ease in this sterner material, one cannot even for long or with safety indulge in them in mere grace and external beauty or the more superficial, mobile and lightly attractive motives. The aesthetic self-indulgence which the soul of colour permits and even invites, the attraction of the mobile play of life to which line of brush, pen or pencil gives latitude, are here forbidden or, if to some extent achieved, only within a line of restraint to cross which is perilous and soon fatal. Here grand or profound motives are called for, a more or less penetrating spiritual vision or some sense of things eternal to base the creation.

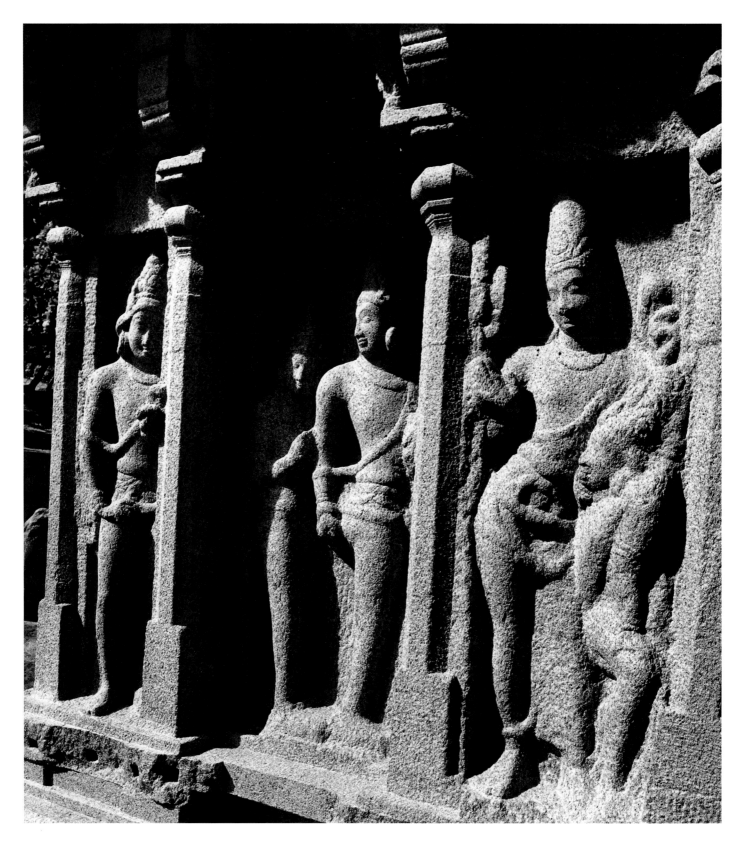

Sculptural panel on the northern façade of the Arjuna Ratha showing a 'princely doorkeeper', a royal couple and Vishnu mounting his *vahana* or vehicle, Garuda. Mamallapuram, Pallava dynasty, 7th-8th century.

Opposite page:
Detail of the 'princely doorkeeper'. Sri Aurobindo remarked on this particular figure in the first issue of the art-magazine 'Rupam'.

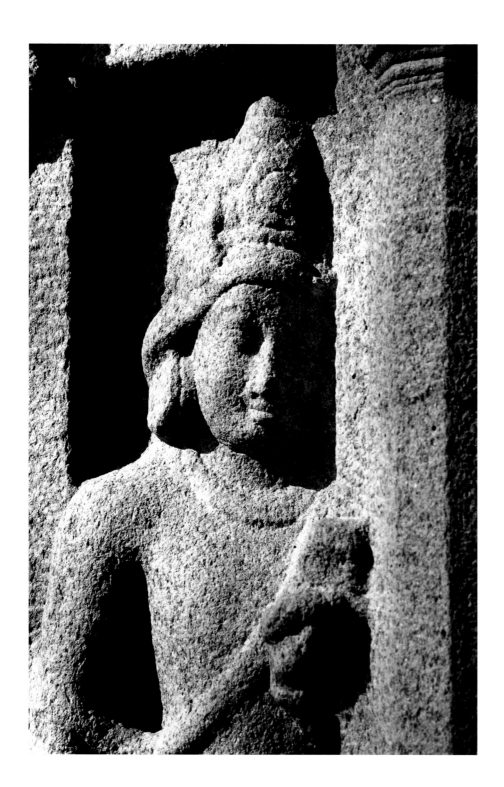

"This example from one of the great styles and periods shows, as is justly said, and shows very perfectly, the Indian principle in the treatment of the human figure, the suppression of small particulars and trivial details in order to secure an extreme simplicity of form and contour, – the best condition for accomplishing the principal object of the Indian sculptor which was to fill the form with the utmost power of spiritual force and significance. The figure of this princely doorkeeper of the temple in its union of calm, grave, sweet and restful serenity with a latent and restrained heroic energy in its stillness...is indeed equal... in its dignity and repose to any Greek statue, but it carries in it a more profound and potent meaning; it is a perfect interpretation of the still and intense Godward feeling, seized in one deep mood, in one fixed moment of it, which was the soul of the great ages of Indian religion."

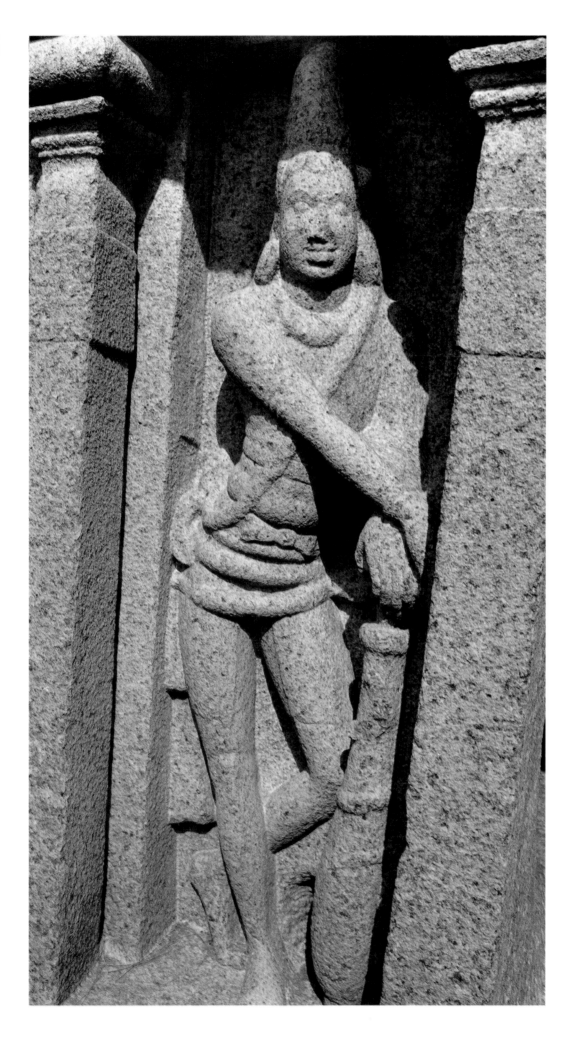

Davarapala or doorkeeper, guarding the entrance of the shrine in the 3rd floor of the Dharmaraja Ratha, Mamallapuram, Pallava.

Opposite page:
Girl carrying a food-offering to the shrine. Dharmaraja Ratha, Mamallapuram. Pallava.

"...and the art of making in stone or bronze calls for a cast of mind which the ancients had and the moderns have not..."

Following pages:
Sculptural panel on the southern façade of the Arjuna Ratha with doorkeepers and royal couples; in the centre niche Shiva, leaning on his bull, Nandi. Mamallapuram, Pallava.

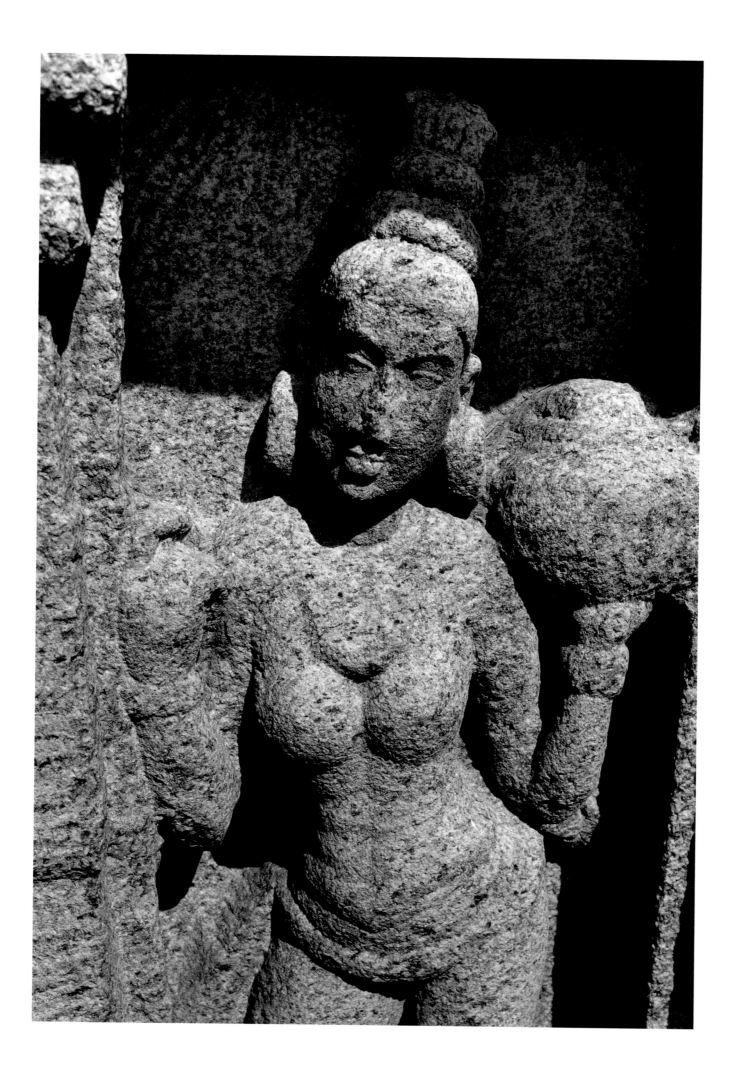

The sculptural art is static, self-contained, necessarily firm, noble or severe and demands an aesthetic spirit capable of these qualities.

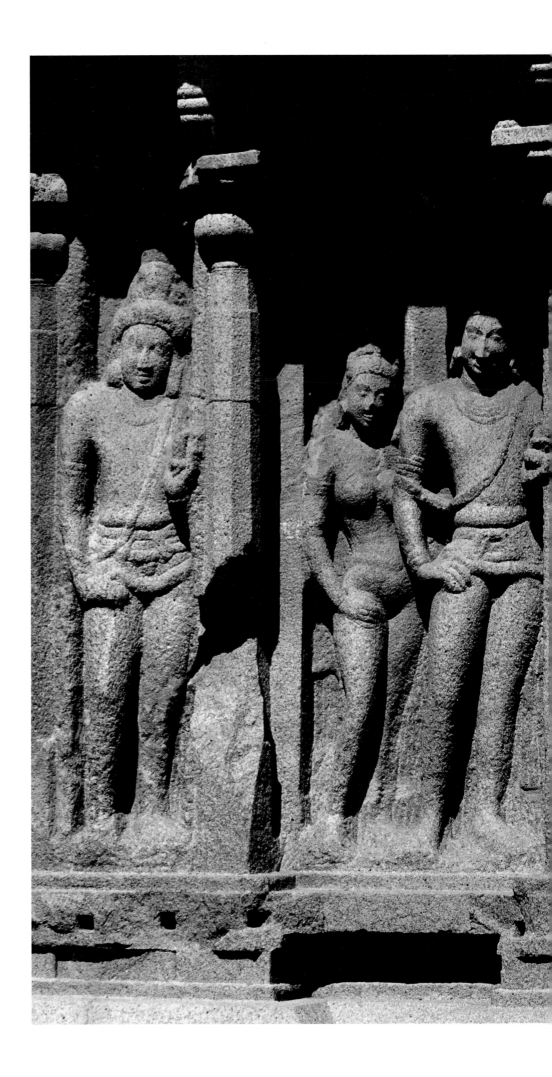

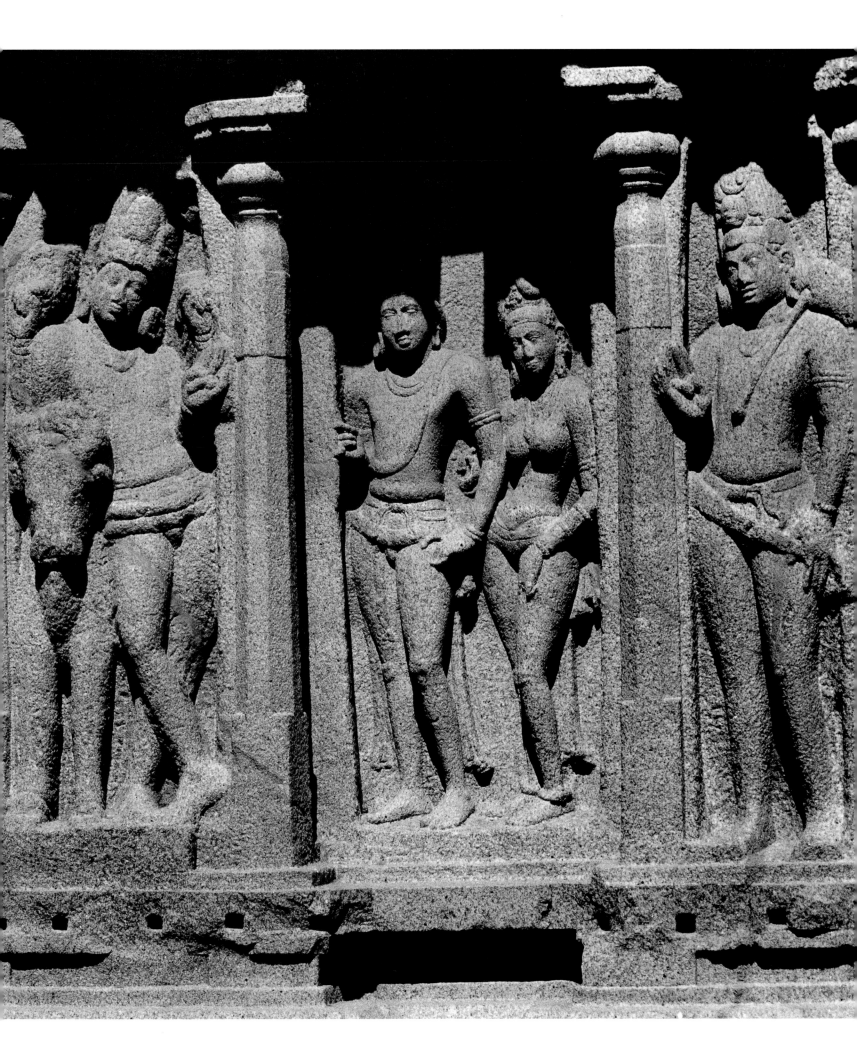

A certain mobility of life and mastering grace of line can come in upon this basis, but if it entirely replaces the original Dharma of the material, that means that the spirit of the statuette has come into the statue and we may be sure of an approaching decadence.

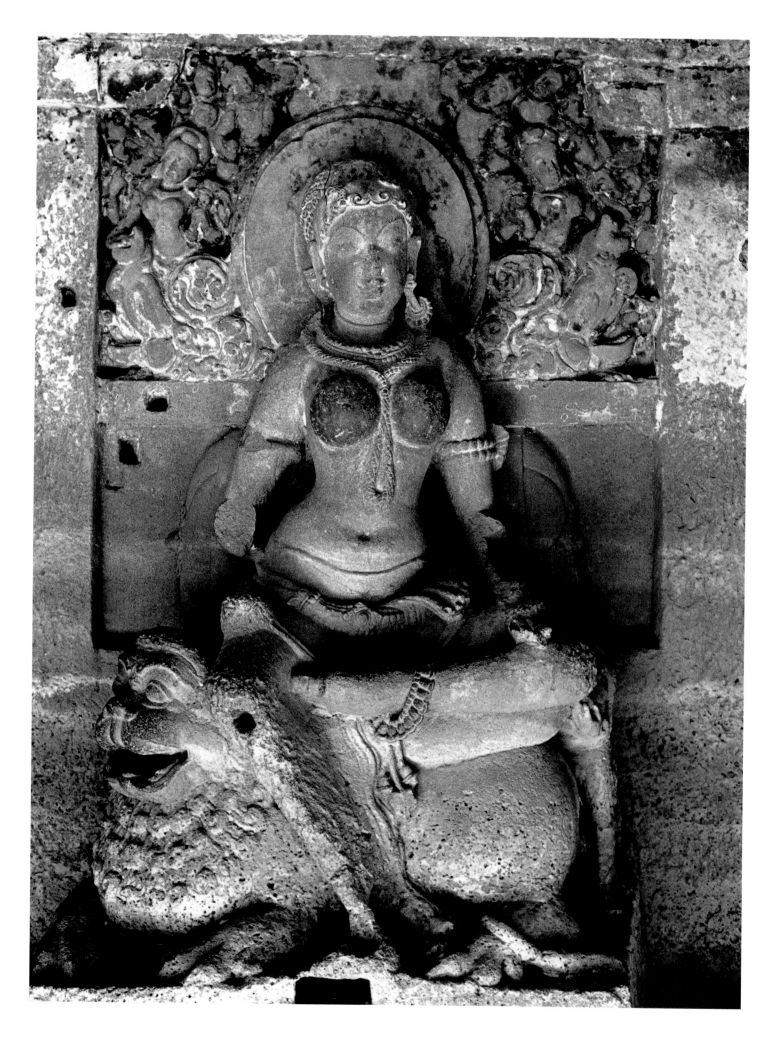

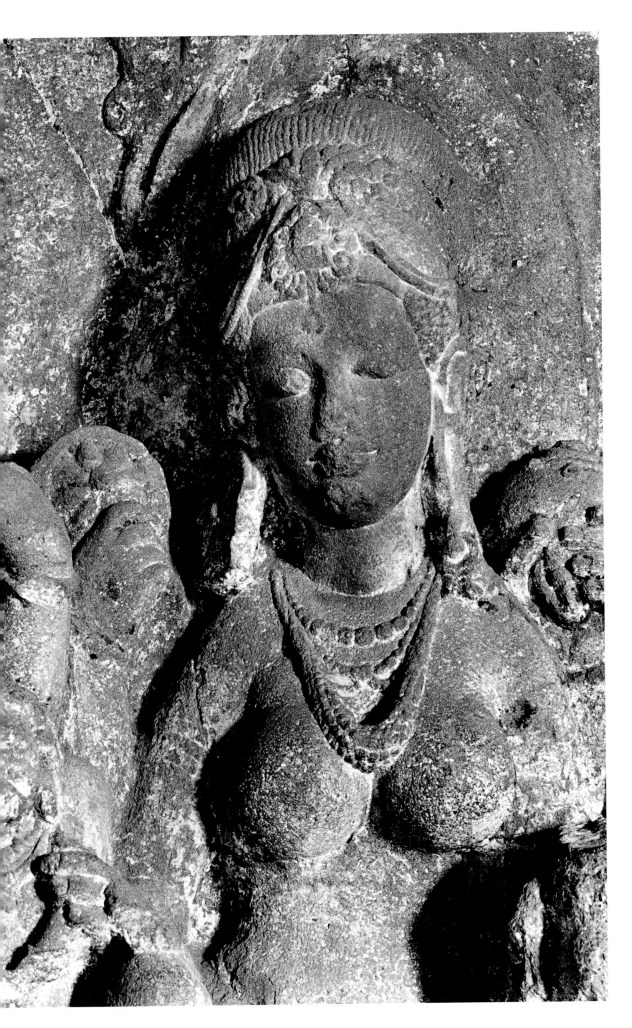

Previous page:
Indrani on her lion. Indra Sabha cave temple, Ellora. 8th century.

Parvati watching the dance of her Lord, Shiva. Ellora, Rameshvara cave temple, Vakataka dynasty, 6th-7th century.

Opposite page:
The same motif further south at the Kailasanatha temple, Kanchipuram. Pallava dynasty, 8th century.

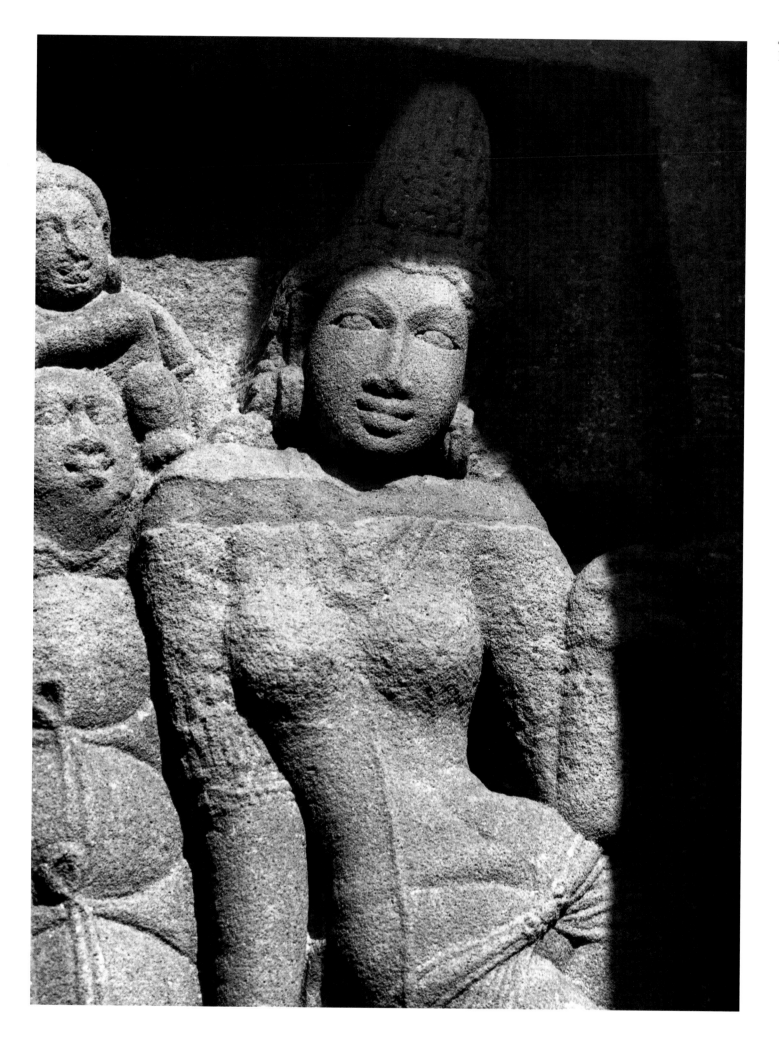

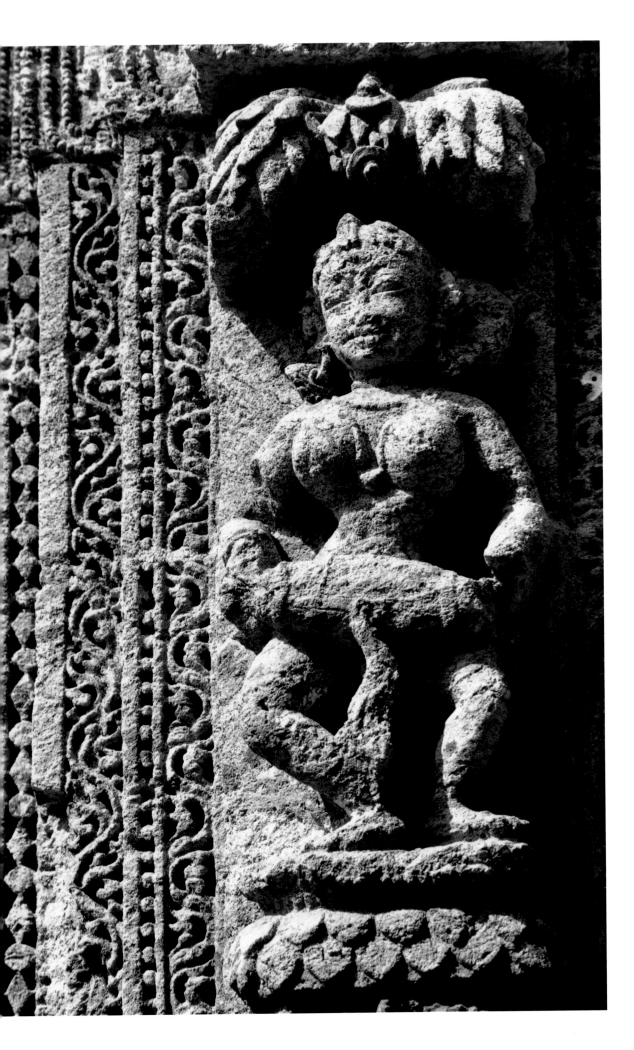

Young musician, dancing
to the beat of her drum.
Natamandapa, Sun
Temple of Konarak,
Ganga dynasty,
thirteenth century.

Opposite page:
Kanya or damsel, holding
the branch of a tree in a
graceful pose.
Mukteshvara temple,
Bhubaneshvar,
tenth-eleventh century.

"...the spirit of the
statuette has come into
the statue..."

Page 157:
Shiva, leaning lovingly on
his bull Nandi, the
personification of pure
bhakti. Detail.
Dharmaraja Ratha,
Mamallapuram, Pallava.

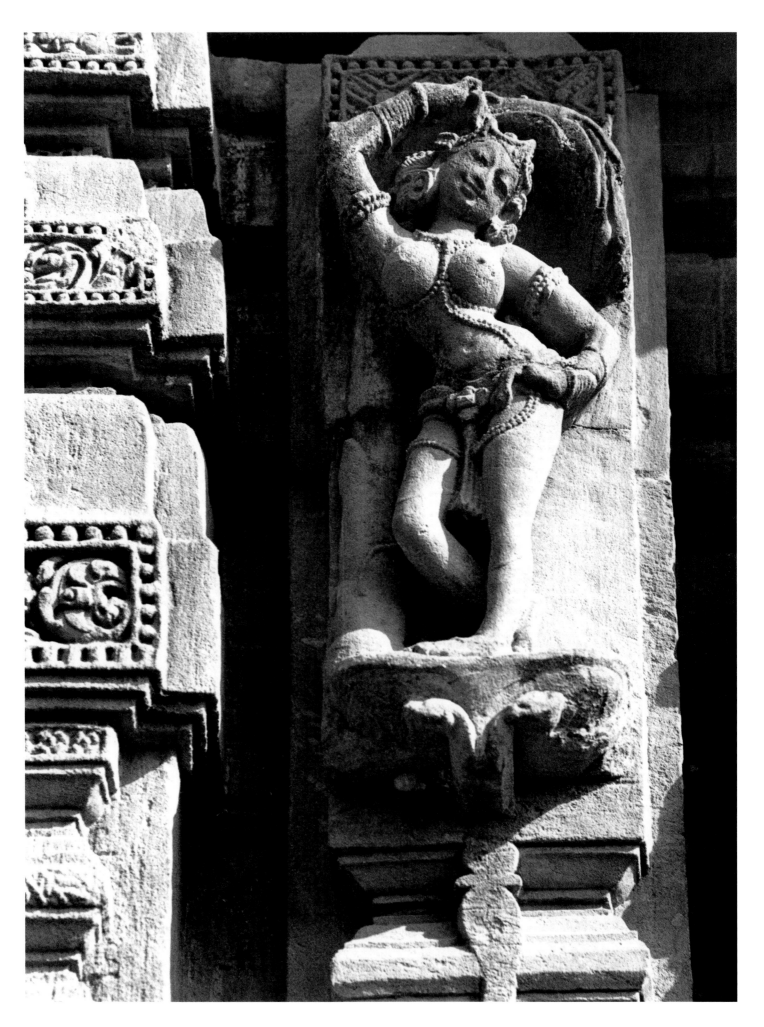

And it is surely time for us to see, as is now by many admitted, that an acknowledgement of the greatness of Greek art in its own province ought not to prevent the plain perception of the rather strait and narrow bounds of that province. What Greek sculpture expressed was fine, gracious and noble, but what it did not express and could not by the limitations of its canon hope to attempt, was considerable, was immense in possibility, was that spiritual depth and extension which the human mind needs for its larger and deeper self-experience. And just this is the greatness of Indian sculpture that it expresses in stone and bronze what the Greek aesthetic mind could not conceive or express and embodies it with a profound understanding of its right conditions and a native perfection.

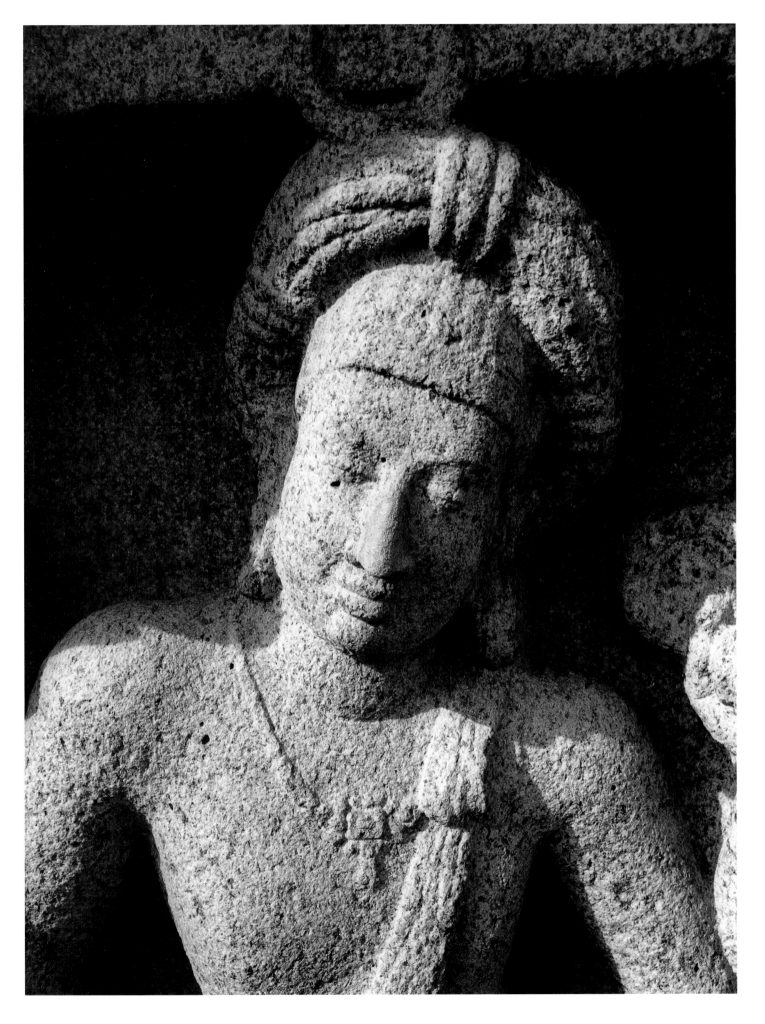

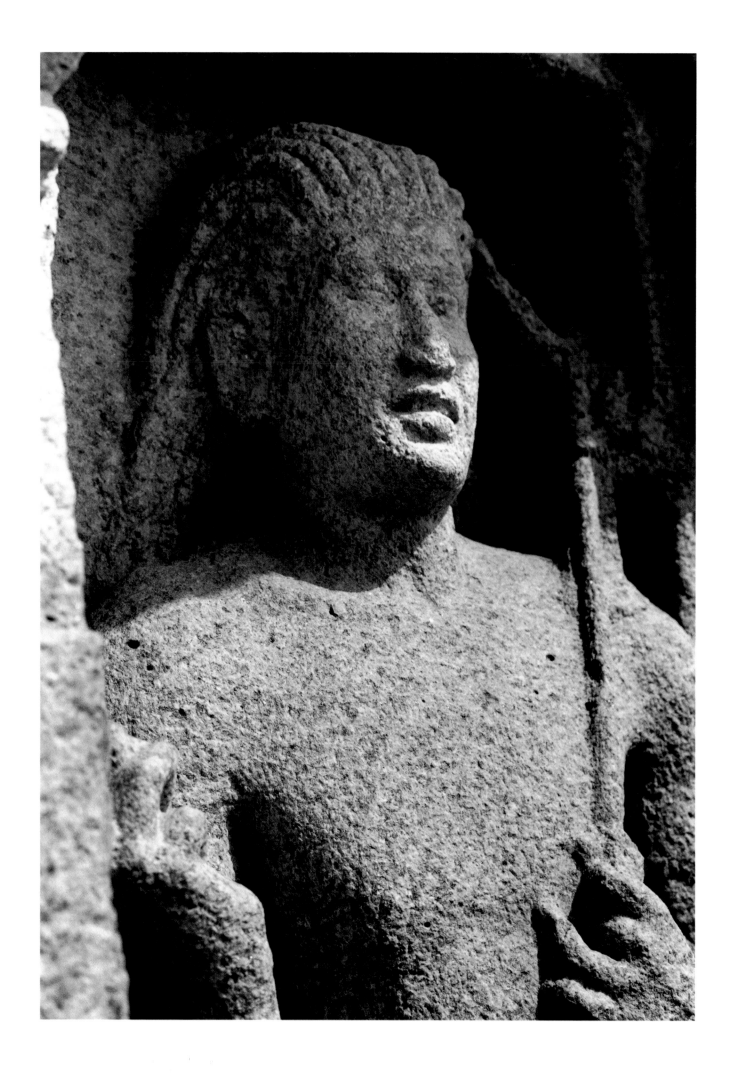

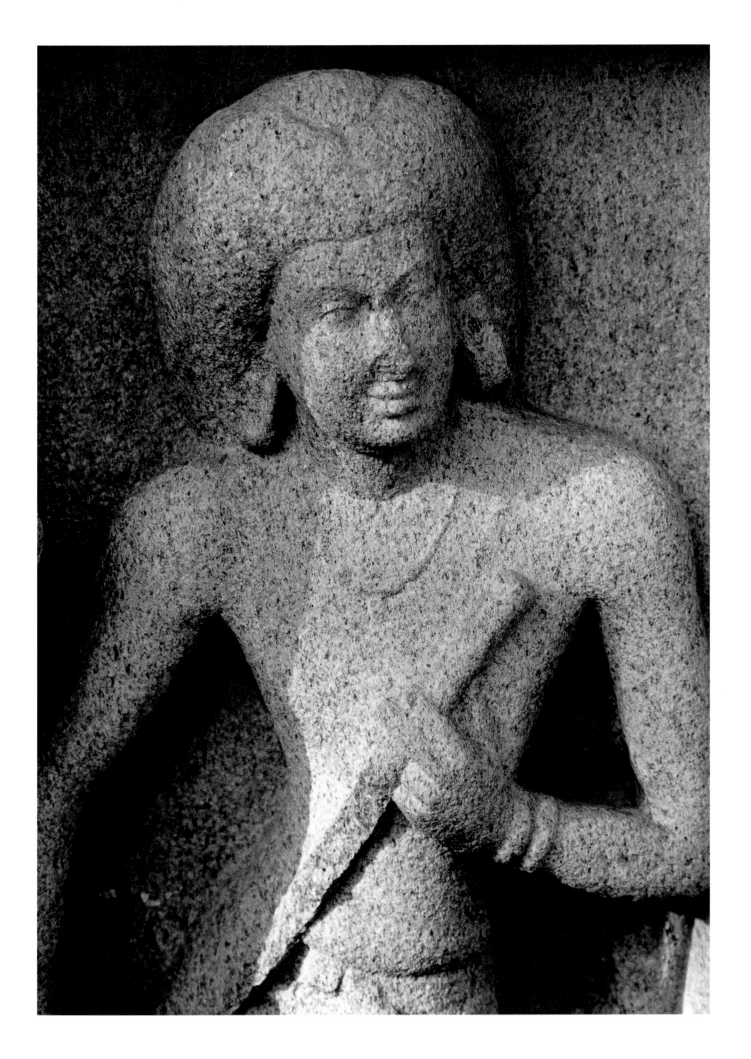

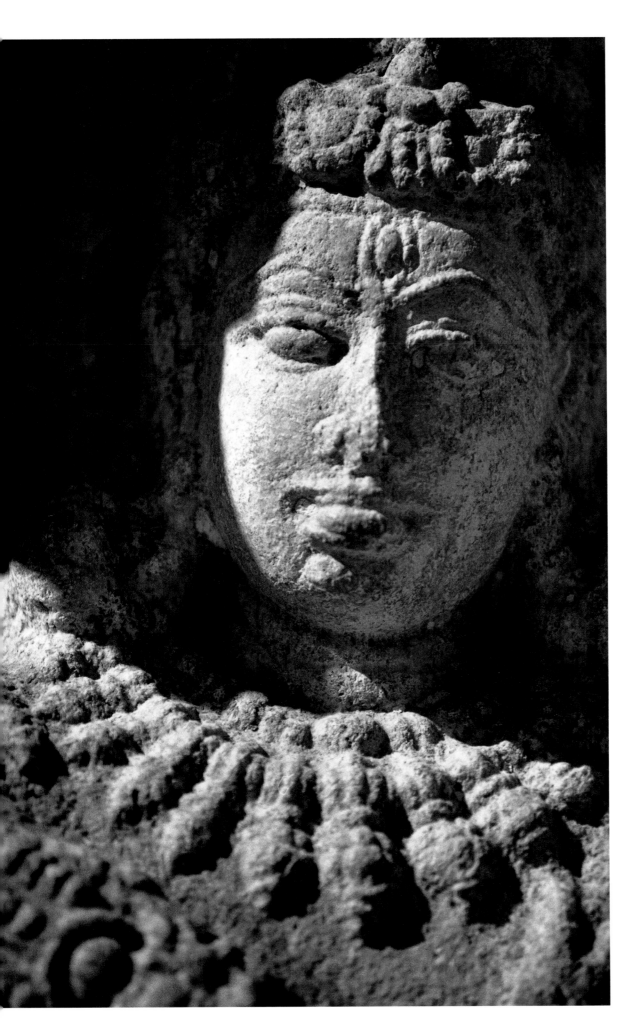

Previous pages:
Left
An enraptured bard or *stavaka*, singing hymns in praise of God. Dharmaraja Ratha, Mamallapuram, Pallava. 7th century.

Right
Shiva Vinadhara, listening to the strains of his *veena*. Dharmaraja Ratha, Mamallapuram, Pallava, 7th century.

Detail of a Shiva Nataraja, absorbed in the rhythms of his dance. Aralguppe, Nolamba dynasty, tenth century.

This sculpture like the architecture springs from spiritual realisation, and what it creates and expresses at its greatest is the spirit in form, the soul in body, this or that living soul-power in the divine or the human, the universal and cosmic individualised in suggestion but not lost in individuality, the impersonal supporting a not too insistent play of personality, the abiding moments of the eternal, the presence, the idea, the power, the calm or potent delight of the spirit in its action and creations.

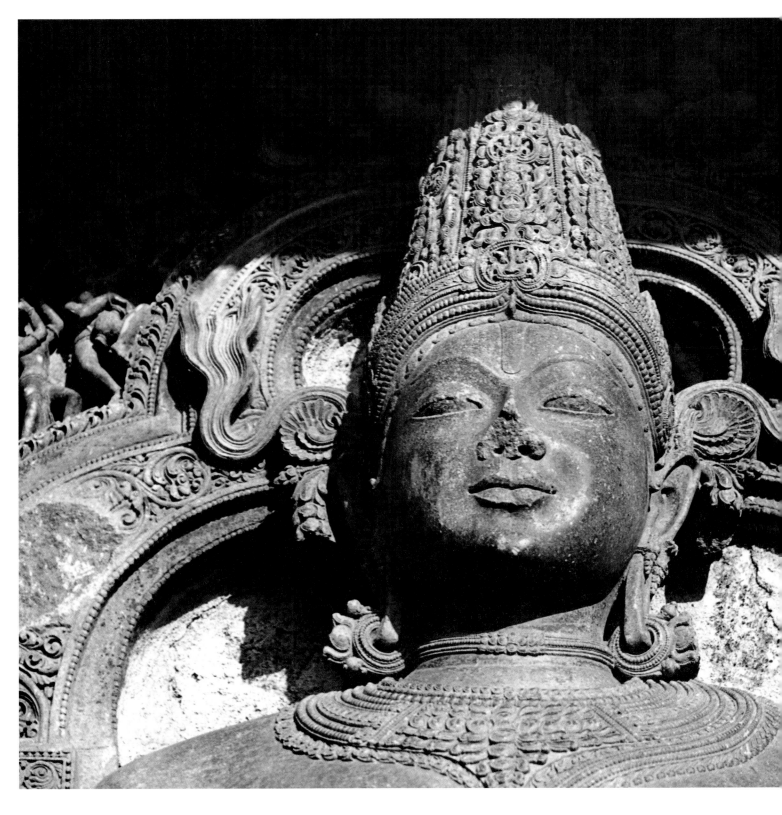

The Sun God Pushan.
Detail. Sun Temple of
Konarak, Ganga dynasty,
thirteenth century.

"..this sculpture like the
architecture springs from
spiritual realisation..."

Opposite page:
Head priest of the
Sun Temple, worshipping
the Sun God.

"What these artists strive always to express is the soul and those pure and absolute states of the mind and heart in which the soul manifests its essential being void of all that is petty, transient, disturbed and restless. In their human figures it is almost always devotion that is manifested; for this in the Shaiva and Vaishnava religions is the pure state of the soul turned towards God."

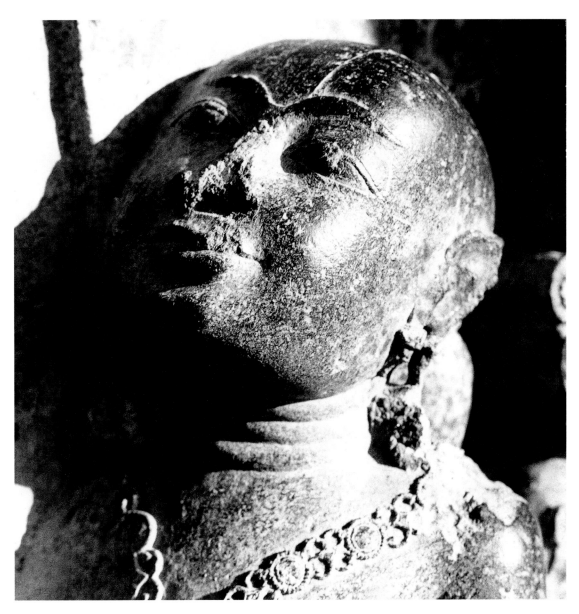

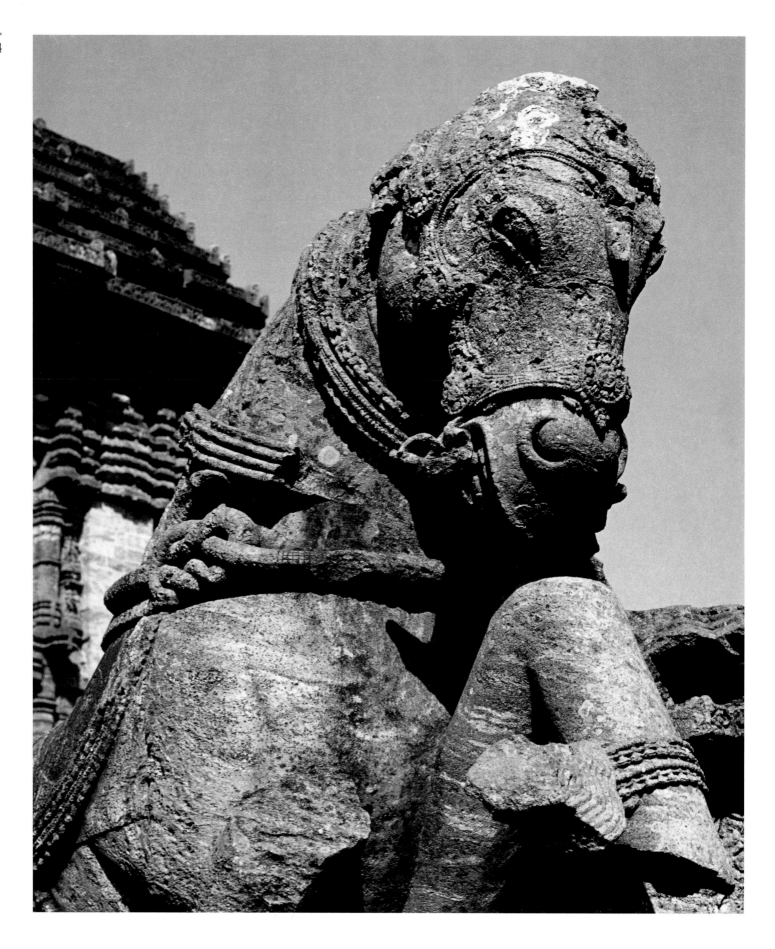

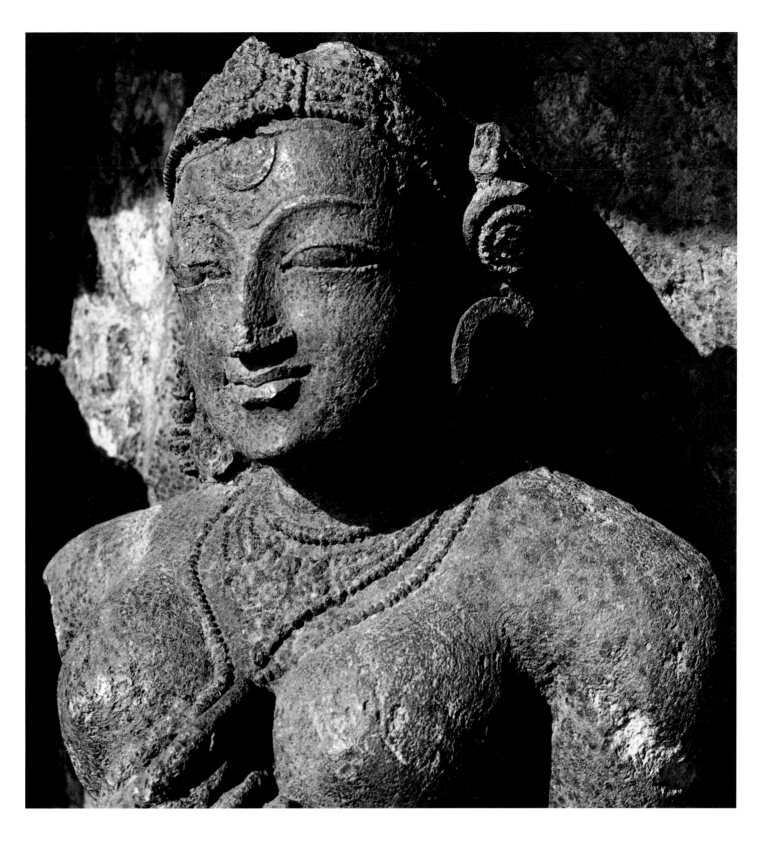

Opposite page: The temple of Konarak is represented as a huge chariot, drawn by the seven horses of the Sun God, all but one destroyed. Animal representation belongs to the finest features of the Indian artist. Sun Temple of Konarak.

Sculpture of a lady, her face reflecting the rising sun. Eastern side of the roof, Sun Temple of Konarak, thirteenth century.

The gods of Indian sculpture are cosmic beings, embodiments of some great spiritual power, spiritual idea and action, inmost psychic significance, the human form a vehicle of this soul meaning, its outward means of self-expression; everything in the figure, every opportunity it gives, the face, the hands, the posture of the limbs, the poise and turn of the body, every accessory, has to be made instinct with the inner meaning, help it to emerge, carry out the rhythm of the total suggestion, and on the other hand everything is suppressed which would defeat this end, especially all that would mean an insistence on the merely vital or physical, outward or obvious suggestions of the human figure. Not the ideal physical or emotional beauty, but the utmost spiritual beauty or significance of which the human form is capable, is the aim of this kind of creation. The divine self in us is its theme, the body made a form of the soul is its idea and its secret.

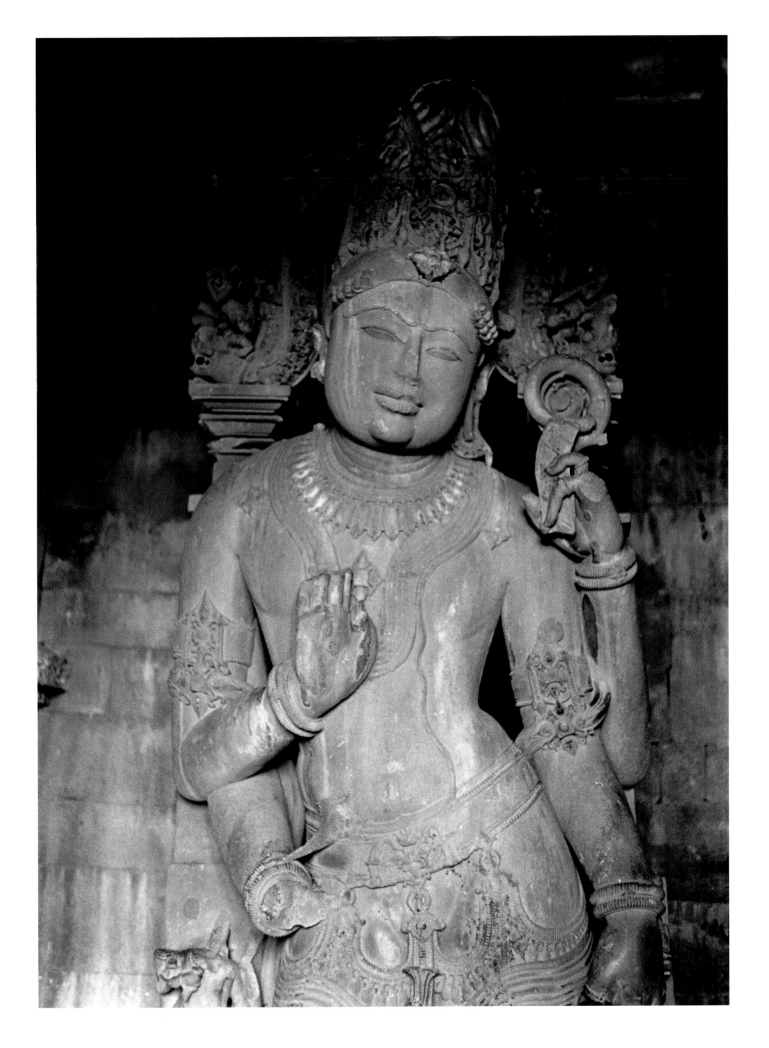

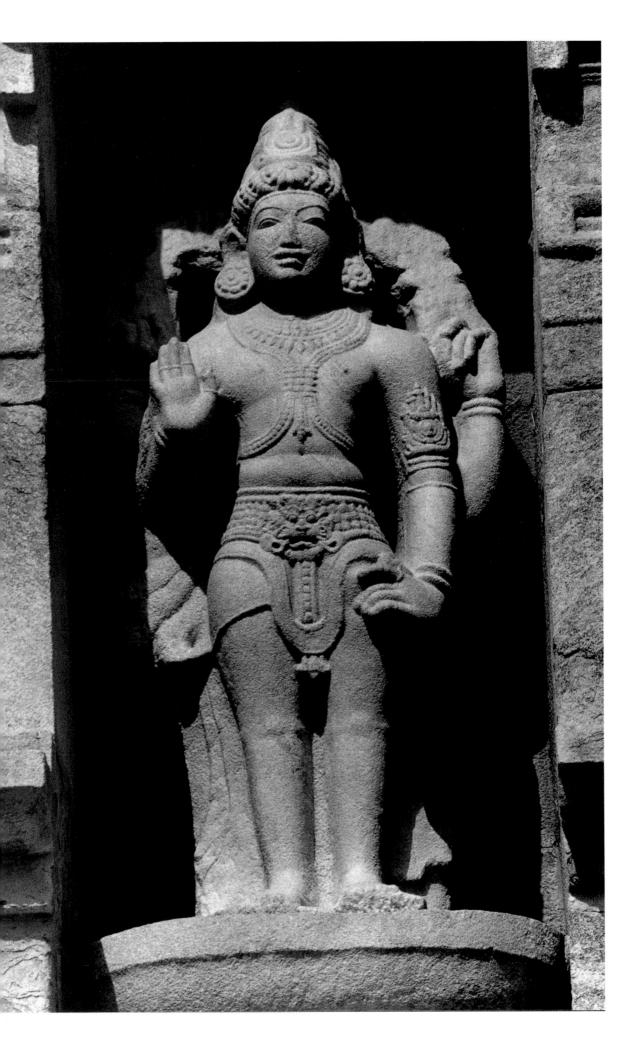

Previous page:
Vishnu, Khajuraho,
Chandella dynasty,
eleventh century.

"... the body made a form
of the soul is its idea and
its secret."

Murugan, as he is called
in South India, or
Kartikeya, the ever
youthful and victorious
son of Shiva.
Brihadishvara temple,
Gangaicondacholapuram,
Chola, eleventh century.

Opposite page:
Chandeshanugraha-murti,
Shiva garlanding his
favourite disciple
Chandesha. Detail,
Brihadishvara temple,
Gangaicondacholapuram.

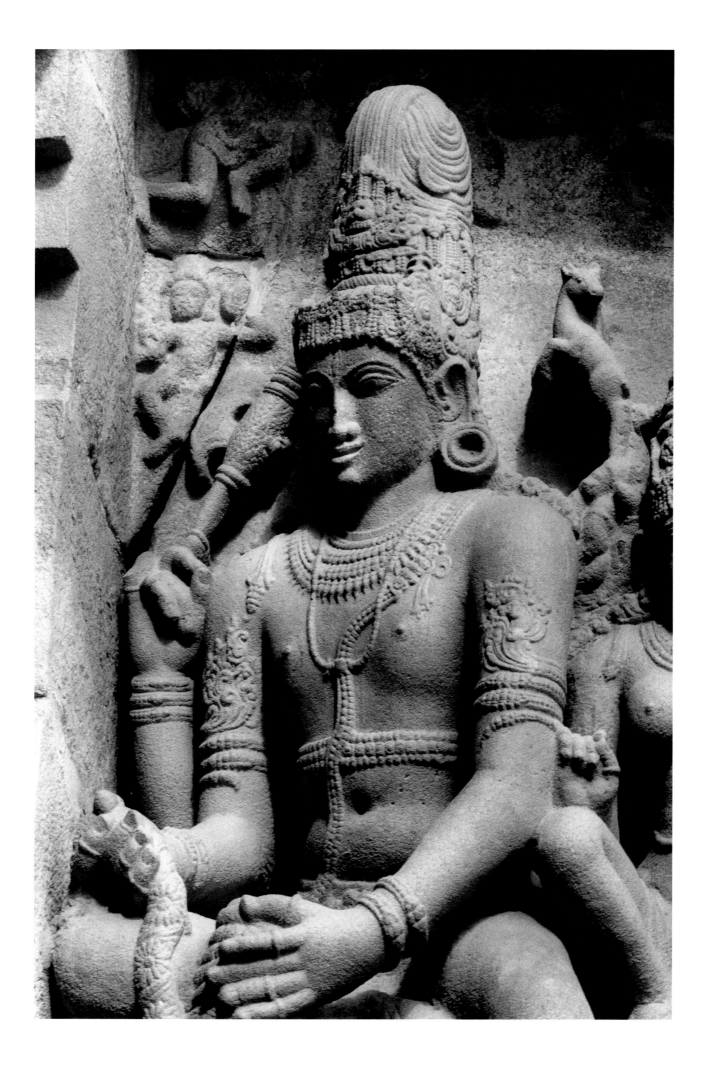

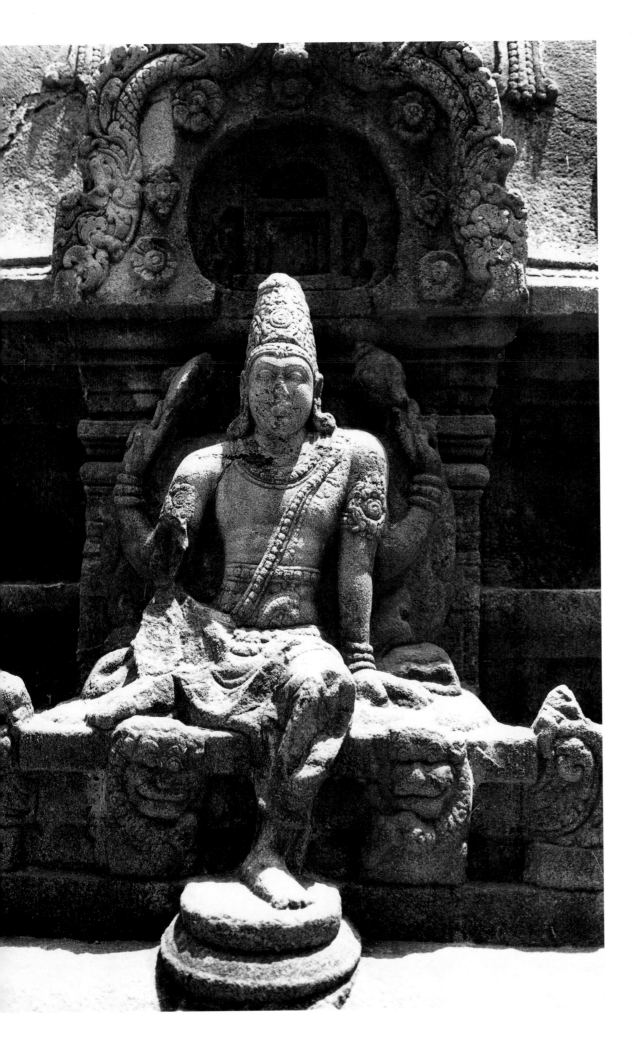

Majestic Vishnu, sculpted
in situ from the monolithic
rock temple at
Kalugumalai. Pandya,
8th century.

Opposite page:
Shiva and Parvati, the
ever blissful divine
couple. Muvarkovil,
Kodumbalur, Irrukuvel
dynasty, tenth century.

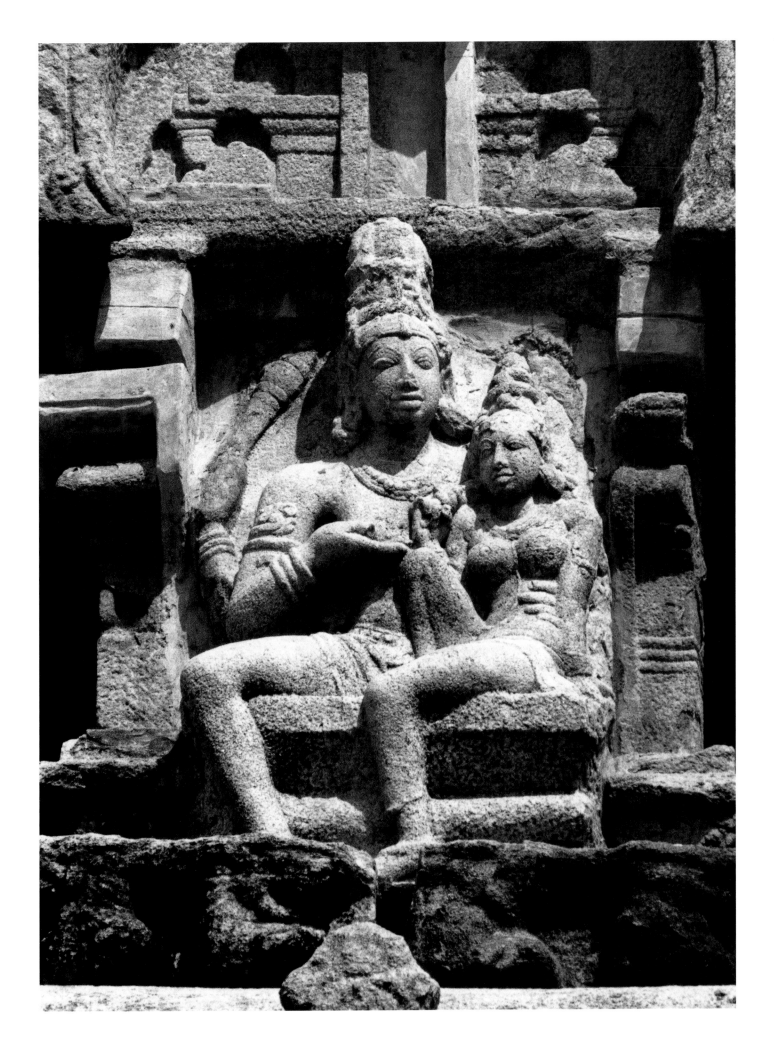

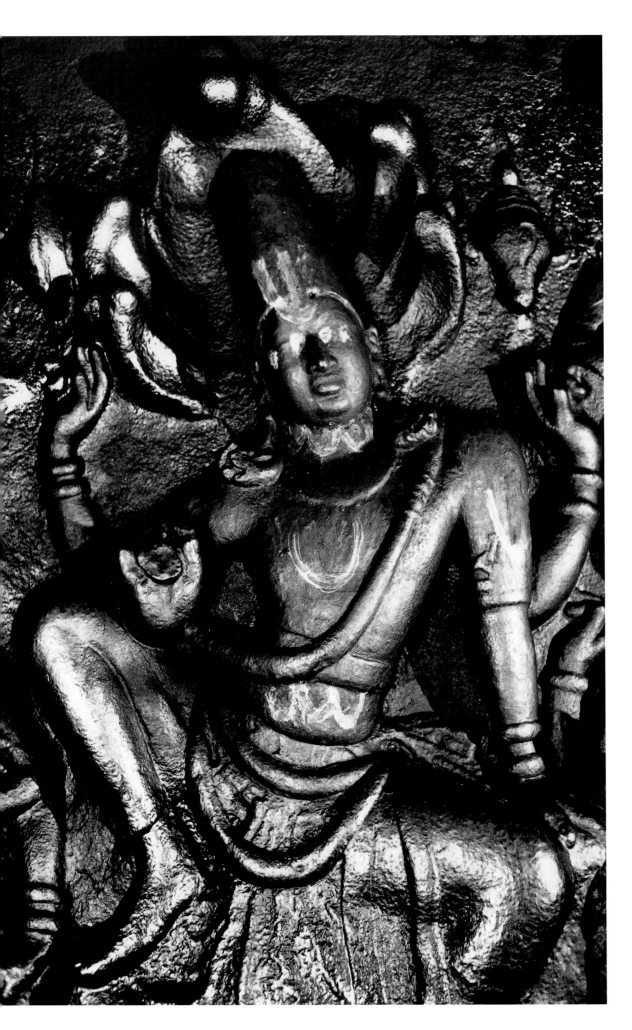

Vishnu as Vaikuntha
Narayana, seated on the
coils of his snake Ananta
in his heaven Vaikuntha.
Detail. Narasimha cave
temple at Namakkal,
Pandya dynasty,
8th century.

Opposite page:
Agastya, the legendary
and powerful saint, who
brought the Vedic religion
to southern India. Naltuna
Ishvara temple, Punjai,
Chola, tenth century.

Following pages:
The two stages of
Bhagiratha's *tapasya*
whose austerities brought
down the heavenly river
Ganga to earth. Open-air
relief, Mamallapuram,
Pallava, 7th century.

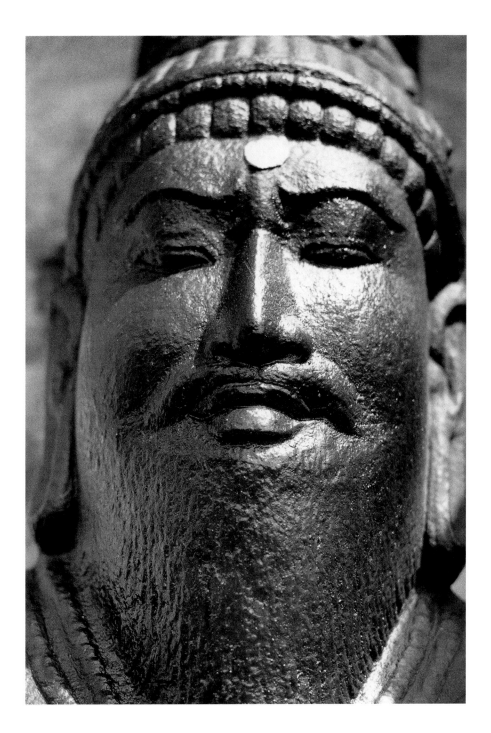

*T*he religious or hieratic side of Indian sculpture is intimately connected with the spiritual experiences of Indian meditation and adoration, – those deep things of our self-discovery which our critic calls contemptuously Yogic hallucinations, – soul realisation is its method of creation and soul realisation must be the way of our response and understanding.

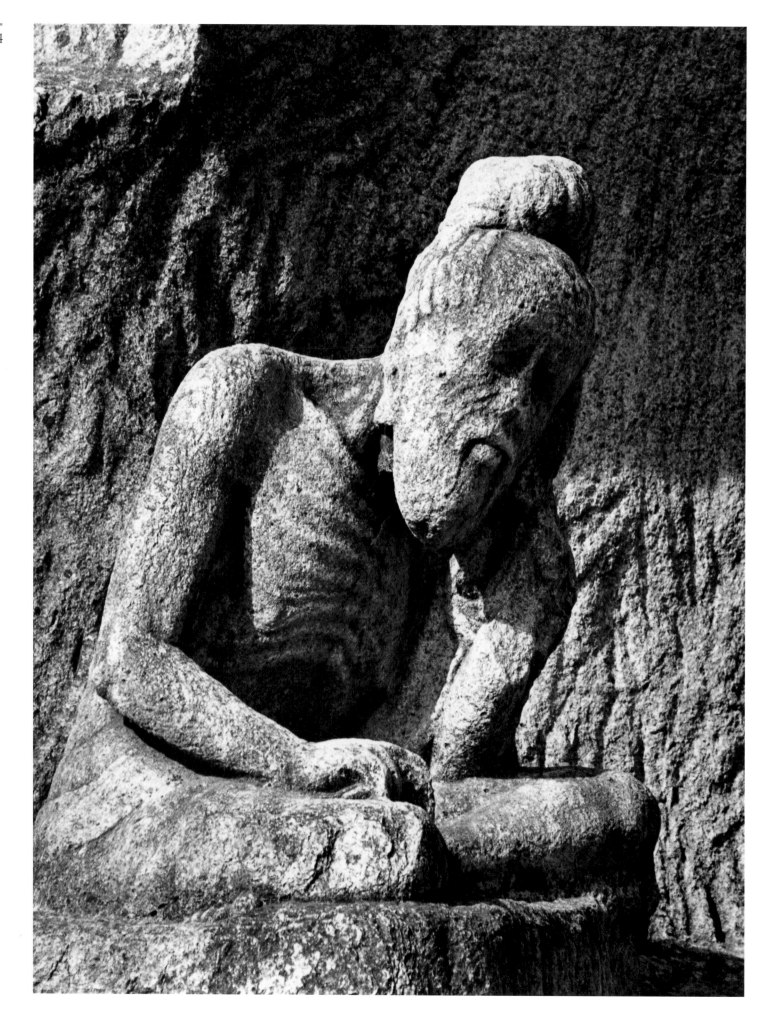

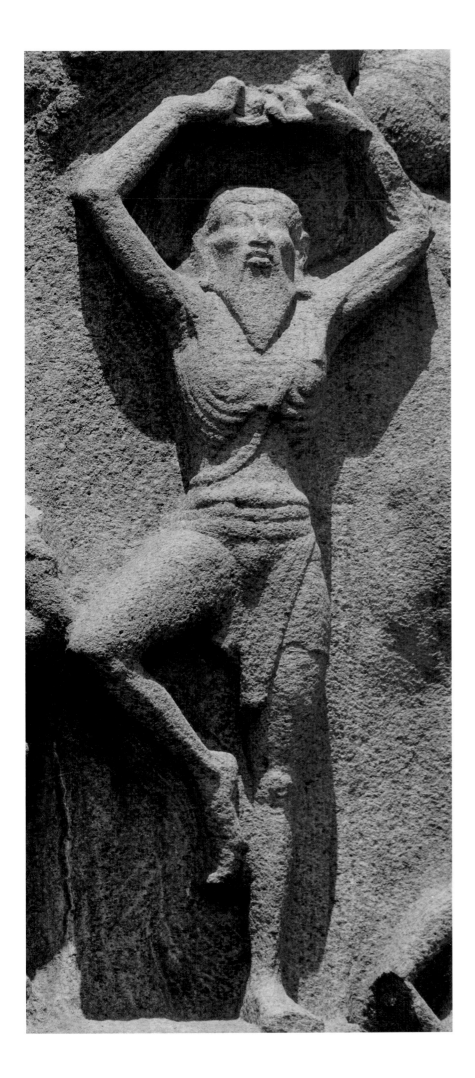

"The idea of penance entered rarely into the austerity practised by Indian ascetics. Nor was mortification of the body the essence even of the most severe and self-afflicting austerities; the aim was rather an overpassing of the hold of the bodily nature on the consciousness or else a supernormal energising of the consciousness and will to gain some spiritual or other object."

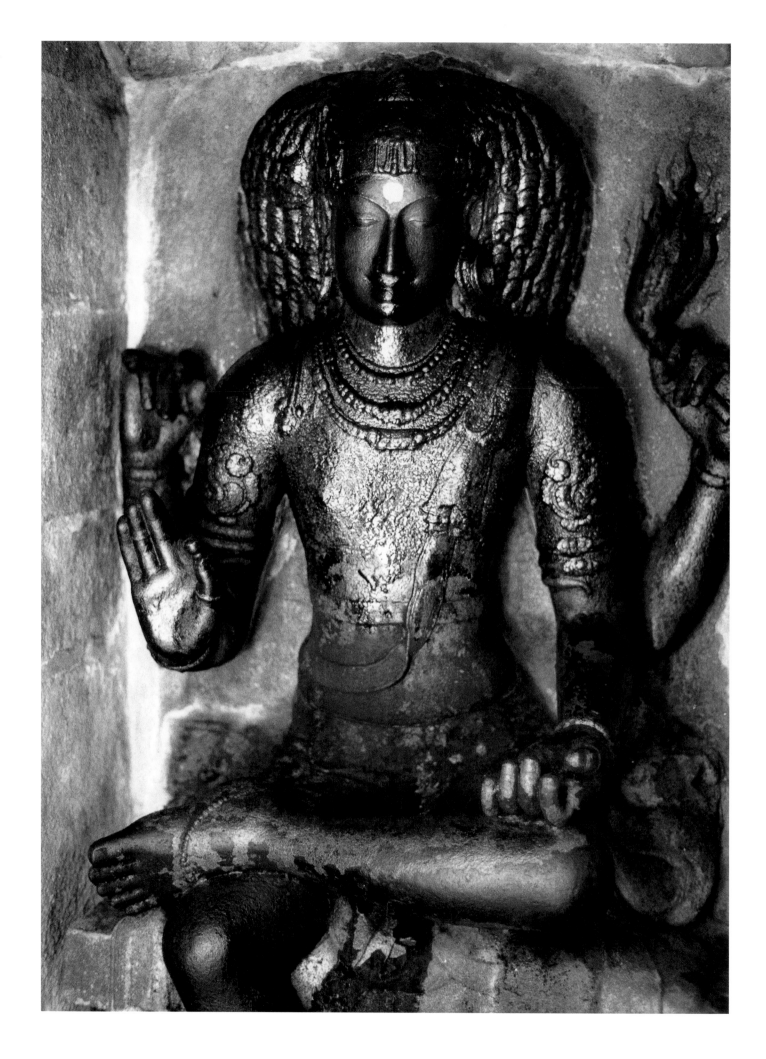

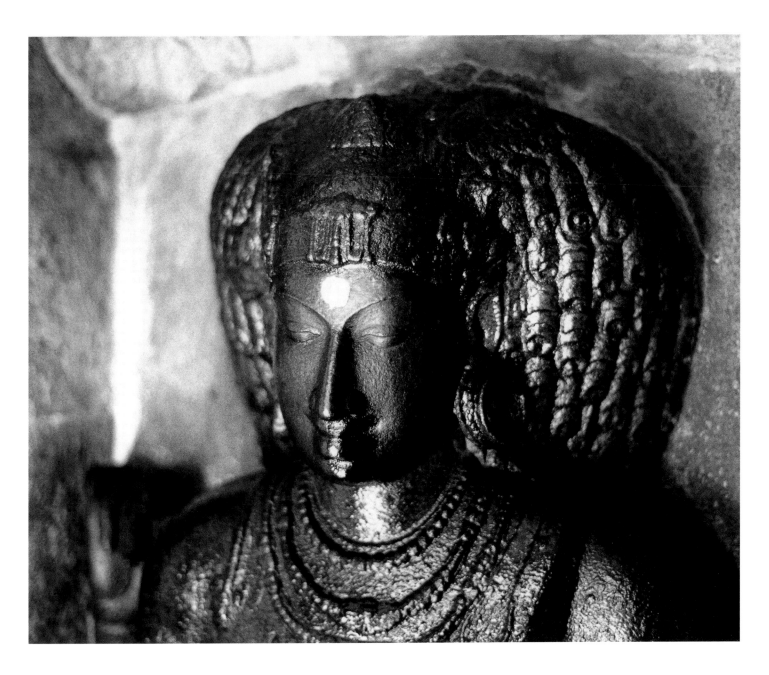

"The appeal of this art is in fact to the human soul for communication with the divine Soul and not merely to the understanding, the imagination and the sensuous eye. It is a sacred and hierartic art, expressive of the profound thought of Indian philosophy and the deep passion of Indian worship. It seeks to render to the soul that can feel and the eye that can see the extreme values of the suprasensuous."

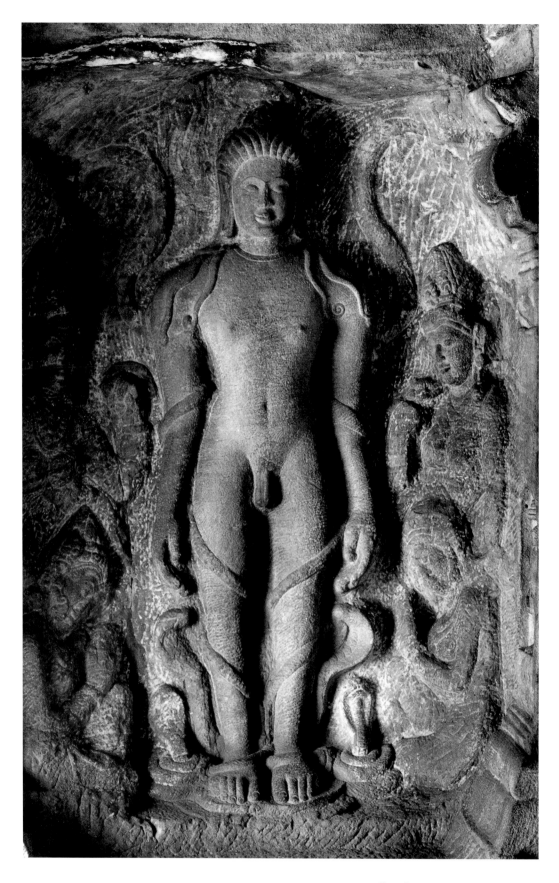

Previous pages:
Shiva Dakshinamurti, the supreme Yogi and Teacher who teaches in silent serenity. Naltuna Ishvara temple, Punjai, early Chola, tenth century.

The Jain ascetic Gommata in blissful immobility, entwined by creepers and worshipped by snakes and men. Jain cave temple, Badami, Chalukya, 8th century.

*A*nd even with the figures of human beings or groups it is still a like inner aim and vision which governs the labour of the sculptor. The statue of a king or a saint is not meant merely to give the idea of a king or saint or to portray some dramatic action or to be a character portrait in stone, but to embody rather a soul-state or experience or deeper soul-quality, as for instance, not the outward emotion, but the inner soul-side of rapt ecstasy of adoration and God-vision in the saint or the devotee before the presence of the worshipped deity.

"Not only the face, the eyes, the pose but the whole body and every curve and every detail aid in the effect and seem to be concentrated into the essence of absolute adoration, submission, ecstasy, love, tenderness which is the Indian idea of *bhakti*. These are not figures of devotees, but of the very personality of devotion. Yet while the Indian mind is seized and penetrated to the very roots of its being by this living and embodied ecstasy, it is quite possible that the Occidental, not trained in the same spiritual culture would miss almost entirely the meaning of the image and might only see a man praying."

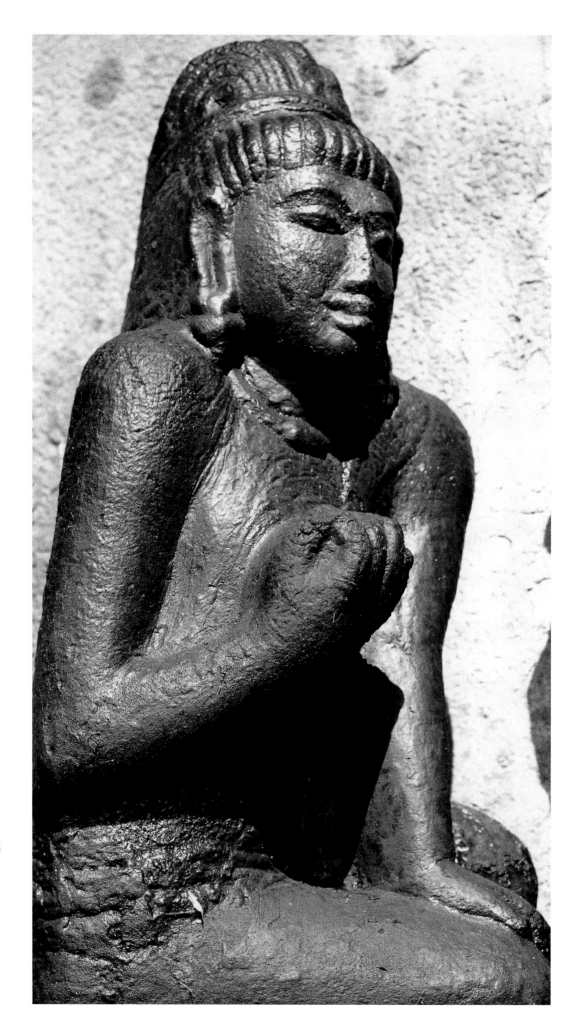

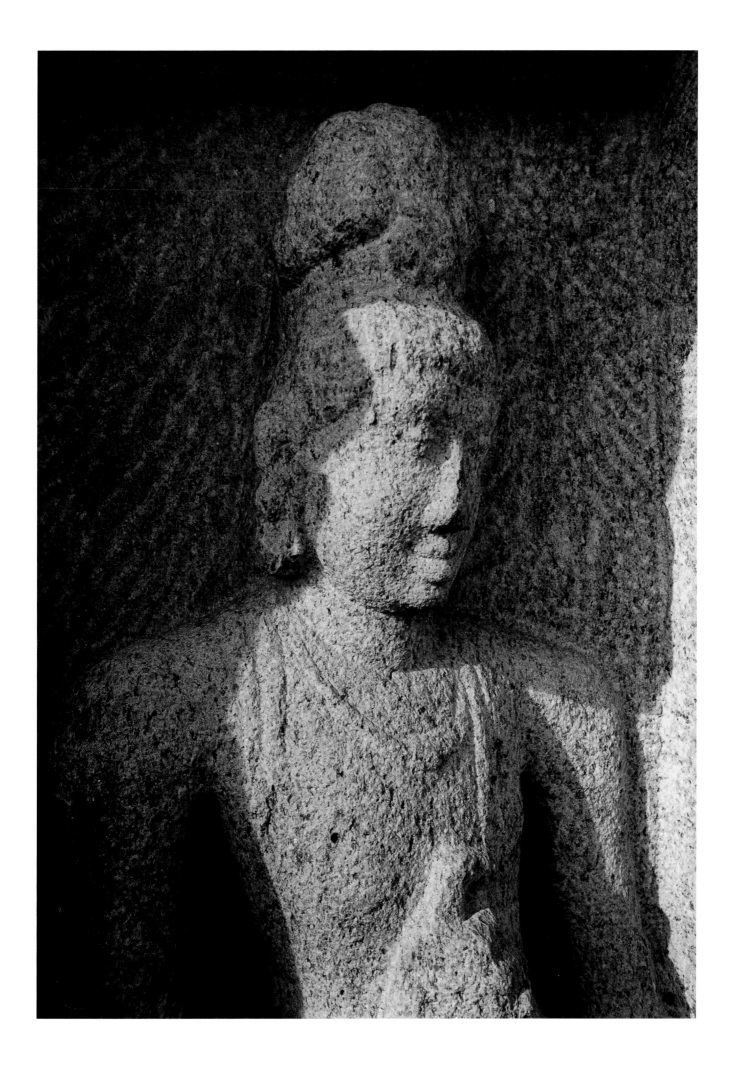

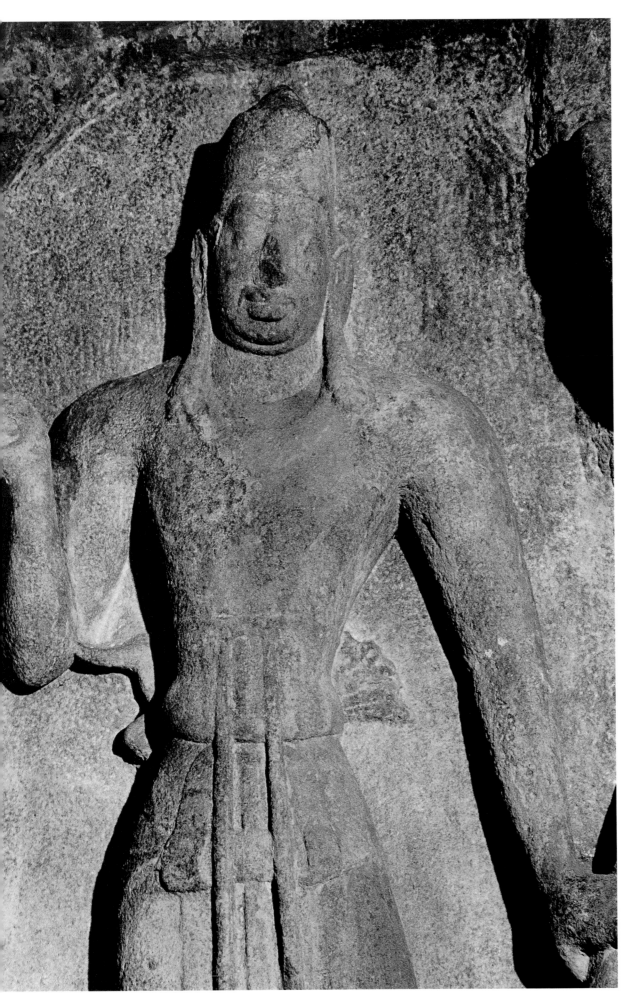

Previous pages:
Left
Devotee, covered by century-old layers of oil, yet his expression of utter devotion being beautifully preserved. Brihadishvara temple, Gangaicondacholapuram, Chola, tenth-eleventh century.

Right
One of the most beautiful devotees in Indian art, lost in contemplation of his inner Godhead. Dharmaraja Ratha, Mamallapuram, Pallava, 7th century.

A Pallava king, leading his two queens to the shrine and standing now enraptured in front of its deity. Detail. Adi Varaha cave temple, Mamallapuram, Pallava, 7th century.

"...the inner soul-side of rapt ecstasy of adoration and God-Vision..."

Oposite page:
A similar scene at the Arjuna Ratha: a Pallava king turns back to his queen, his face all delight, to show her the divinity in front of him. (see page 144) Mamallapuram.

Page 185:
Buddha, Sarnath museum, Gupta, 5th century

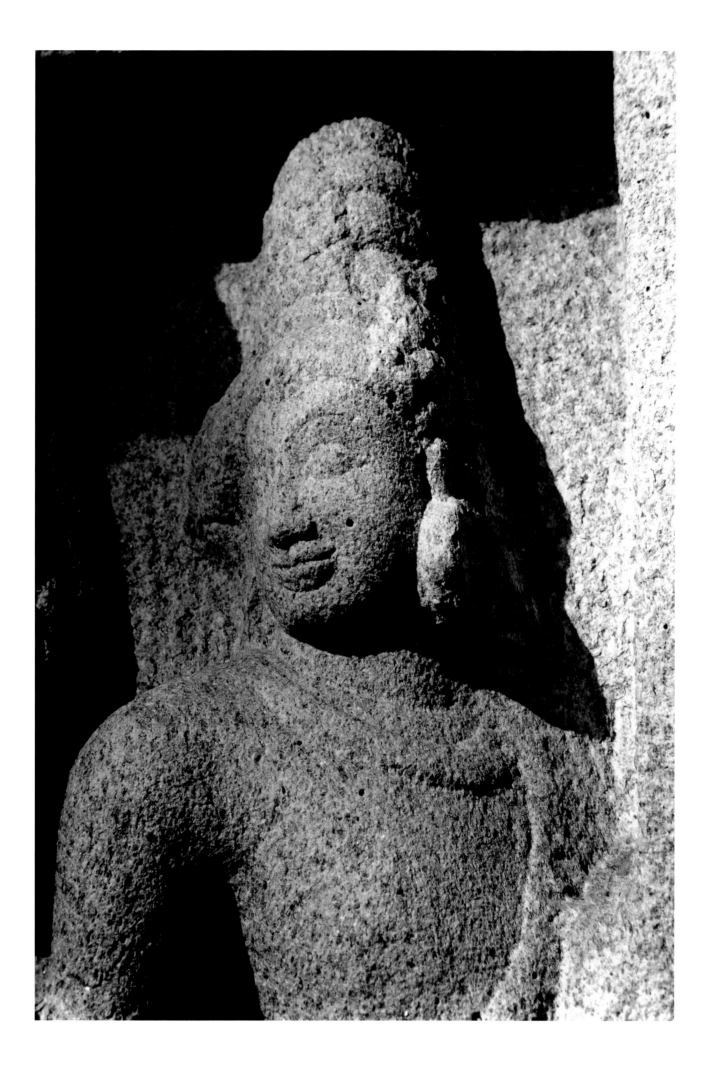

*T*ake the great Buddhas – not the Gandharan, but the divine figures or groups in cave-cathedral or temple,... the Kalasanhara image, the Natarajas. No greater or finer work, whether in conception or execution, has been done by the human hand and its greatness is increased by obeying a spiritualised aesthetic vision. The figure of the Buddha achieves the expression of the infinite in a finite image, and that is surely no mean or barbaric achievement, to embody the illimitable calm of Nirvana in a human form and visage.

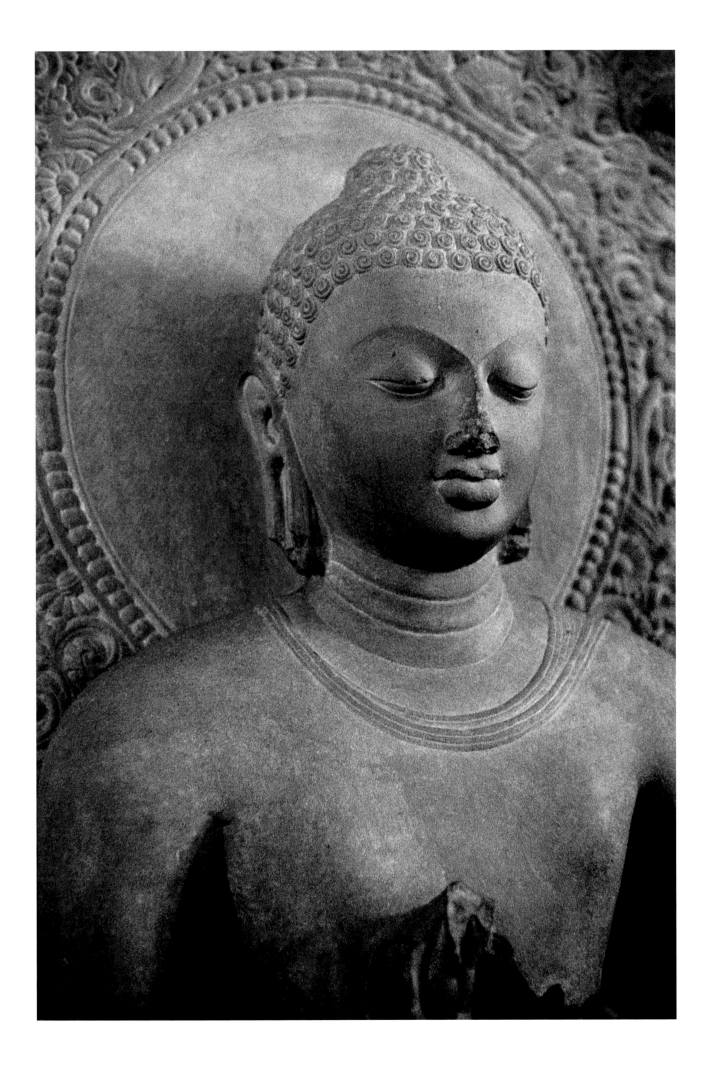

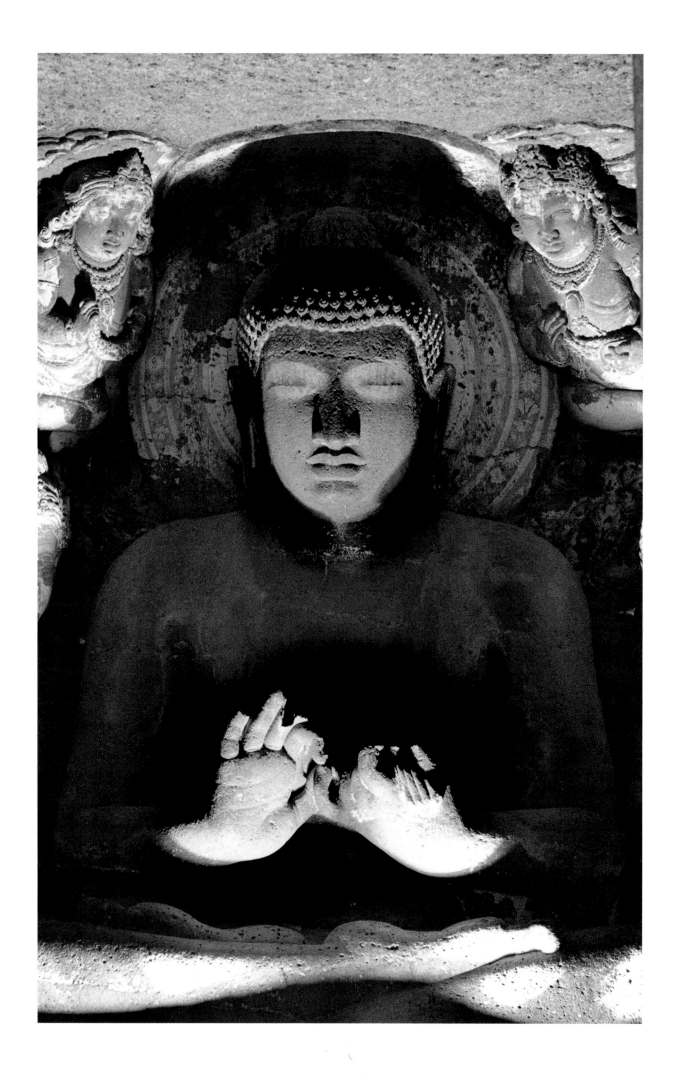

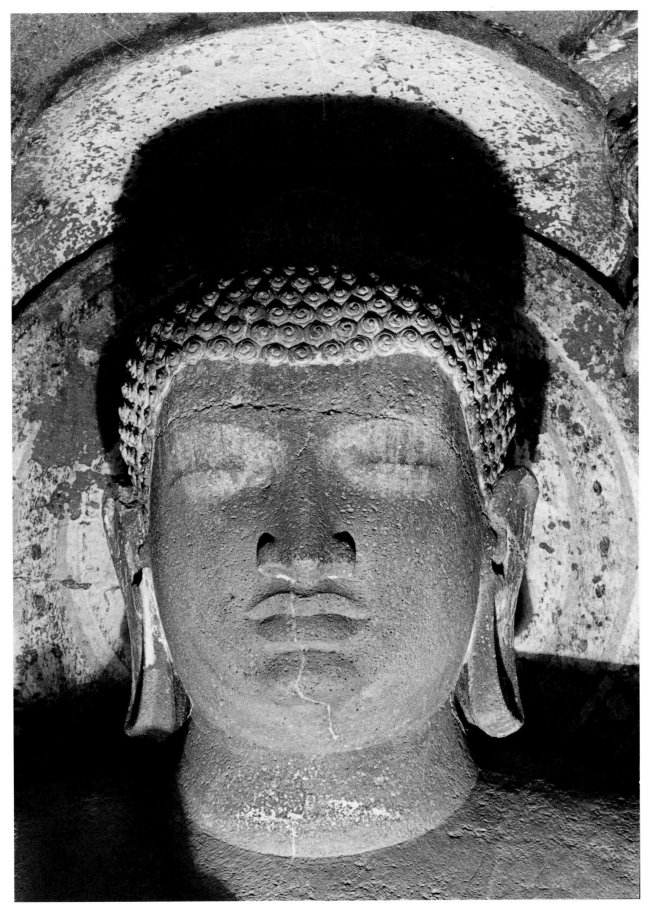

"The greatness of the ideals of the past is a promise of greater ideals for the future. A continual expansion of what stood behind past endeavour and capacity is the one abiding justification of a living culture."

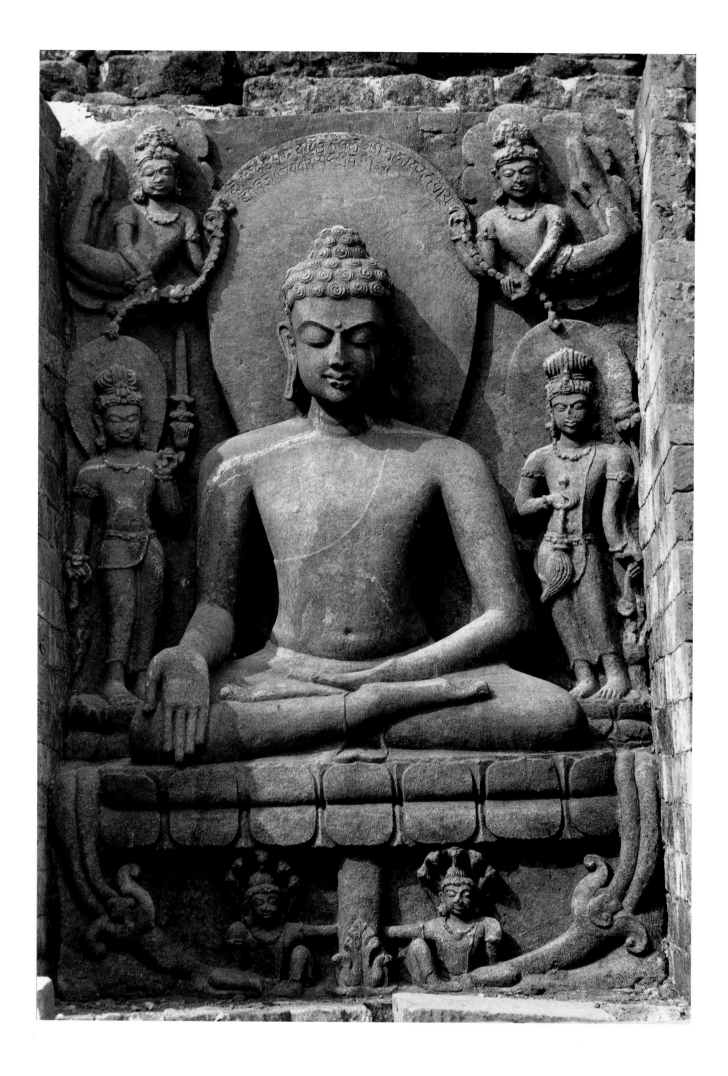

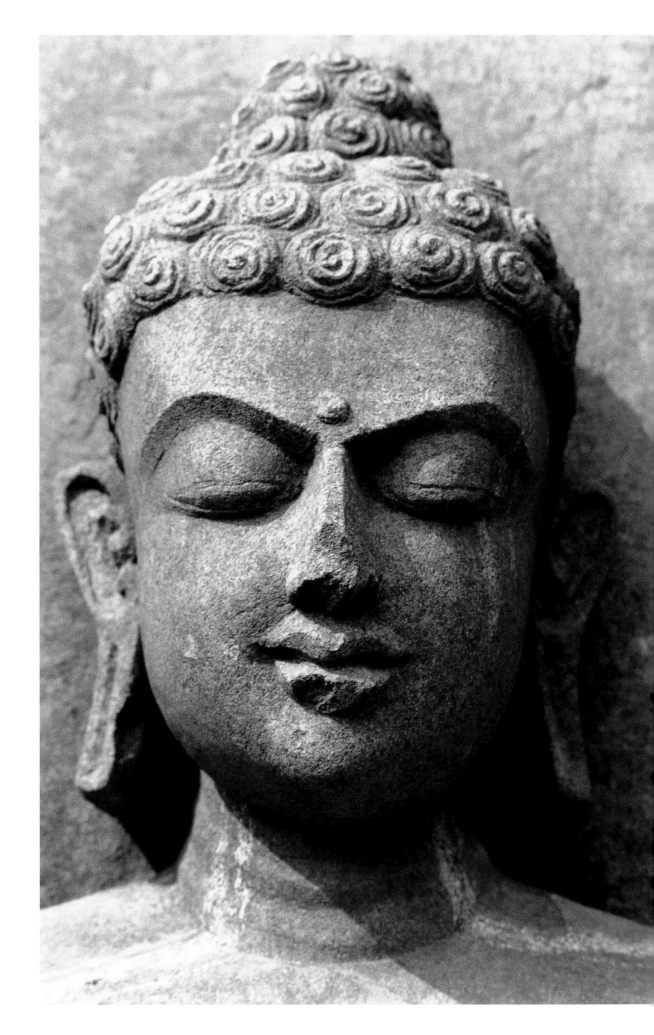

Previous pages:
Buddha, cave temple at
Ajanta, Vakataka,
5th-6th century.

Buddha, recently
excavated at Udayagiri,
Orissa, probably
7th-8th century.

The Kalasanhara Siva is supreme not only by the majesty, power, calmly forceful control, dignity and kingship of existence which the whole spirit and pose of the figure visibly incarnates, – that is only half or less than half its achievement, – but much more by the concentrated divine passion of the spiritual overcoming of time and existence which the artist has succeeded in putting into eye and brow and mouth and every feature and has subtly supported by the contained suggestion, not emotional, but spiritual, of every part of the body of the godhead and the rhythm of his meaning which he has poured through the whole unity of his creation.

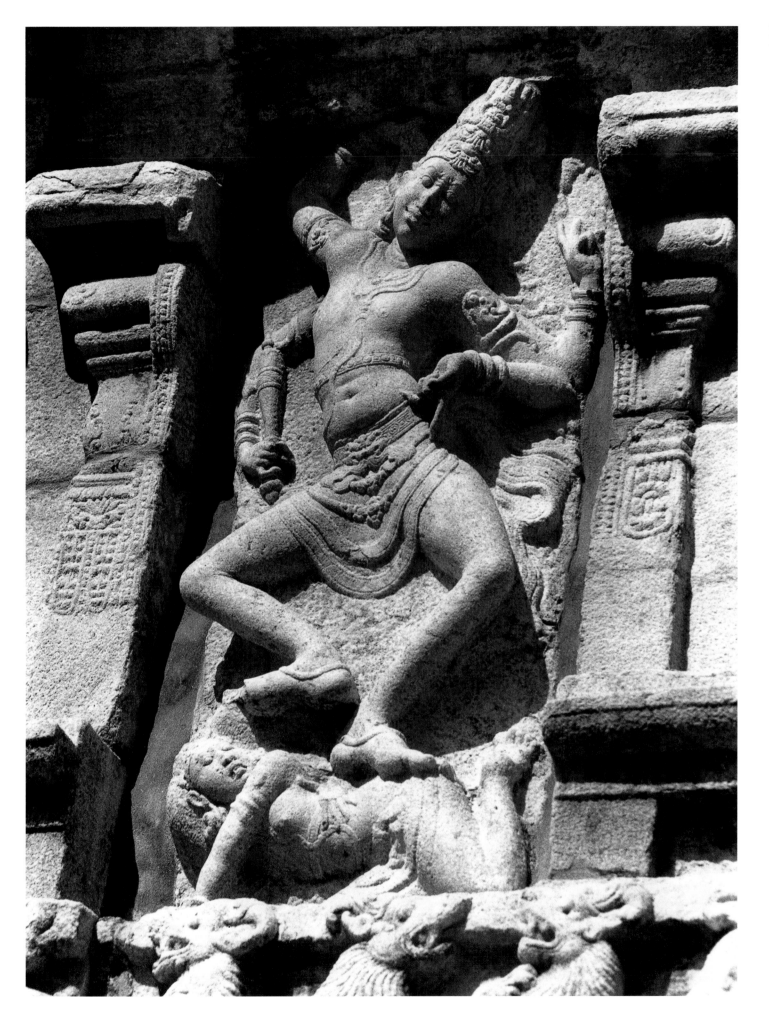

Or what of the marvellous genius and skill in the treatment of the cosmic movement and delight of the dance of Siva, the success with which the posture of every limb is made to bring out the rhythm of the significance, the rapturous intensity and abandon of the movement itself and yet the just restraint in the intensity of motion, the subtle variation of each element of the single theme in the seizing idea of these master sculptors? Image after image in the great temples or saved from the wreck of time shows the same grand traditional art and the genius which worked in that tradition and its many styles, the profound and firmly grasped spiritual idea, the consistent expression of it in every curve, line and mass, in hand and limb, in suggestive pose, in expressive rhythm...

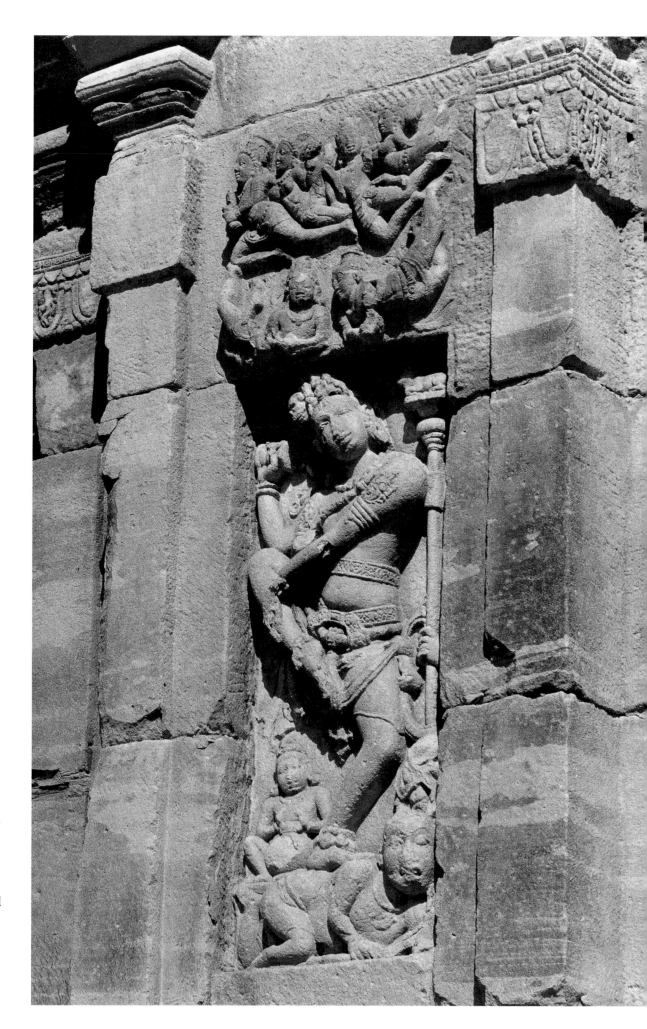

Page 191:
Kalasanhara Shiva,
Muvarkovil, Kodumbalur,
Irrukuvel dynasty,
8th century.

Shiva dancing enraptured
in the *urdhvajanu* mode
on Apasmara Purusha,
the dwarf of Ignorance.
Virupaksha temple,
Pattadakal, Chalukya
dynasty, 8th century.

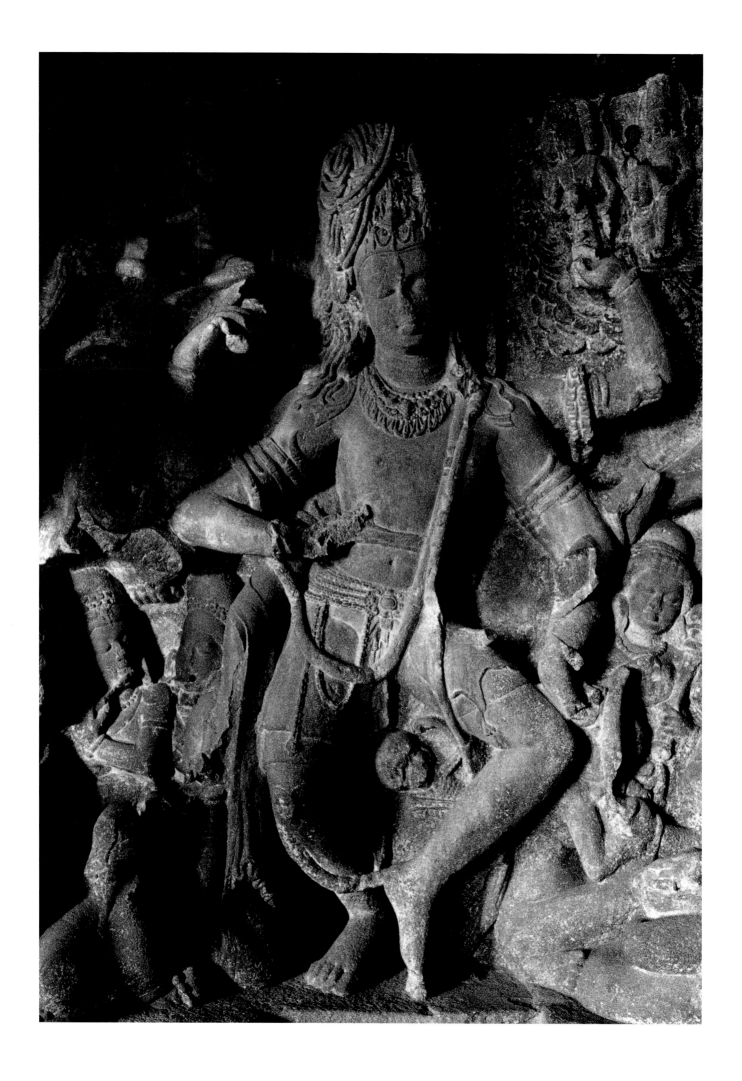

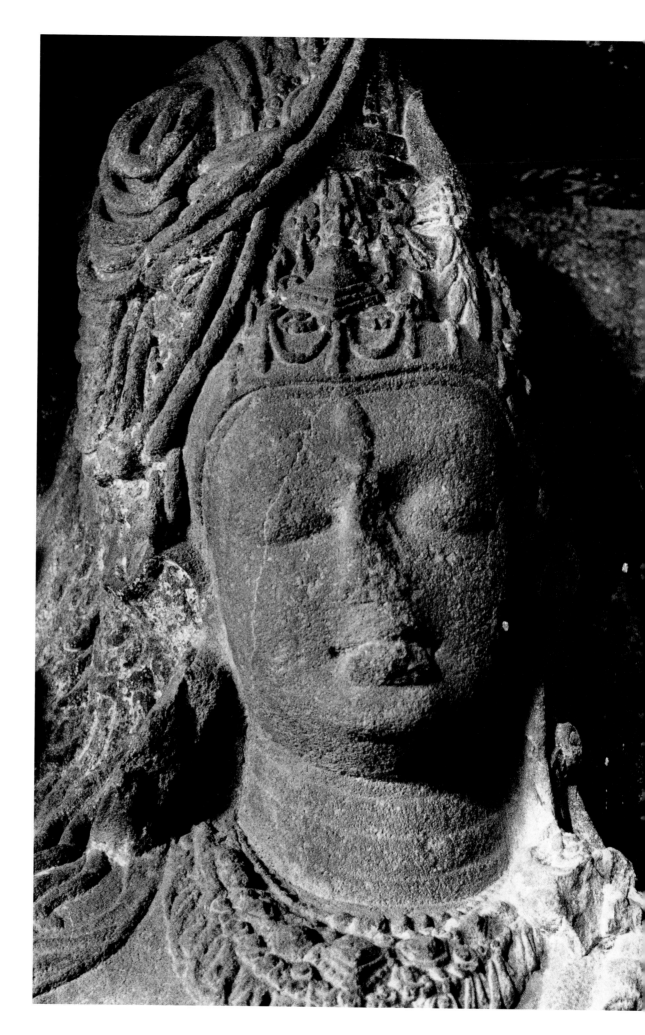

Pages 194-195:
Shiva dancing the
chatura tandava, floating
as it were in a subtle
physical world. Details,
Rameshvara cave-temple,
Ellora, Vakataka,
6th century.

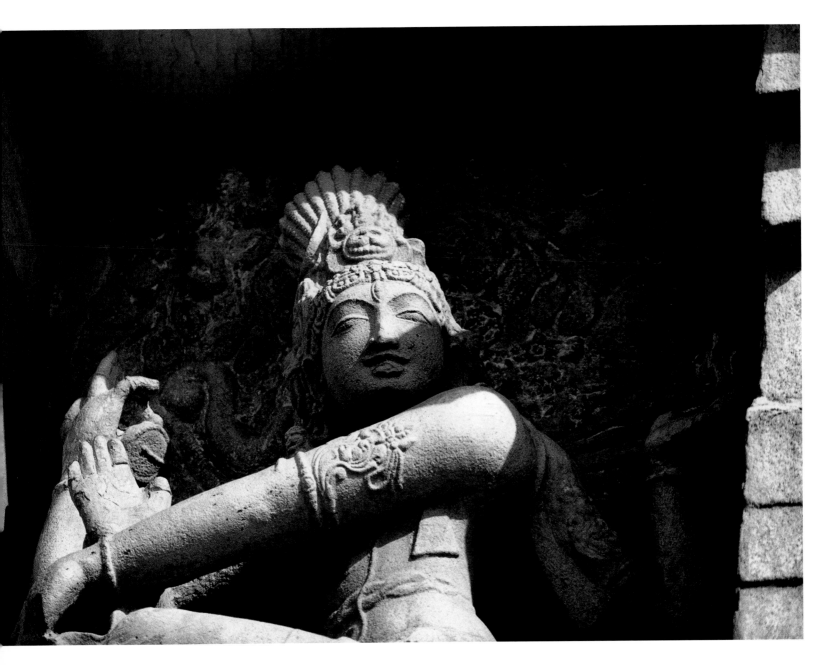

Ecstatic Shiva dancing the
Ananda Tandava at the
Brihadishvara temple,
Gangaicondacholapuram,
Chola dynasty,
eleventh century.

Opposite page:
The harmony and balance
of this much damaged
Shiva Nataraja at Ellora
can still be recognised,
6th-7th century, Vakataka
dynasty.

Page 198:
Shiva Nataraja, bronze,
New Delhi, National
Museum.

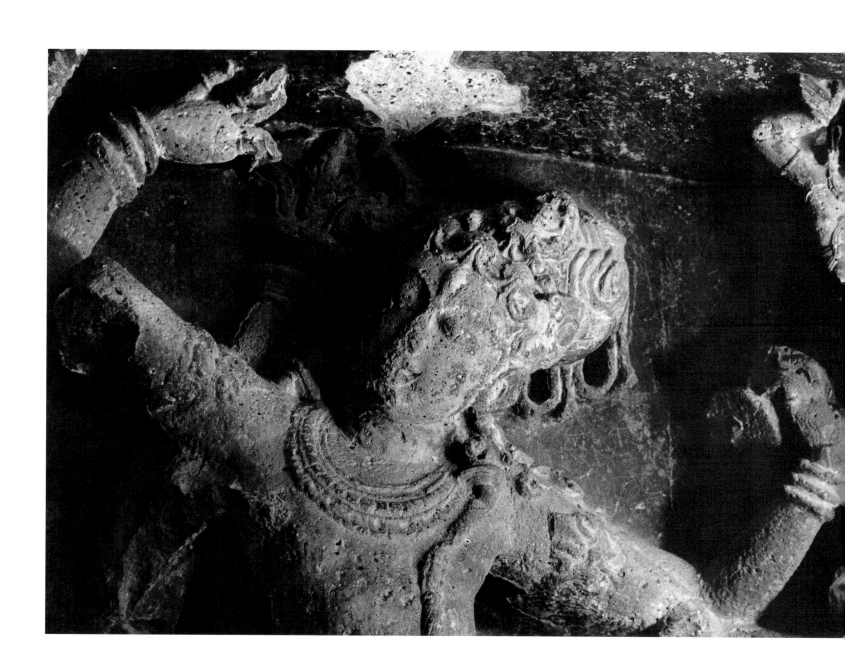

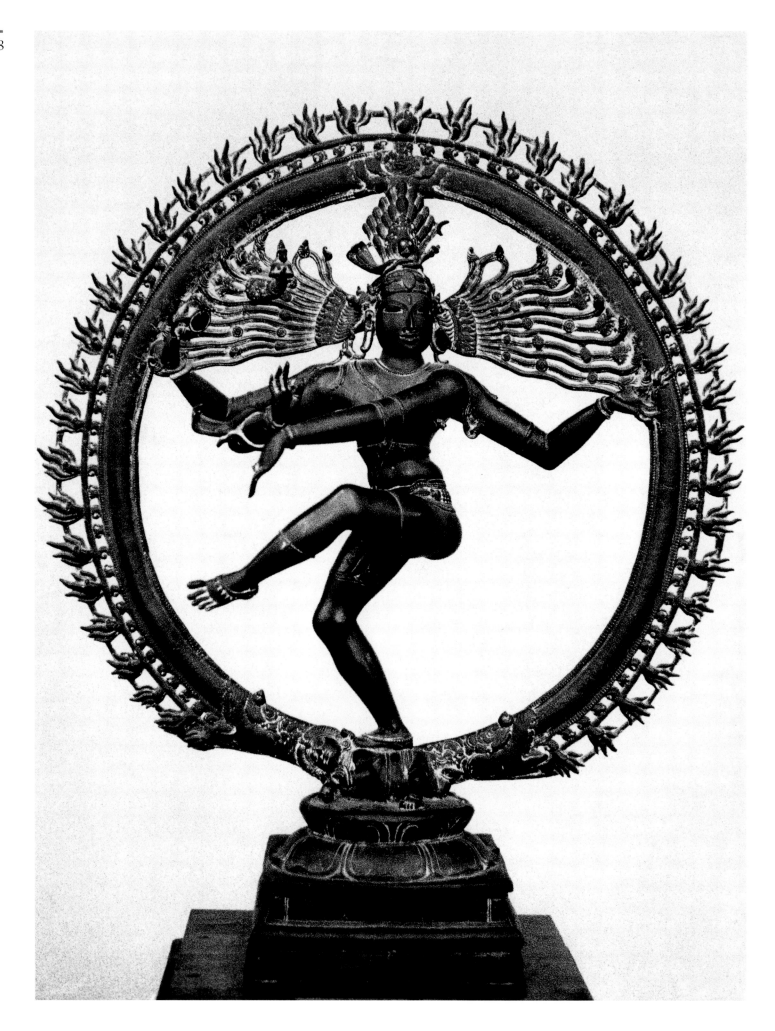

The inspiration, the way of seeing is frankly not naturalistic, not, that is to say, the vivid, convincing and accurate, the graceful, beautiful or strong, or even the idealised or imaginative imitation of surface or terrestrial nature. The Indian sculptor is concerned with embodying spiritual experiences and impressions, not with recording or glorifying what is received by the physical senses. He may start with suggestions from earthly and physical things, but he produces his work only after he has closed his eyes to the insistence of the physical circumstances, seen them in the psychic memory and transformed them within himself so as to bring out something other than their physical reality or their vital and intellectual significance. His eye sees the psychic line and turn of things and he replaces by them the material contours.

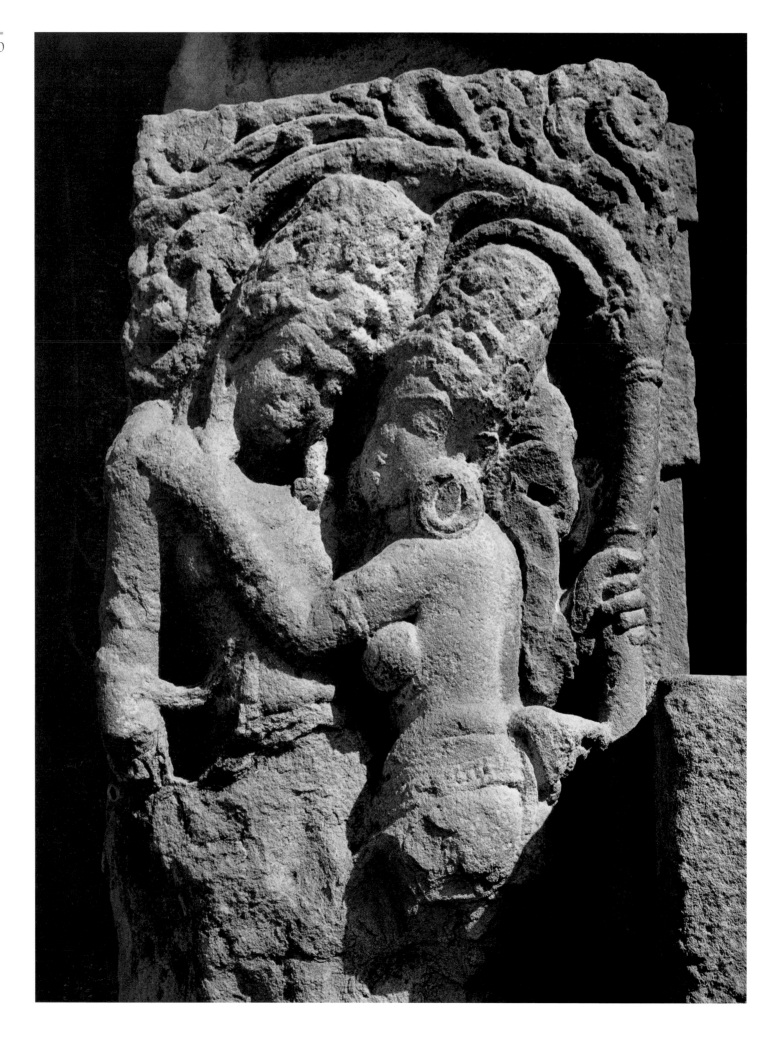

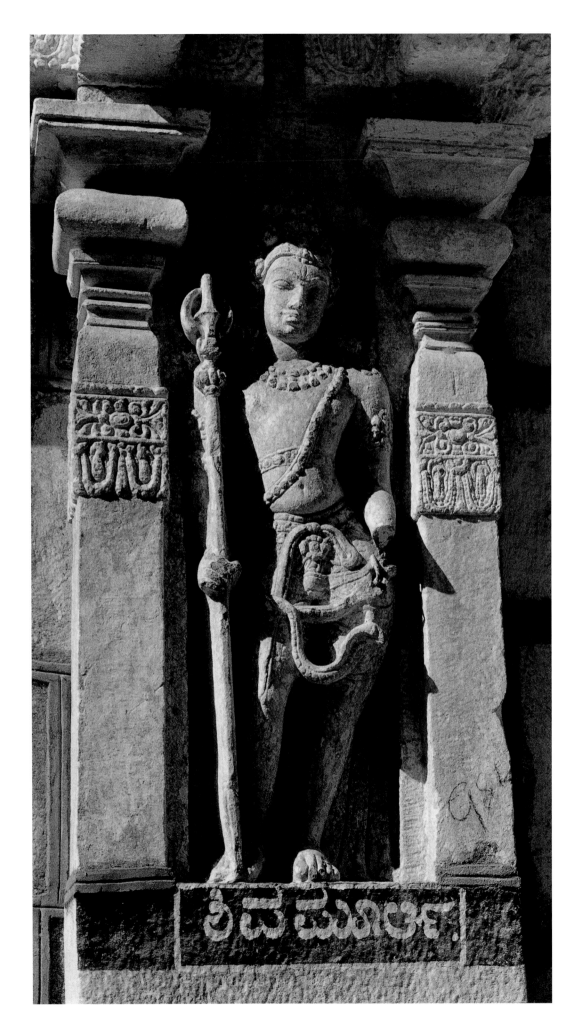

Opposite page:
Kama and Rati, (the God
of Love and his wife)
embracing each other
tenderly. Though much
eroded, this early
mithuna group is of rare
beauty. Lad Khan temple,
Aihole, early Chalukya,
6th century.

Shiva with his trident as
door-guardian.
Mahakuteshvara temple,
Mahakut (near Badami),
Chalukya, 7th century.

Following pages:
Left
Dvarapala or doorkeeper,
leaning with large,
dreaming eyes on his
club, fully aware of the
godhead inside the
temple. Cave temple in
remote Bhairavakonda,
(Andhra Pradesh),
probably 6th century.

Right
Shiva Ardhanarishvara
(half man, half woman),
one of the finest
examples of Chalukya
sculpture. Detail.
Sangameshvara temple,
Mahakuta, 7th century.

"Nature will not see herself there as in a mirror, but rather herself transformed into something wonderfully not herself which is yet her own deeper reality."

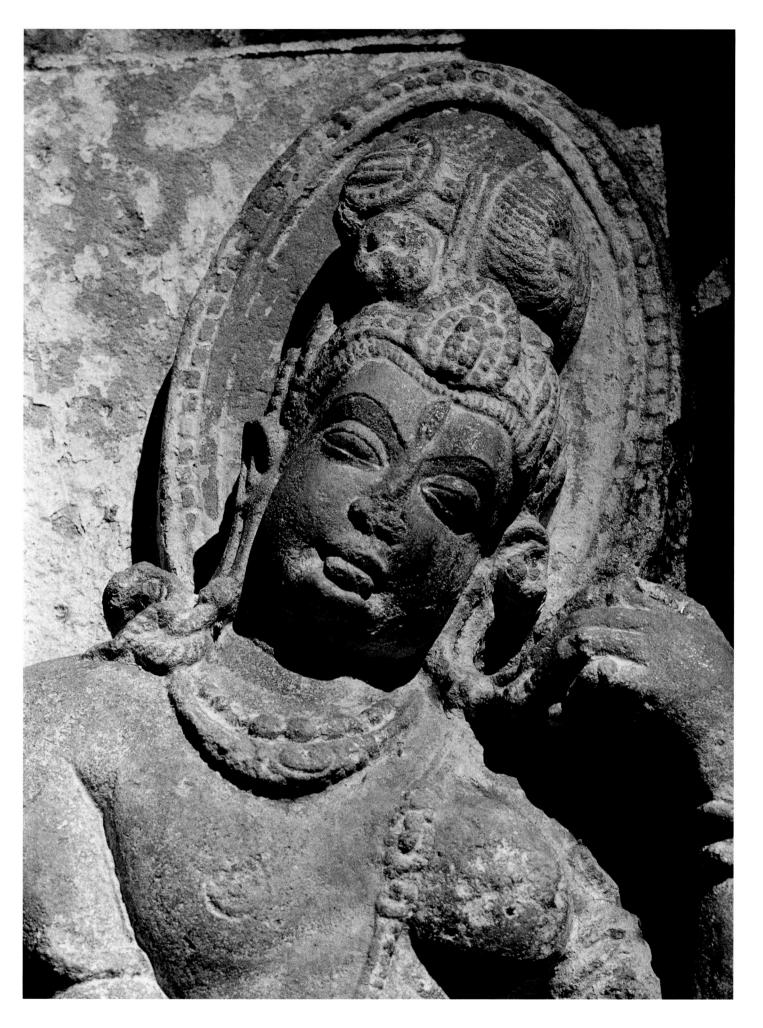

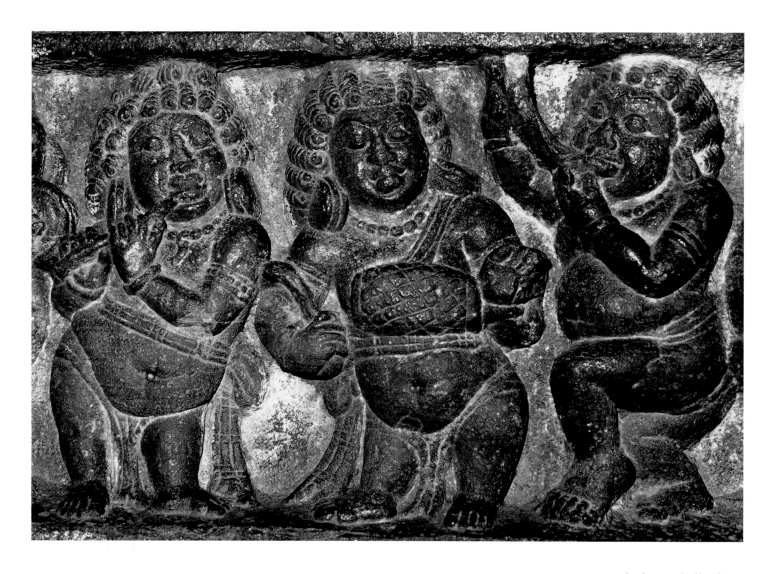

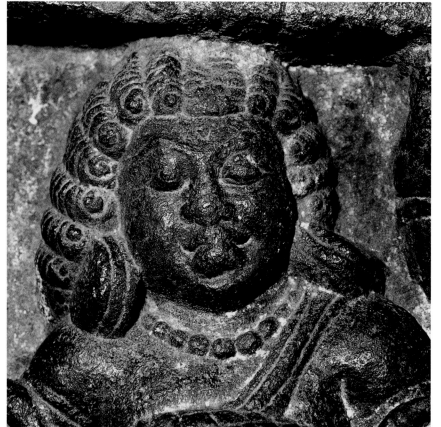

Ganas, little pot-bellied beings, fond of music and dance are a favourite subject in Indian sculpture. Cave temple, Badami, early Chalukya, 6th century.

Opposite page:
Dust-covered *ganas* with particularly expressive faces in the rock temple of Kalugumalai. Pandya, 8th century.

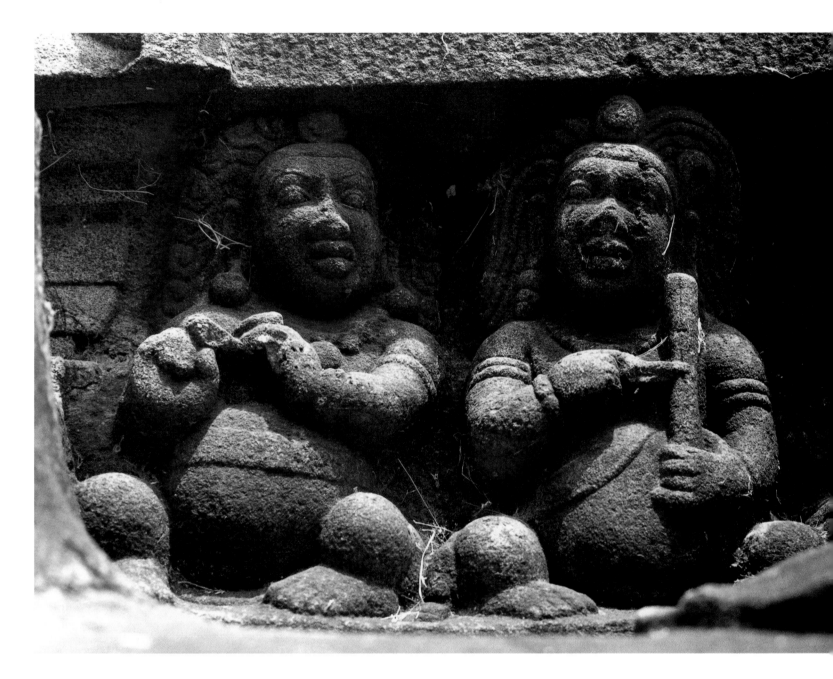

"Art can express eternal truth, it is not limited to the expression of form and appearance. So wonderful has God made the world that a man using a simple combination of lines, an unpretentious harmony of colours, can raise this apparently insignificant medium to suggest absolute and profound truths with a perfection which language labours with difficulty to reach. What Nature is, what God is, what man is can be triumphantly revealed in stone and canvas."

There is the familiar objection to such features as the multiplication of the arms in the figures of gods and goddesses, the four, six, eight or ten arms of Shiva, the eighteen arms of Durga, because they are a monstrosity, a thing not in nature. Now certainly a play of imagination of this kind would be out of place in the representation of a man or woman, because it would have no artistic or other meaning, but I cannot see why this freedom should be denied in the representation of cosmic beings like the Indian godheads. The whole question is, first, whether it is an appropriate means of conveying a significance not otherwise to be represented with an equal power and force and, secondly, whether it is capable of artistic representation, a rhythm of artistic truth and unity which need not be that of physical nature. If not, then it is an ugliness and violence, but if these conditions are satisfied, the means are justified and I do not see that we have any right, faced with the perfection of the work, to raise a discordant clamour.

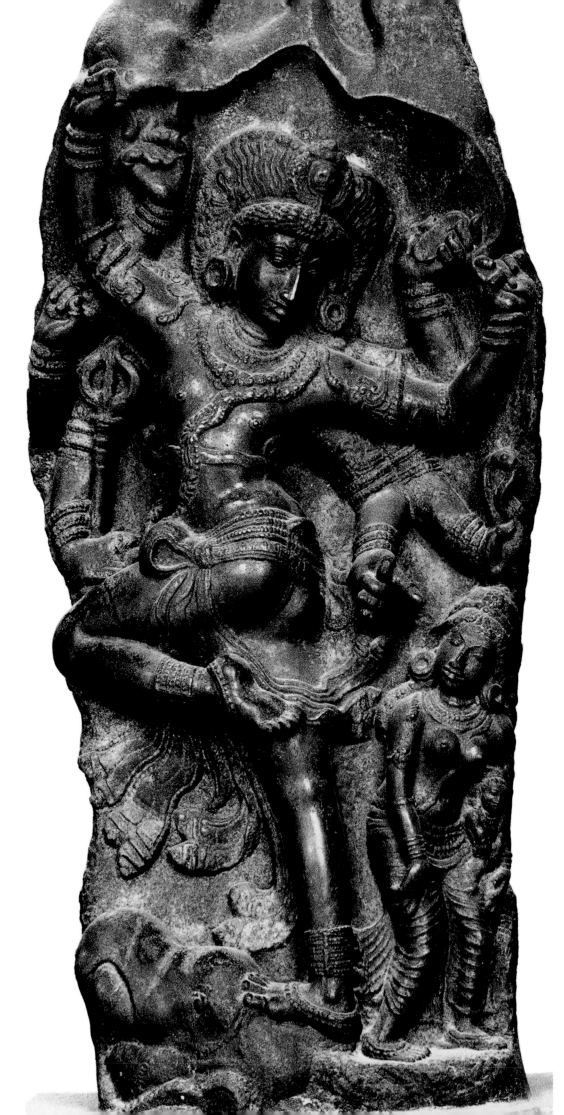

Eight-armed Shiva
Gaja-Samhara dancing a
triumphant dance,
wrapped in the skin of
the elephant demon.
From Darasuram, now in
the Tanjore museum.
Chola, twelfth century.

Following pages:
Eight-armed Shiva,
dancing in the *alidha* or
squatting mode.
Kailasanatha temple,
Kancipuram, Pallava,
8th century.

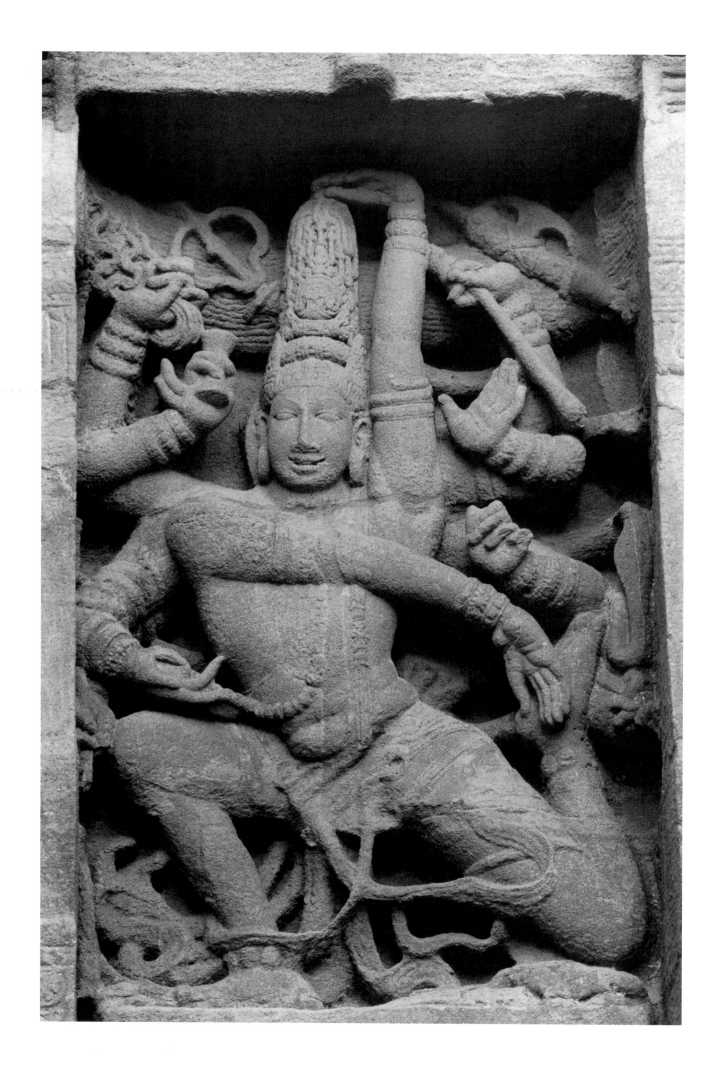

"...we can at once see that the spiritual emotion and suggestions of the cosmic dance are brought out by this device in a way which would not be possible with a two-armed figure....Art justifies its own means and here it does it with a supreme perfection."

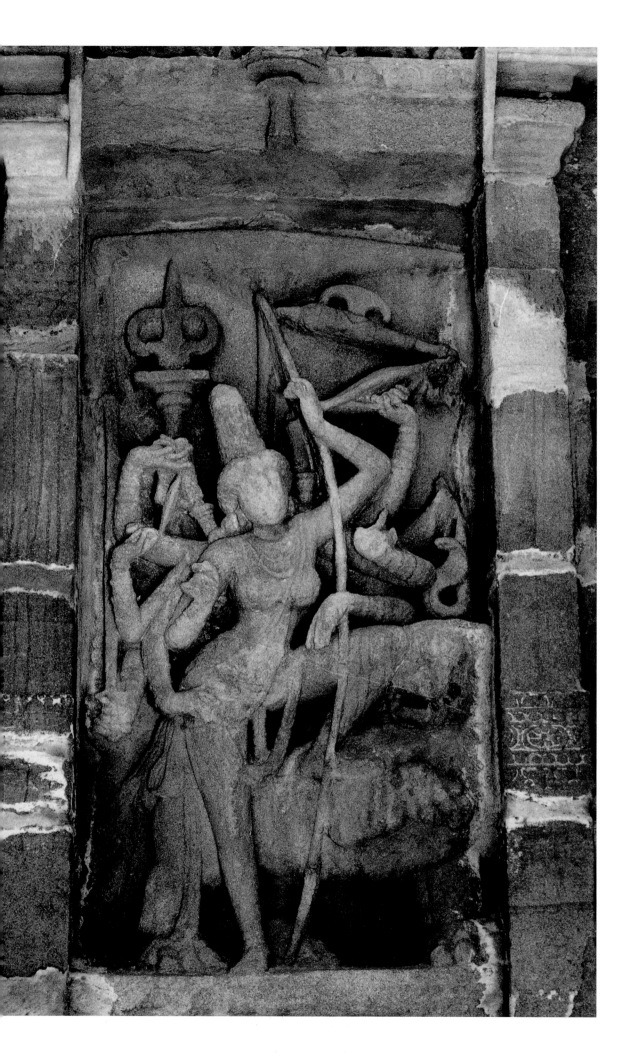

Ten-armed graceful Durga on her lion. Kailasanatha temple, Kanchipuram, Pallava.

Opposite page:
Four-armed Durga, standing on the head of the buffalo-demon killed by her. A splendid sculptural achievement of the early Chola period. Naltuna Ishvara temple, Punjai.

Page 212:
Ten-armed Shiva, dancing a wild and weird dance amid the *saptamatrikas* or 'Seven Mothers'. Ravalapadi cave temple, Aihole, Chalukya, 6th century.

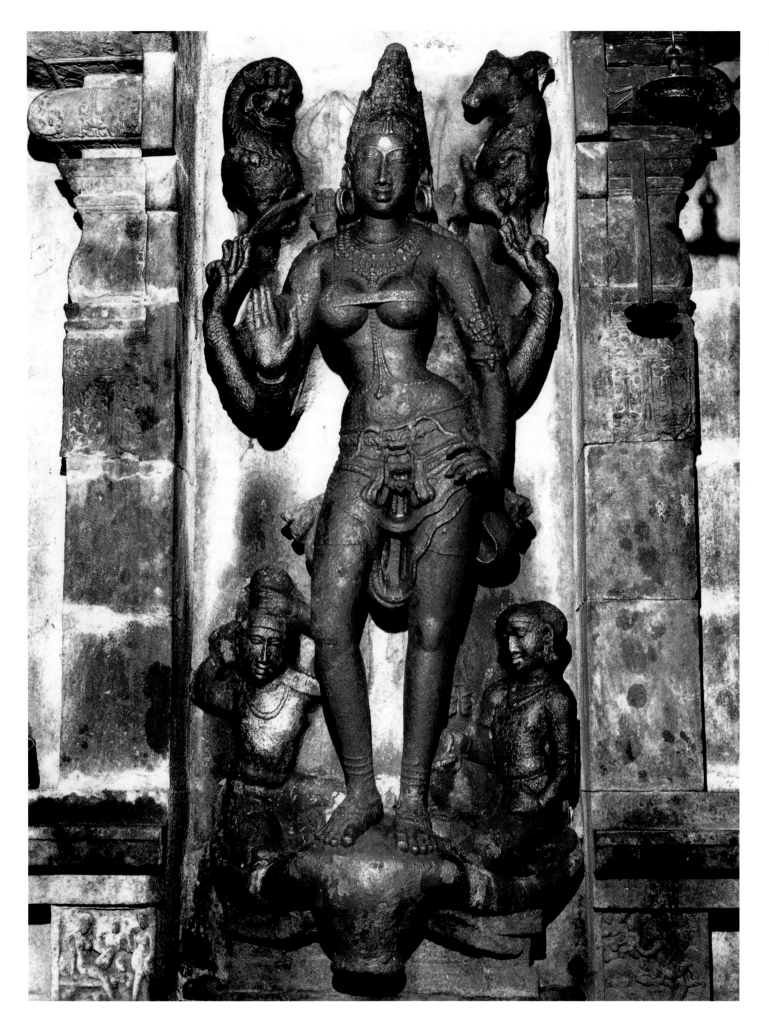

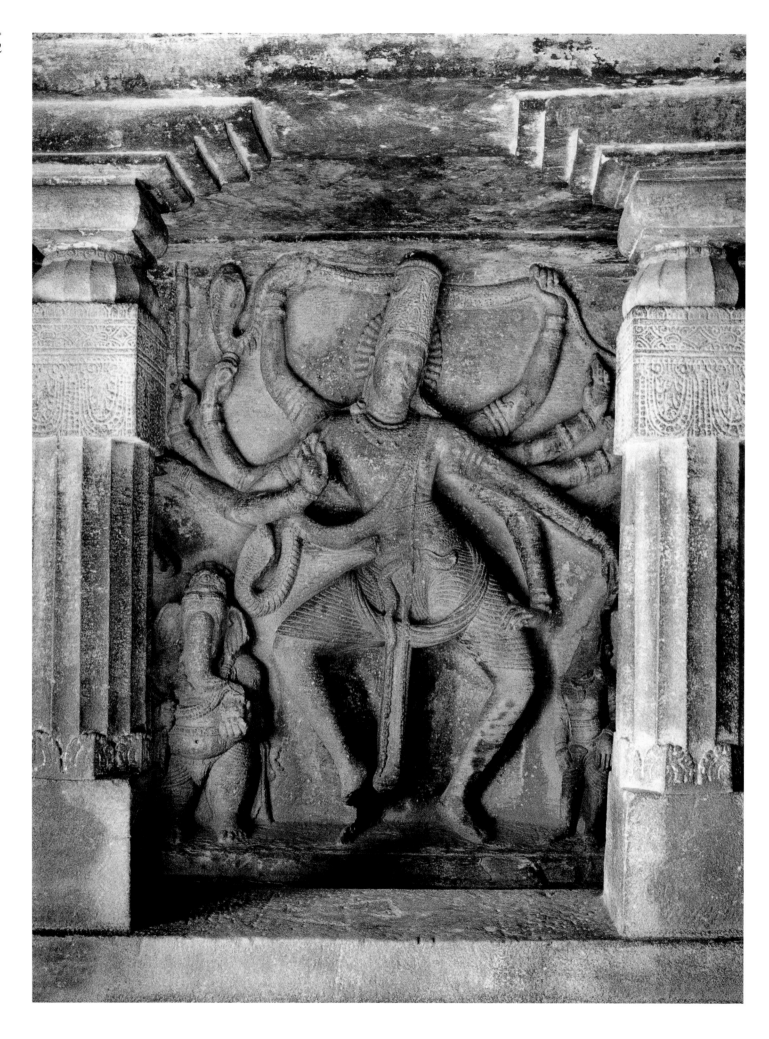

*A*rt after all is not forbidden to deal with the unusual or to alter and overpass Nature, and it might almost be said that it has been doing little else since it began to serve the human imagination from its first grand epic exaggerations to the violences of modern romanticism and realism, from the high ages of Valmiki and Homer to the day of Hugo and Ibsen. The means matter, but less than the significance and the thing done and the power and beauty with which it expresses the dreams and truths of the human spirit.

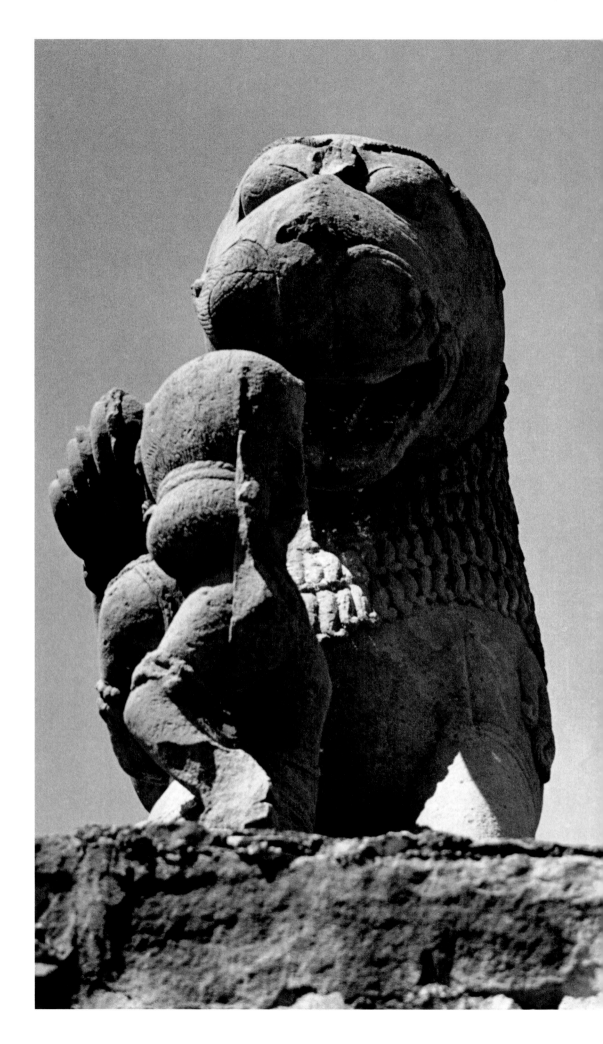

Lion playing with woman. Khajuraho, Chandella dynasty, eleventh century.

"Art after all is not forbidden to deal with the unusual..."

Opposite page:
Dancing Rishis. Natamandapa, Sun Temple of Konarak, thirteenth century.

"And as for the strangeness and formidable aspect of certain unhuman figures or the conception of demons or Rakshasas, it must be remembered that the Indian aesthetic mind deals not only with the earth but with psychic planes in which these things exist and ranges freely among them without being overpowered because it carries everywhere the stamp of a large confidence in the strength and the omnipotence of the Self or the Divine."

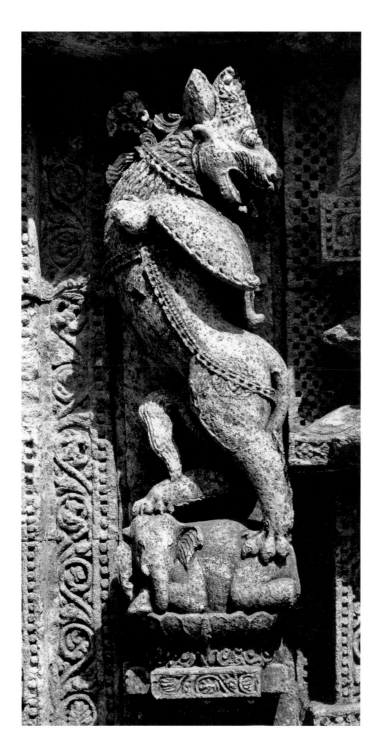

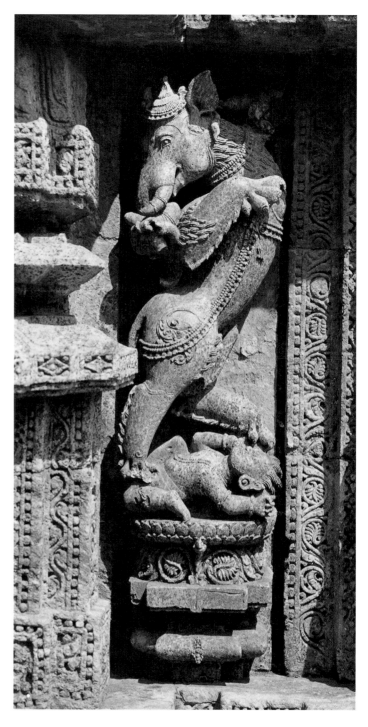

Mythological animals,
crushing the demons of
tamas (inertia) and
ignorance. Konarak,
thirteenth century.

Opposite page:
Entrance to a well. The
formidable lion-face is
supposed to ward off evil.
Brihadishvara temple,
Gangaicondacholapuram,
Chola, thirteenth century.

Page 218:
Elephant crushing the
demon of the night.
Sun Temple of Konarak,
Ganga dynasty,
thirteenth century.

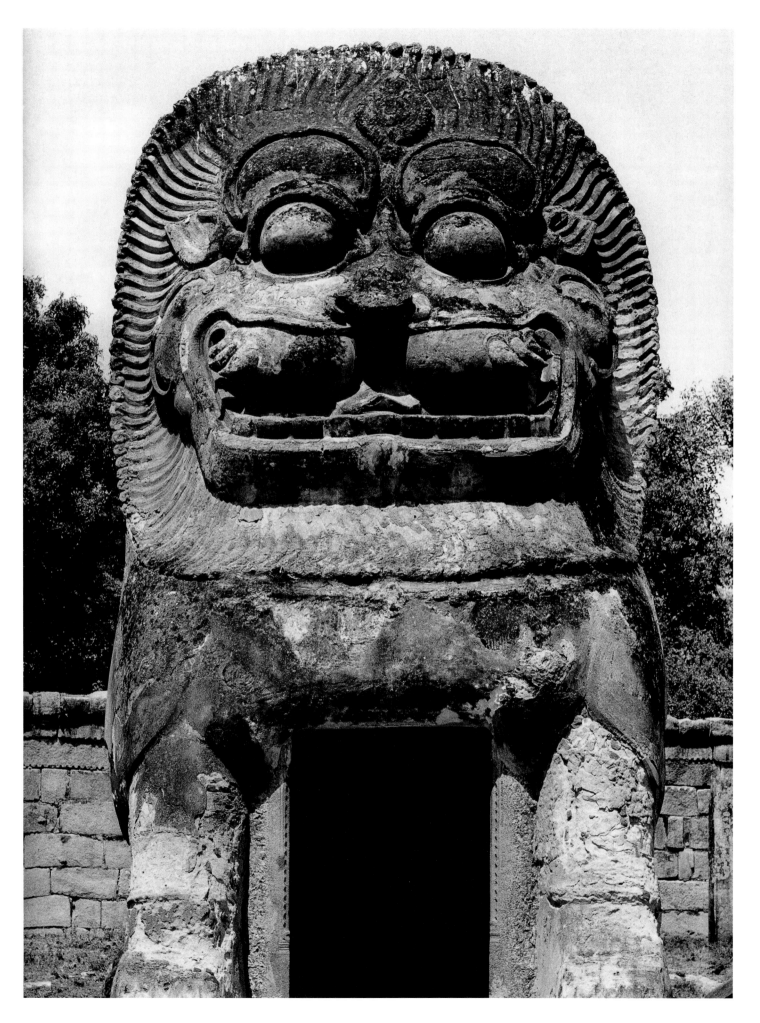

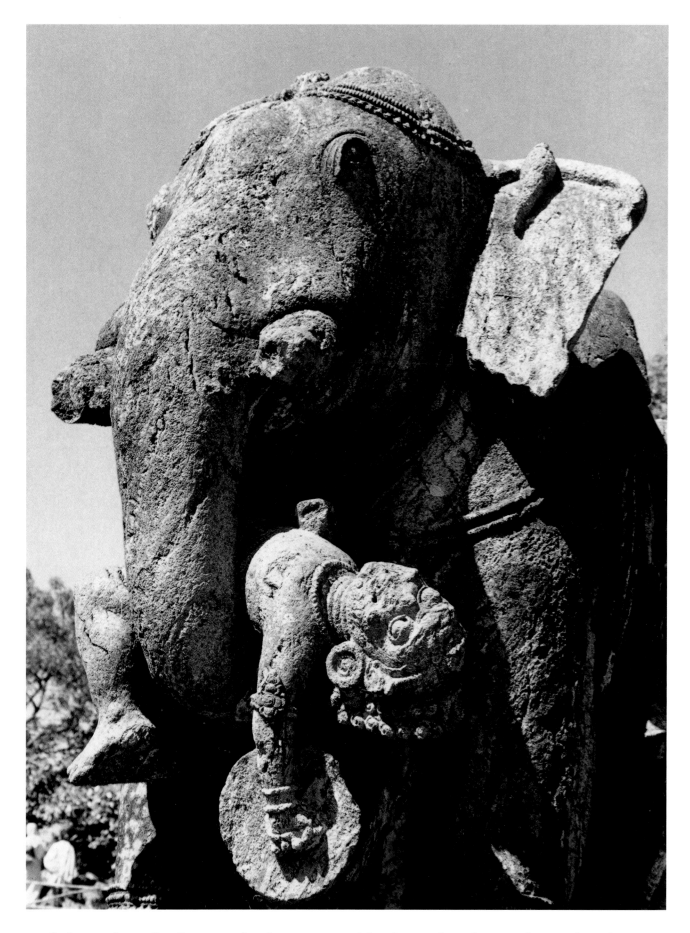

"The Indian thinking and religious mind looks with calm, without shrinking or repulsion, with an understanding born of its agelong effort at identity and oneness, at all that meets it in the stupendous spectacle of the cosmos."

The dignity and beauty of the human figure in the best Indian statues cannot be excelled, but what was sought and what was achieved was not an outward naturalistic, but a spiritual and a psychic beauty, and to achieve it the sculptor suppressed, and was entirely right in suppressing, the obtrusive material detail and aimed instead at purity of outline and fineness of feature. And into that outline, into that purity and fineness he was able to work whatever he chose, mass of force or delicacy of grace, a static dignity or a mighty strength or a restrained violence of movement or whatever served or helped his meaning. A divine and subtle body was his ideal...

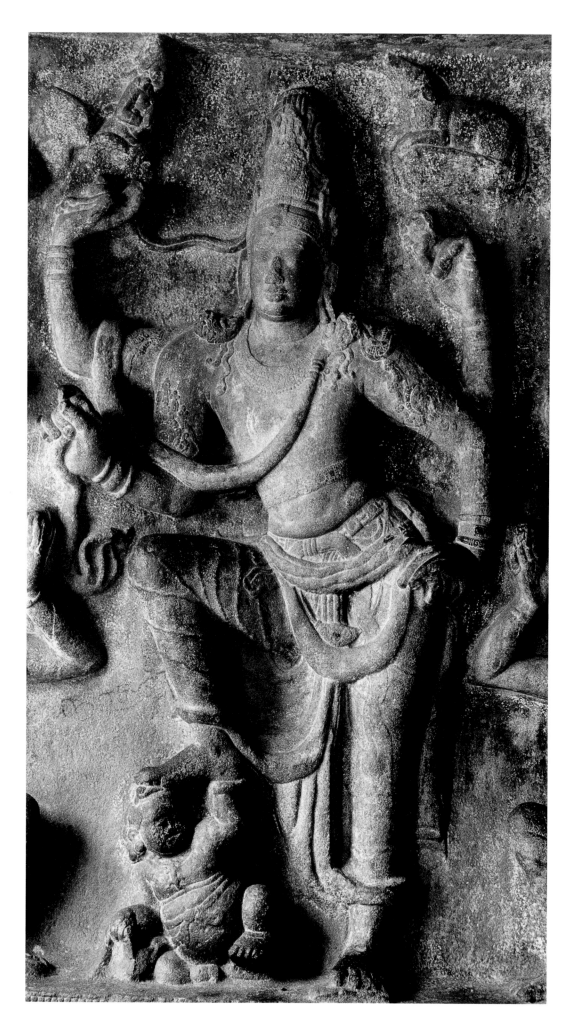

Shiva Gangadhara, catching the river goddess Ganga in a lock of his hair. Upper cave temple at Tiruchirapalli, Pallava, 7th century.

Opposite page:
Durga, riding on her lion against the buffalo demon. Mahishasura cave temple, Mamallapuram, Pallava, 7th century.

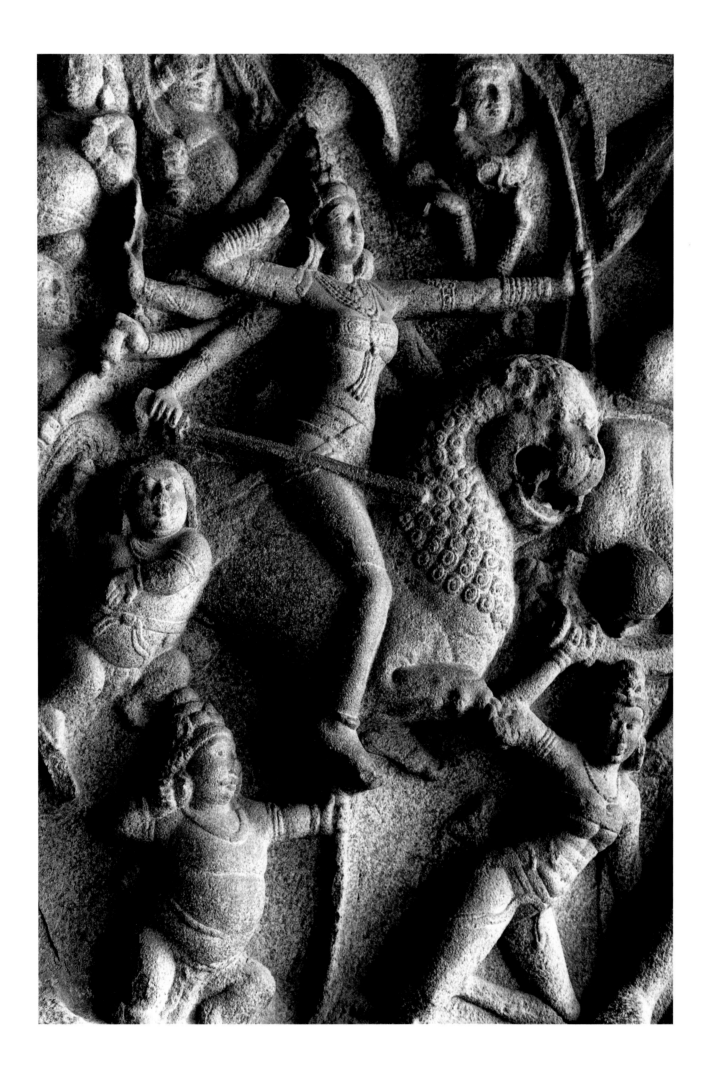

Previous pages:
Left
Two maidens, probably
Pallava princesses,
carrying water in pots to
the goddess
Gaja Lakshmi. Adi Varaha
cave temple,
Mamallapuram, Pallava,
7th century.

Right
Gaja Lakshmi, the
sovereign goddess,
permeating the world with
her power and beauty.
Adi Varaha cave temple,
Mamallapuram, Pallava.

Shiva leaning lovingly on
his bull Nandi. Arjuna
Ratha, Mamallpuram,
Pallava, 7th century.
(See page 148)

Opposite page:
Two-armed Shiva, serene
and youthful, the
ever different god.
Virupaksha temple,
Pattadakal, Chalukya,
7th century.

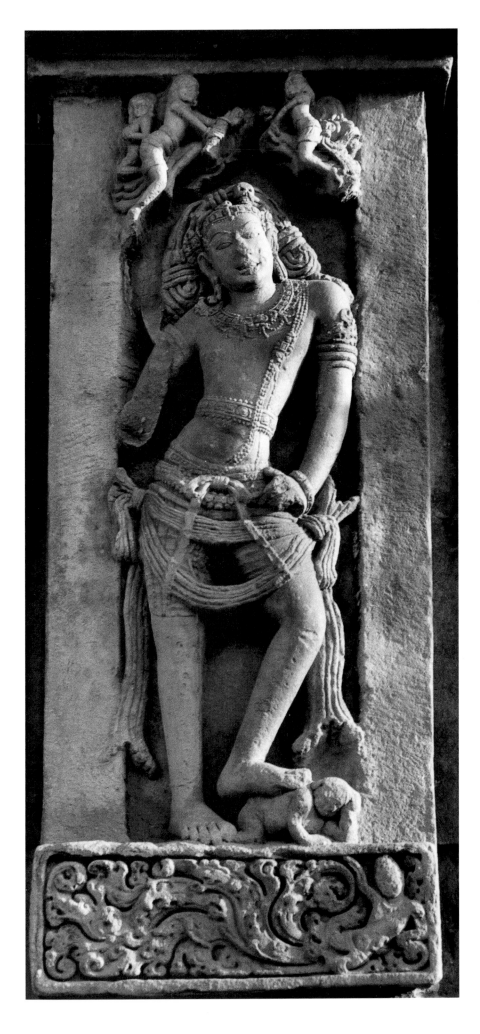

"To suggest the strength and virile unconquerable force of the divine Nature in man and in the outside world, its energy, its calm, its powerful inspiration, its august enthusiasm, its wildness, greatness, attractiveness, to breathe that into man's soul and gradually mould the finite into the image of the Infinite is another spiritual utility of Art. This is its loftiest function, its fullest consummation, its most perfect privilege."

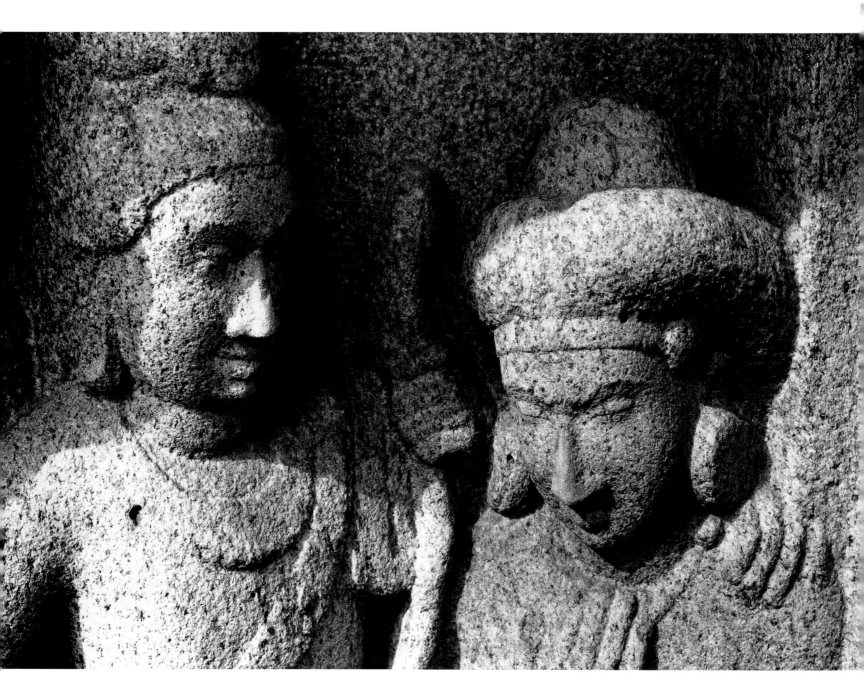

Shiva embracing his
favourite disciple
Chandikeshvara.
Dharmaraja ratha,
Mamallapuram, Pallava
dynasty, 7th century.